FAMILY HISTORY
in FOCUS

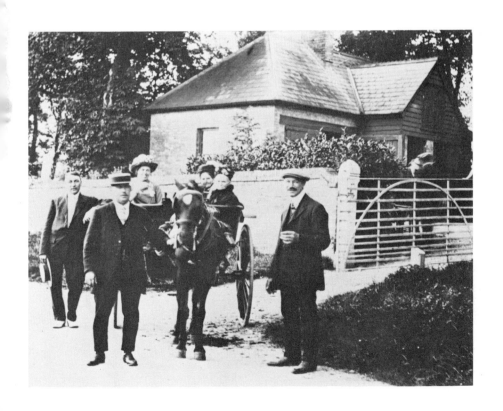

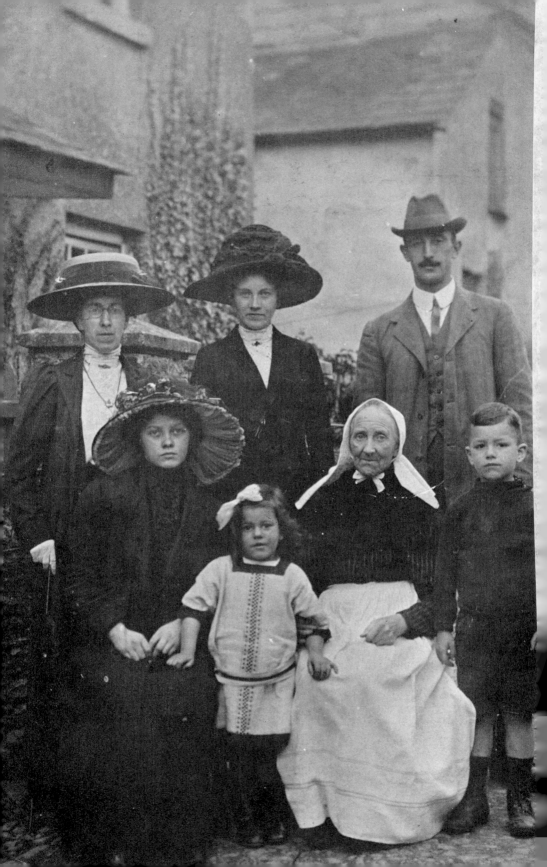

FAMILY HISTORY
in FOCUS

Edited by
DON STEEL
and
LAWRENCE TAYLOR

LUTTERWORTH PRESS
GUILDFORD SURREY ENGLAND

First published 1984

6152

ISBN 0-7188-2530-6 (cased)
Selection and editing copyright © 1984 by Don Steel and
Lawrence Taylor

Chapters 1, 3, 6, and 10 copyright © 1984 by Don Steel;
Chapters 2 and 11 copyright © 1984 by Peter Marmoy;
Chapter 4 copyright © 1984 by Mary Bone;
Chapter 5 copyright © 1984 by David Barnes;
Chapters 7 and 8 copyright © 1984 by Lawrence Taylor;
Chapter 9 copyright © 1984 by Howell Green.

Typeset by Katerprint Co Ltd, Oxford
Printed and bound in Great Britain at
The Camelot Press Ltd, Southampton

Contents

The photograph on page 1 shows an informal group captured at the moment of setting out on a family excursion. On page 2, in contrast, is a posed family group of first-generation townsfolk visiting Granny, taken at Diptford near Totnes in Devon, c. 1913. Compare the old lady's countrified clothes with the sophisticated smartness of the daughter behind her, who reappears half a century later in the wedding group on page 163 (far right, front row) where her own daughter, the little girl in the 1913 picture, is the mother of the bride.

The authors and publishers are grateful to all those who have given permission for the reproduction of illustrations, and in particular the following:
Don Steel, pages 2, 8 (above), 17, 129, 162–3, 168, 169, 178, 181 (above); Lawrence Taylor, 1, 68 (right), 118, 123, 125, 132; Steel and Taylor Collection, 9, 22, 32, 44, 45 (left), 111, 113, 114, 165, 166, 181 (middle and below); Cedric Bush and Ron Bathurst Associates, 8 (below); Arthur E. Pearson, 24–5; Joy Clayson and Peter Wright, 28–9; Jenny Overton and Ron Bathurst Associates, 37, 91, 164; Gordon Honeycombe, 38, 64, 68 (left); M. R. Tedd and the Wednesbury Library, 43; Peter Marmoy, 27, 45 (right), 116; Mary Bone, 48, 52, 54, 59; Kodak Museum, 49; Victoria and Albert Museum, 50, 76, 81, 89, 104, and Science Museum, 57 (above) (Crown Copyright); Essex R.O., 57 (below); the Master and Fellows of Trinity College, Cambridge, 58; Joan Ashwell, 61; David J. Barnes, 62, 66–7, 71; Collection of Bernard Howarth-Loomes, 85, 87 (right); International Museum of Photography at George Eastman House, 87 (left); Professor Norman McCord, Mr Stephen Martin and the University of Newcastle upon Tyne, 120; Mrs D. Foster and the Manchester Studies Archive of Family Photographs, Manchester Polytechnic, 121; Radio Times Hulton Picture Library, 128, 130; Glyn Taylor, 132 (inset), 175, 179, 182, 183; Associated Biscuits Ltd, 134; Manchester Studies Archive of Family Photographs, Manchester Polytechnic, 139; David G. May, 141; Maurice G. Lewis, 145; Howell Green, 147, 148; the Union-Castle Line, British and Commonwealth Shipping Co. Ltd, 151 (above); Adrian Vicary and P. A. Vicary Maritime Photo Library, 151 (below); National Army Museum, 153; the Order of St John, 154; The Africana Museum, Public Library, Johannesburg, 155, 156; the Wollaston Society, 158; London Midland Region (B.R.), 180.

Preface

Family History in Focus seeks to help family historians with the four main areas in which photography impinges upon their work: building up a photographic archive, identifying and dating the pictures in it, exploring sources of photographs other than family ones to produce a well-illustrated family history and, less obviously, making a photographic record of their own environment and way of life for the benefit of future generations. In each section except the last an overview of the subject is followed by more specialist chapters exploring particular aspects. Though no such book could claim to be exhaustive, it suggests a series of approaches which can be readily applied to other areas, particularly with regard to identification and dating by environmental and studio features.

It is suggested that the most practical way to use the book is to read through the overviews and to consult the more detailed chapters for reference as the need arises.

The editors are grateful to the other contributors, Peter Marmoy, Mary Bone, David Barnes and Howell Green, for writing their specialist chapters, and also to Colin Chapman, Arthur Gill, Robert Lassam and Brian Coe for reading through the manuscript and making numerous suggestions for its improvement. We are particularly grateful to Arthur Gill for considerable assistance with Chapter 6 and for allowing the use of his two charts which were originally published elsewhere. Above all our thanks are due to Jenny Overton of Lutterworth Press for considerable assistance with the editing at every stage and for seeing the book through the press, and to her secretary, Hilary Dean.

Don Steel
Lawrence Taylor

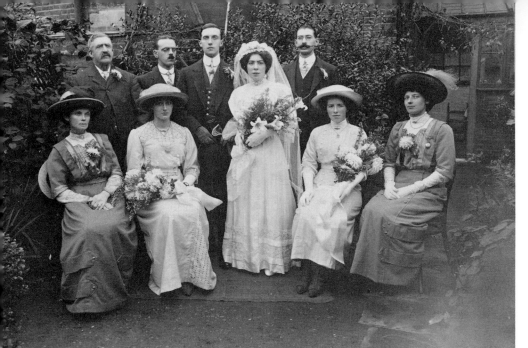

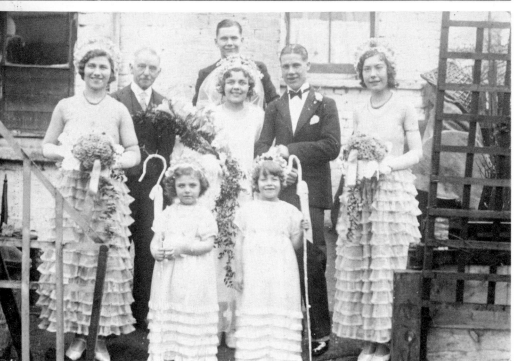

A marriage certificate, however informative, cannot rival the immediacy of a photograph. Two South London wedding groups: above, Fred Coombes, footman, and Lizzie Sprague, ladies' maid, in 1913—note the elegant hats; below, George Bush, electrician, and Eva Billington, furrier, c. 1931—fashionable frilled skirts, and Bo-Peep crooks

I

The Family Photographic Archive

A Survey

DON STEEL

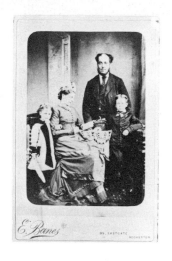

Until fairly recently family historians have shown little interest in photographs. Considerable effort is put into locating the marriage certificate of great-great-grandparents, but very little into tracking down a picture of their wedding. Yet few documents can rival the appeal of a photograph—our ancestors materialize from the dusty album and become real people. Whether used simply to humanize your personal investigations or to illustrate a printed or typescript family history, it gives identity and personality to what are frequently just names and dates on a family tree. The photograph has other roles in family history which are almost as important. It is a means by which the family historian can not only get to know a long-deceased ancestor, but can begin to identify with a living relative—even a parent or grandparent—who is not easily recognizable as the dashing young man or the beautiful young woman portrayed in the family album.

Quite apart from its inherent interest, a photograph can also act as a conversational catalyst. It is surprising how many people tape record the memories of elderly relatives without a photograph in sight. But as Granny thumbs through the pages of her album—or even browses through a disorderly pile of photographs—the pictures spark off all kinds of memories that might otherwise never have surfaced, and fill the room with the ghosts of people whom she has not thought about for sixty years. Moreover, photographs can provide ancestors and relatives with a local and social context. Though 'milieu' photographs are not so common in family collections, they can often be found in local, regional and national photographic archives (see below, pages 130–45).

The photographic record constitutes one of our richest historical legacies from the recent past and yet, even more than other kinds of family document, it is the victim of thoughtless destruction whenever an older member of the family dies. The location, collection and copying of family photographs is as great a service to posterity as genealogical research. Indeed, in most cases the archival sources will still be there for your great-grandchildren to search themselves, but without your help the family photographs will probably have disappeared. This chapter is concerned with the basic procedures involved in creating, documenting and organizing a family photographic archive.

STAGE 1: COLLECTING

Your own photographic collection is probably scattered throughout the house in a state of disarray. Some of the pictures you have taken yourself; others have been inherited from close relatives. Sort and list these first. Next comes the slower but more rewarding task of contacting other relatives, particularly the elderly. The diligent family historian will personally visit as many as possible, persuading them to ransack their cupboards, drawers and attics. There, gathering dust, may lie photographs in all shapes, sizes, thicknesses and colours, and—if you are fortunate—representative of all periods of the photographic age. Some will be loose, some in albums, some tucked away in old envelopes and folders. A mistake often made by the family historian is to acquire only *old* photographs, ignoring the snaps of the last fifty or sixty years. But not only are these as much a part of a family history as those of the previous fifty years, they are also, as is shown in Chapter 7, equally illustrative of social changes and attitudes. Of course, while searching for photographs, the family historian will also be interested in the tales relatives have to tell, as well as in any documents they may produce.

In contacting relatives, do not confine yourself to those with whom you are already in touch, but make an all-out effort to trace *every* living descendant, both on male and female lines, of any ancestor or relative who lived after the beginnings of photography, i.e. the 1840's. Far too many family historians are preoccupied with locating relatives in the male line. This is always a mistake; often the daughter of a great-aunt may know more about her grandfather's family than all the rest of the family

put together, as traditionally women have taken more interest in these matters than men. Moreover, letters or other family documents often come down female lines.

Another common error is to visit only the eldest member of a family. How can younger brothers or sisters add anything, still less middle-aged nephews and nieces? Yet it may be that the person who took the most interest in the ancestral albums after the parents died was the youngest daughter. When she died, inconsiderately young, they were left in turn to her daughter, now only thirty-seven and for this reason ignored by the family historian when so many elderly relatives were still living. It is astonishing how often the photographic collections of various members of the family will complement each other.

Lastly, do not forget to use your own camera to fill in any gaps. Some of your relatives may not have had their picture taken for years. When you visit them, use flash to get some typical photographs of them in their own environment. Such pictures will not only enhance your archive but may prove invaluable if you later decide to compile a 'How I Did It' written account, slide-tape presentation or film (see below, Chapter 10). If any buildings where your ancestors and relatives lived and worked still survive, photograph them too. At the present rate of redevelopment, they may not be there next year.

SOME GUIDELINES FOR SELECTION

In the process of building up a photographic archive, the family historian is acting partly as curator and conservationist, and partly as historian. In the case of older photographs, you will rarely be called upon to make a judgment as to what is worth preserving and what is not, for a family archivist should, as far as possible, try to keep the original or a copy of every photographic record of the family's more distant past. The closer to the present, the greater is the profusion of photographs. It is scarcely surprising that many family historians choose to ignore these altogether. However, your family history will be the poorer if its photographic archive peters out in the 1950's.

There are five main criteria for selection:

1. Pictures of family events, e.g. christenings, weddings, relatives' visits, Christmas gatherings;
2. A representative selection of pictures for a particular branch of the family across time, right up to the present;

3. Photographs which capture the everyday pattern of family life, e.g. growing up (childhood, schooldays, adolescence), work and leisure;
4. Photographs which illustrate changing social and economic trends, e.g. pictures of housing (including interiors), family transport, holidays;
5. Photographs which may have a wider historical significance and appeal because they portray people, places and events of particular interest, e.g. a group of civic dignitaries, a row of houses long since bulldozed in a road-widening scheme, a local football derby.

Do not discard a picture on impulse because it initially appears uninteresting. Try to imagine what a very 'ordinary' picture taken in 1974 might say to the future family historian in terms of dress or hair-style.

Many of the more recent pictures will be on slides, and there may be cine films or videotapes as well. Since copying these is so expensive, your criteria will need to be even more rigorously applied.

PROVENANCE

Whenever you persuade a relative to unearth a long-undisturbed collection of photographs, as well as getting your informant to identify as many pictures as possible you should also try to establish the history of each photograph and in particular to discover any changes in ownership. So a hierarchy of questions suggests itself:

1. Where did the photograph originate?
2. Can the present owner identify anybody?
3. Who was the previous owner?
4. Is it known how it came into his/her hands?
5. If the previous owner is alive, can contact be made?
6. Can *this* person throw any light on the picture?

The process is not dissimilar to the method of authentication used by the art expert, and for the family historian the fruits of research may be as highly valued.

BORROWING PHOTOGRAPHS

Sometimes relatives will give you old photographs, feeling that you will look after them better than they can. More often, they

will lend them to you for copying. It is most important to avoid damage to prints. If you are having photographs sent to you through the post, whether as a gift or a loan, ask the sender to take particular care with the packing to protect them against both creasing and damp. The following procedure is suggested:

1. Put the photographs in an envelope;
2. Put the envelope in a polythene bag in case the package gets wet;
3. Tape the bag to the *centre* of a large piece of cardboard;
4. Tape another piece of cardboard, the same size, on top;
5. Put the bag into a large envelope or flat box;
6. Label the package: *Photographs. Please do not bend.*

STAGE 2: COPYING

Whenever you borrow pictures, it is essential to copy them before returning them to their owners. There are two possible methods: photocopying, or having copy negatives and contact prints made.

The advantages of the first method, photocopying, are that it is cheap, it is quick, you need no special equipment, and you can easily run off multiple copies. The disadvantages are the poor quality of the reproduction, and the fact that if you subsequently decide you want a good-quality photographic print made of the picture, you must borrow back the original (and it may have been lost or destroyed in the interim) and have it re-photographed.

Photocopiers differ a great deal in the quality of reproduction, so make sure you use a good copier and a good-quality paper. Remember that a good copier may often produce poor copies if not properly maintained or serviced. Experiment with the light-control setting: you may need it rather darker than for copying a document, but do not set it so dark that you lose the detail.

The alternative to taking photocopies is to have copy negatives made, and to order relatively inexpensive contact prints off these, rather than larger good-quality prints. If you have the necessary expertise, and access to a dark-room, you can make contact prints yourself (see Chapter 2); if not, you can have it done by a professional. The advantages of this method are that it gives you a complete copy set of pictures; they are small (contact prints are the same size as their negatives), but of better quality than photocopies; and you have a master set of negatives and so can subsequently order good-quality enlarged prints of any pictures

you want, without borrowing back and re-photographing the original. The disadvantages are the greater cost, the slower process, the smaller size of the copies, and the need to pay a professional unless you yourself have the necessary skills and equipment.

Ideally, six sets of copies should be made, though in practice lack of time and money may enforce some compromise:

1. *A photocopy or contact print of every picture for your archive*
 This is your reference set, in which each batch of pictures is preserved intact, and in its original order. If you borrow a whole album, it is essential to preserve with your accession list page-by-page photocopies or sheets of contact prints showing the original order of the photographs, since this may assist identification. If further research shows that a particular picture is important, you can identify it from the archive copy, and either borrow it back and re-photograph it, if you have a photocopy, or order an enlarged good-quality print, if you have a contact print.

2. *Good-quality prints of pictures of particular interest*
 In many cases it is possible to produce a modern print which is much better than the original (see Chapter 2). If you cannot afford good-quality prints of all the pictures you have identified, make sure, at least, that your selection is representative. There should be at least one photograph of each individual on the family tree, as well as any which are evocative of their period.

3. *A second photocopy or contact print of every picture of which you do not have a good-quality print*
 Second copies are used for distribution throughout your collection.

4. *A photocopy of any information given on the back of a picture*
 The photographer's name and address, and any other information noted on the back of a photograph, may assist in dating it.

5. *Spare sets of photocopies or contact prints for loan to relatives*
 Send these spare sets for identification to any relative or other person who might be able to help. If you can afford it, send *two* sets—one to be retained, the other to be returned to you annotated with any helpful information. Having the free copy may well encourage co-operation.

6. *Spare sets of photocopies or contact prints for distribution to relatives*

As knowledge of your photographic collection gets round the family, you may well be inundated with requests for copies. Not all your relatives, however, will be sufficiently enthusiastic to want to spend substantial sums on good-quality prints, and will probably be quite happy with good photocopies or contact prints.

Slides are obviously expensive to copy, and unlike photocopies of prints, there is no way of getting cheap reference copies. Cine films and videotapes pose even greater problems. Though copying videotapes *is* becoming increasingly cheaper, you may have to settle for careful notes on their location and contents.

STAGE 3: DOCUMENTATION

As you build up your family photographic archive, it is important not only to store your pictures safely, but also to document them as thoroughly as possible and to devise a system by which any photograph in the collection can be easily located.

ACCESSING

The majority of pictures in your collection will probably be copies of photographs borrowed from relatives. It is essential to give every picture an accession number, so that its history is known and the original can be borrowed back if necessary. Give each batch of pictures, whether owned or borrowed, a batch number. Thus:

Batch 1 Pictures held in 1982 by Don Steel, Crossways, Jarvis Lane, East Brent, Highbridge, Somerset
Inherited from James Currie Steel and Alice Steel (*née* Goodman)
1/1 Alice Goodman aged about 15, *c.* 1906
1/2 Dr Robert Steel and family, *c.* 1901
Batch 2 Pictures held by James R. Steel, 15 Edmunds Road, Hertford; copied and returned, 1974
2/1 . . . etc.

These accession numbers should cover all pictures in your possession, irrespective of the ancestral family with which they are associated. Nor is the order of any significance. However, when it comes to storing and displaying prints, the groups should be broken up so that pictures of each ancestral family are kept separately (see below, page 19). The best way to ensure that you

know the whereabouts of every picture is to keep photocopies or contact prints by batches. Each picture should be annotated with its accession number, and with the personal numbers of everyone portrayed in it (see below, pages 19–20).

ANNOTATION

As well as keeping lists and indexes, you should document each photograph as thoroughly as possible. The ideal information is the date it was taken, the place, the names and ages of the people portrayed, the occasion, and above all the *source* of the photograph and of the identification, together with as much of the history of the picture as is known (i.e. it may be borrowed from Aunt Mabel who inherited it from her maternal grandmother). It is also important to include the present location of the original. At the end, put your own name and the date. Not only will future generations want to know what is in the picture, but they may also need to assess the reliability of the identification. So they must know who the writer was.

Accession No. 1/2

Date taken	*c.* 1901
Place taken	? Crook, County Durham
Persons (l. to r.)	Jean Steel (M5★) aged *c.* 4 (sister)
	Dr Robert Steel (M1, L17) of Crook, County Durham, aged *c.* 35 (father) (1866–1931)
	James Currie Steel (M4), aged *c.* 7
	Elizabeth Steel (M7), aged *c.* 18 months (sister)
	Jeanie Steel (M2, L18), *née* Mitchell, aged *c.* 34 (mother)
Occasion	?
Source	inherited from James Currie Steel

Dated and identified by James Currie Steel

Annotated by Don Steel, 28 Aug. 1976

★ The personal numbers are explained on page 19.

Of course, lack of time may well force some compromise with this ideal, and in most cases it is unlikely that you will have such precise information as this. You will simply have to do the best you can. However, do give full Christian names, surname and place if possible. *Not* 'Grandfather Steel', but 'Dr Robert Steel (1866–1931) of Crook, County Durham'. But should you record

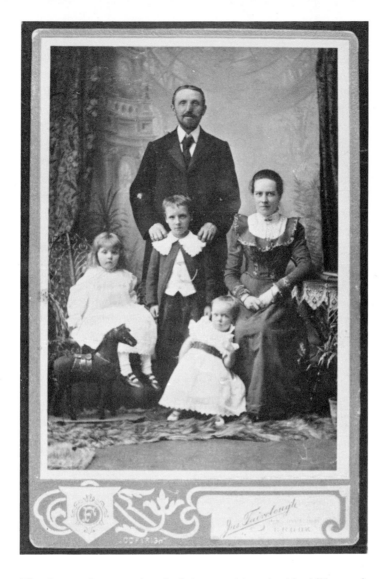

The photograph annotated on the facing page (Accession No. 1/2); note the formal poses, the 'Sunday best' costumes and the ornate studio backcloth

this on the back of the photograph or on a separate index card? In endorsing pictures, there is a great danger of the print being damaged if a ballpoint pen or hard pencil is used. On the other hand, if you put only a number on the back of the picture, with a key in a separate notebook or on a sheet of paper, there is a danger of its becoming separated from the photographs and leaving your great-great-grandchildren an even more infuriating legacy—a key once existed but where is it?

Even if there is no photographer's name or any existing inscription on the back, sticking an adhesive label on the picture is not a good solution either—most gums will eventually migrate through the thickness of the paper and affect the 'film'. Adhesive tape is even worse: it exudes deleterious substances which seep through to the image. It also loses its adhesive quality after a few years and no longer retains the label. Nor should you ever attach your annotation to the photograph with a paper clip as this will leave an impression on the picture, or even a rust mark after some time.

So a conflict obviously exists between the interests of conservation and identification. The best compromise is to write an accession number and a basic identification very lightly in one corner of the back of the print. However, be sure to rest the print on a hard surface and to write with a very soft pencil; do take care not to press too hard. Further information can be given either below the picture, if mounted in an album, or in a separate book. Alternatively, each print can be kept in a separate envelope together with full documentation.

In your travels, you will probably accumulate pictures you find very difficult, if not impossible, to annotate. The principal methods of identification and dating are discussed in the next section.

INDEXING
If your collection becomes at all extensive, as it probably will, it is a good idea to make a loose-leaf index; include every known individual and give their personal numbers (see below, page 19) and the accession numbers of every photograph in which they appear. As your reputation as the family's photographic archivist grows, you will continually get requests for copies of pictures of particular individuals, and such an index can prove an invaluable finding aid.

STAGE 4: ORGANIZATION
The basic recording device for the family historian is the family tree. Usually this consists of a number of separate charts of different branches. The following system is a comprehensive one in that it brings together genealogical data, biographical information and photographic material:

1. Keep separate collections for each ancestral surname, i.e. father's family, mother's family, paternal grandmother's family, maternal grandmother's family, etc.
2. Include on each chart full names; exact dates and places of birth (or baptism), marriage and death (or burial) if they are known, or approximate dates if they are not; full addresses of living persons, where known. Give some indication of occupations (it is not always possible to include all of them). Further information on individuals should be kept in separate files.
3. Give each chart a letter (or letters) of the alphabet. Do not use 'A' for the first chart as you may want to add charts in front of it as well as behind it. So select a letter about the middle of the alphabet—say, M. The following charts might be MD, MK and MS, thus allowing further charts—say, MB or MN—to be added in between as sub-branches are followed up. You could, of course, call your second chart N but it is a mistake to use up a lot of single letters of the alphabet too early as you may not have enough left for new major branches discovered subsequently. So use single letters to start off major branches and double letters for sub-branches. As you use up the double letters you may have to go to a third letter on occasions, i.e. two new charts added between MC and MD could be called MCG and MCP, still allowing further scope for expansion.
4. Give each person on each chart a personal number going from left to right, as shown on page 20.

If further individuals are added, 'a' numbers can be used (e.g. another child discovered between William Taylor and Eric Taylor would be given the number M13a). The personal numbers on the charts should also be used as the basis for storing biographical information and, of course, photographs. The prints should be mounted in loose-leaf albums, with a section devoted to each chart. Within the section, as far as possible, mount prints of individual members of the family according to their personal numbers, though in many cases group photographs will make this impossible. Nearly all persons in Chart M will appear in the Steel album—including the Taylors (M13 and M14) since they are Steel descendants.

Where the same individual appears on two or more charts

CHART M

M1 (L17) Dr Robert Steel
b. Stewarton, Ayrshire,
1866
medical practitioner,
Crook, Co. Durham
d. Crook, 1931

=

M2 (L18) Jeanie Mitchell
b. 1867 dau. of
Andrew Mitchell
of Paisley, Renfrewshire,
master plasterer,
and Jean, *née* Harvey
d. 1901

M3 Alice Goodman
b. Camberwell, Surrey
4 June 1891 dau. of
Boaz Goodman
of Lambeth, London
(then Surrey),
cab driver,
and Alice, *née* Hulme
d. Wokingham, Berks
27 Sept. 1970

=

M4 James Currie Steel
b. Kilmaurs, Ayrshire,
1894
var. occup., latterly
postman and clerical
officer, Min. of
Fuel and Power
d. Morden, Surrey,
16 June 1967

M5 Jean Steel
b. 1897
=
M6 William Taylor
of Crook, Co. Durham,
afterwards of Doncaster

M7 (MK13) Elizabeth Steel
b. 1900
=
M8 (MK12) Matthew Steel
of New Tyle, Angus

→ SEE CHART MK

M9 Eileen Doughty
dau. of
Cecil and Alice
Doughty

=

M10 James Robert Steel
b. New Malden, Surrey,
18 September 1932
electrical engineer,
later traffic
engineer
now (1983) of
15 Edmunds Road,
Hertford, Herts

M11 Donald James Steel
b. Morden, Surrey,
27 October 1935
secondary teacher,
later college lecturer
and BBC Education Officer
now (1983) of
Crossways, Jarvis Lane,
East Brent, Highbridge,
Somerset

=

M12 Monica Jenner
b. 9 March 1937 dau. of
Albert and Verlie
Jenner of Worcester
Park, Surrey

M13 William Taylor
b. c. 1925
=
M14 Eric Taylor
b. c. 1927

M15 Janet Elizabeth
Steel
b. Hertford,
15 Feb. 1966

M16 Andrew James
Steel
b. Hertford,
20 May 1967

M17 Marion Susan
Verlie Steel
b. Epsom, Surrey,
29 June 1963

M18 Alison Jane
Steel
b. Epsom, Surrey,
13 May 1967

M19 Delwyn Peter
James Steel
b. Reading, Berks,
10 August 1972

(e.g. Elizabeth and Matthew Steel also appear on Chart MK and Dr Robert Steel on Chart L) either put the material under one number, with a cross-reference in the other section, or have duplicate copies made. However, duplicates should also carry the cross-references because when later information is added on an item which has not been cross-referenced, it is easy to forget to add it to the duplicates as well. Where a photograph includes individuals appearing on different charts, a duplicate copy is definitely preferable. For example, let us suppose there were a group picture which included James Currie Steel (M4) and his uncle William (L19—not shown on Chart M). You should have two copies of the picture, one in the L section, another in the M section, for these sections might well end up in different albums.

In the case of the direct ancestresses (M2 Jeanie Mitchell, M3 Alice Goodman, M12 Monica Jenner) there will probably be separate collections for the Mitchells, Goodmans and Jenners. In this case, the ideal is to copy pictures for Jeanie, Alice and Monica and file them in both collections. If, because of the numbers involved, this is not practicable, keep their pictures prior to the marriage in their own ancestral collection and later ones in the collection of their married name. But be sure to cross-reference.

With regard to Boaz Goodman, father of Alice Goodman, or Verlie Jenner, mother of Monica Jenner, one cannot be dogmatic and say they should never appear in the Steel collection. After all, most married couples retain close contact with their parents and the latter are very much part of the family circle. The best solution is to keep most of these pictures in the Goodman and Jenner albums, but make a second copy of selected ones to keep in the Steel album.

Of course, you may wish to arrange your photographs according to other criteria. But whatever system you choose, make sure there is a written explanation of it, including details of the location of the collection. Keep one copy of this with the collection and distribute others to members of the family. Well, you never know. We all have to join our great-great-grandparents some time.

2
The Family Photographic Archive
Technical Aspects

PETER MARMOY

From visits to and correspondence with relatives you will probably have borrowed or acquired a fairly substantial number of photographs. What can you do to ensure that you hand this precious heritage on safely, and in good order, to the next generation? The care, restoration and repair of early film material is a responsible and painstaking task, and if you have the slightest doubt about your ability to cope, *leave it alone.* Early nitro-cellulose film is highly inflammable, and can be brittle (which is why it should be copied at the earliest opportunity). In general, the less you handle film material, the better. The acid on your fingertips will eat into the emulsion and the damage is irretrievable. Use lightweight cotton gloves, or the thin, transparent plastic gloves marketed for industrial use which are cheap and good. Never hold anything by its faces, but only by the edges.

CLEANING
NEGATIVES
With any luck you will need only to clean up your acquisitions. As ordinary soft brushes can create enough static to draw dust to the surface rather than disperse it, use a special anti-static 'puffer' brush, the ideal dusting tool, obtainable from photographic suppliers. Never get any water on the emulsion side; you can damage it badly. Fingerprints can be removed from the NON emulsion side of glass plate negatives and from most film with proprietary film cleaner. Scratches on the NON emulsion side of plates and film can be reduced by carefully wiping them over with a smear of grease before printing. You will need to clean the equipment afterwards.

PRINTS

Again, avoid getting water on the emulsion side. Fingerprints on the surface can be removed with a print cleaner, and pencil marks rubbed out with a soft eraser.

RESTORING
NEGATIVES

Damage to the emulsion side of material is a serious problem and should be tackled with great care, if at all. Never, under any circumstances, apply water to the emulsion; it will certainly go sticky, and may even dissolve.

If the emulsion on a glass plate is lifting, it can be very carefully pressed back into place by putting another piece of optical glass on top of the original and making a print from the sandwich. If the new piece of glass is the same size as the plate, the two can be taped together.

Broken glass plates can be held together with transparent sticky tape applied to the NON emulsion side, and then contact printed on to film material. If they are strong enough, they should be enlarged, using a glass sandwich, and the print spotted and re-photographed, as described on page 31.

With other forms of damage, the minuteness of detail involved is the major problem and the application of 'magic cures' by the amateur can result in the image disappearing before your very eyes—for ever. There are, however, several things you can do. Clean up the negative as described above, and then make as large a print as possible, damage and all. You then have a secondary image to work on, which can be retouched (see pages 24 and 31) and re-photographed to give you an improved negative.

DIRECT POSITIVES

Ambrotypes (collodion positives; see below, page 84) can sometimes be improved by backing them with black paper. Any other restoration to ambrotypes, including the removal of existing backing, and any form of restoration of daguerreotypes, should be left to the expert. But as pages 24–5 show, re-photographing a damaged original and retouching the print can work wonders.

PRINTS

The watchword is unchanged: keep water off the emulsion side.

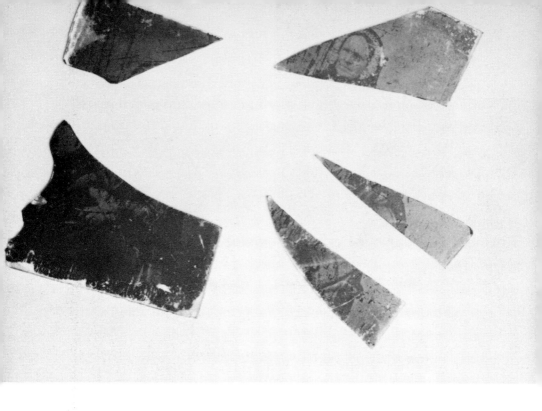

Arthur E. Pearson writes: 'An elderly relative produced a tobacco tin in which were five fragments of glass (see above), said to be a photograph of her great-grandmother. On one side was a negative photographic image in poor condition, and on the reverse a scratched and partly removed layer of black paint—the remains of an ambrotype. An ambrotype is a negative image on a glass plate, with the reverse side coated black: when viewed by reflected light, the image appears positive (see below, page 84). I reassembled the negative on a matt black board and viewed it with a 35mm SLR camera fitted with a 135mm close-focusing lens, to give a full-frame image. Lighting was from about 45 degrees but adjusted to give the best visual effect, i.e. maximum contrast without direct reflections from the glass. (The 135mm lens gives greater camera-to-subject distance than a standard 50mm lens, hence more freedom of lighting.) I used Pan F film to give grain-free enlargement and to allow about 50% extended development to boost contrast. Several bracketed exposures were made, and from the best negative I produced a 10 × 8" print (shown on the facing page, left). Further improvement seemed possible by retouching, so a second 10 × 8" print was made on Grade 3 paper-based bromide paper (much easier to handle with a retouching knife than a resin-coated print). The background was carefully cut away and the remainder mounted with spray adhesive on a 12 × 10" board. There followed many hours of work with the knife. I scraped every black mark, to a greater or lesser degree, until I achieved a level of grey matching the surrounding area. Where the mark crossed a light area, I had to remove the emulsion layer revealing the white paper beneath, which I then tinted to match the surrounding emulsion. A water-based black paint, diluted as necessary, may be applied with a very fine artist's brush; in textured areas, such as the shawl, I drew fine lines with a very sharp lead pencil (see below, page 31). Finally, I re-photographed the retouched print, again using Pan F film and slightly extended development to give adequate contrast (facing page, right). There were few subtle tones in the original negative, so boosting (within reason) the contrast in the re-photographing stages provided impact while losing nothing of the original image.'

24

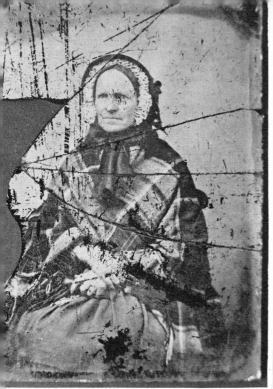
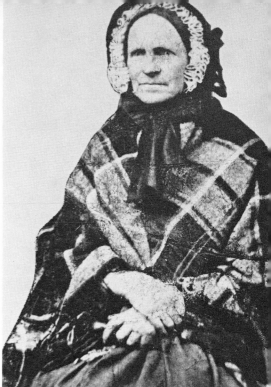

However, if the prints need flattening, you can place them *picture side up* on a piece of damp blotting paper, and gradually apply pressure until the paper becomes pliable. Remove the blotting paper and press the print with a sheet of glass on the picture side and clean paper on the reverse side.

STORAGE
None of the work described above would have been necessary with adequate storage. Proper storage (*a*) protects the material from dust, scratching and other damage, and (*b*) enables you to locate it easily.

NEGATIVES
Negative material should be encased in separate suitable envelopes. Plastic can encourage condensation which is a serious problem. The alternative is paper: there is a wide variety available, including some bound in books with appropriate indexing. Selection is a matter of personal choice. Glass negatives should be grouped in sturdy cardboard or wooden boxes. Do not line the boxes with rubber or plastic foam sheeting as these may cause damage.

PRINTS

Prints are not at their best bundled together in old envelopes. Mount them in an album that inspires you—but avoid the modern PVC print albums which can be very hazardous. Never use adhesives, even on modern copy prints: corner mounts are the best and safest way. If you want to store your prints, polyethylene or polyester 'envelopes' are probably best.

COPYING

NEGATIVES

Old negatives can usually be printed right away. With glass, nitro-cellulose and colour negatives (see below, pages 78, 80, and 103) it is particularly important to get this done as soon as possible, to ensure the survival of a copy which will not deteriorate further. Good results can usually be achieved on modern papers after a little trial and error.

PRINTS

Most acquisitions from relatives will probably be prints, which need to be copied and returned. The cost of commercial copying varies and it is wise to shop around. Beware of the photographer who insists on retaining the negatives; if you want additional prints in the future, you can be charged any price he cares to name. You may well have to pay extra to purchase them, but it is worth it in the long run as more and more relations ask for copies. So before the work is commenced, specify that you require the negatives, and secure the photographer's agreement in writing to pass them over to you. But quite apart from the question of price, you may have difficulty in finding a professional photographer willing to take on the copying, especially if the job is a modest one. If so, consider contacting your local camera club or photographic society (or even your local technical college). One of its members, well provided with equipment and expertise, might be prepared to undertake the copying for you in return for the cost of materials involved. However, the most satisfying solution is to do the photographing yourself, though not necessarily the developing and printing.

SETTING IT UP You will obviously need a camera with the facility to photograph at close quarters. A single-lens reflex camera with close-up rings is the simplest answer. Focusing and

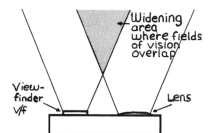

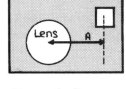

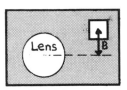

With a non single-lens reflex camera you will encounter the problem of parallax, which is accentuated in close-up work.

1. Measure the distance from the centre of the lens to a line dropped vertically from the centre of the viewfinder: Distance A.

2. Measure the distance from the centre of the viewfinder to a line drawn horizontally from the centre of the lens: Distance B.

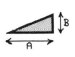

3. On a piece of thick paper, draw a right-angled triangle to these measurements. Cut this out.

4. Focus the camera on the object to be photographed, using a close-up lens.

5. Place the cut-out paper triangle on the object, with Point 1 at its centre. The base of the triangle and the base of the camera should be parallel.

6. Look through the viewfinder and centre it on Point 1.

7. Now move the camera so that Point 2 is at the centre of the viewfinder.

Remove the paper triangle. Take the photograph.

sighting are straightforward and the exposure can be worked out by temporarily substituting for the original a piece of mid-grey paper or card (the inside of a breakfast cereal package is often suitable). Fixed-focus cameras need more persuading to come up with good results. What you see framed in the viewfinder of a fixed-focus camera is not necessarily what the lens sees and records. This problem, called parallax, may be dealt with as shown in the diagram (above).

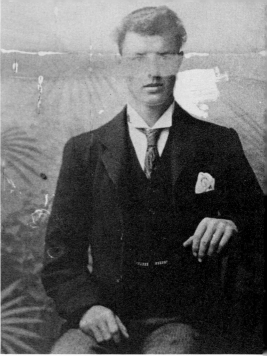

A photograph of the original picture taken through a yellow filter

Beginning of retouching: bleach or white paint on background

Family historian Joy Clayson found in her attic an old photograph (above left) of her grandfather, Sydney George Clayson (1882–1962) of Harrold, Bedfordshire

To get your picture in focus you may need to clip a macro or close-up lens on to the front of your camera. Close-up lenses are usually measured in dioptres: 1, 2, 3, 4 or 5, according to the degree of magnification. Simple clip-on close-up lenses for fixed-focus cameras are not expensive and open up a whole new world of photography. You *can* photograph through an ordinary magnifying glass, but although the results may be spectacular, this method is unreliable.

To photograph the original print, you need to hold the camera poised and still above it. If you have a tripod, this can be manipulated so that the camera points downwards at the object. Some of the new miniature tripods with clamps attached are ideal for this purpose. Failing this, you can place your camera face-down on a sheet of glass propped between two chairs, and centre it over the original—precarious, and not ideal, but many a successful shot has been taken this way. If you are going to copy a lot of photographs, a proper stand is worth the investment.

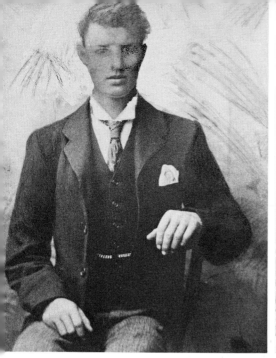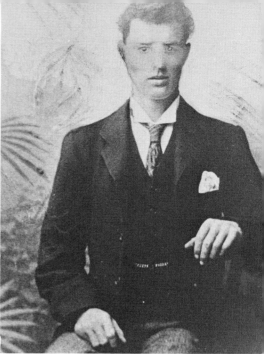

Three methods of retouching: (a) dots on face; (b) painted area on arm; (c) pencil on background

The final retouched print: criticisms—left arm too dark, right arm too pale

Though Sydney's face had suffered badly, a former colleague, Peter Wright, was able to reconstruct the damaged features as shown here.

Stands which point the camera downwards are preferable to those which point it sideways, simply because of the problems of holding the material to be photographed flat and straight. If the original is not absolutely flat, you may need to place a piece of glass on top if it. Do watch out for reflections in the glass or you may finish up with a photograph of yourself rather than Great-Aunt Patience. A piece of the non-reflective glass used in picture-framing can be a useful asset, at least up to a point, but may subdue the detail and affect the contrast of the original. Alternatively, you can attach a polarizing filter to the camera.

The secret of successful copying, unlike photographing your dearest and maybe nearest, is to get flat, even lighting. Two evenly balanced lights equidistant on either side of the object, about 45 degrees from the horizontal and above the line of your camera lens, would do admirably. The professional can introduce batteries of spotlights at this stage—and, if you have such luxuries, this is their moment. If not, all you need do is wait

for a bright day and take your photograph by the window, where there is maximum light, or in the garden. Sunlight is colour balanced and strong, and presents no problems.

Faded yellow-brown originals may be photographed through a tri-colour blue filter to reconstitute their contrast (for example, using Kodak Panatomic X film with a No. 47 filter). Blue, being the complementary colour to brown, will make the brown appear darker. A word of advice on exposing and developing copies to increase the contrast is given below (page 31).

THE FILM Copies should be in black and white whatever the original, as colour prints often have a suspect life length. The film you choose will have a significant effect on the resulting print. Film speed, i.e. its sensitivity to light, is measured in ASA's (American Standards Association) or DIN's (Deutsche Industrie-Normen). 100 ASA film is twice as sensitive to light as 50 ASA film; 200 ASA film is four times as sensitive. The light-sensitivity of a film has a direct connection with the graininess of the final print. Faster film tends to be grainier, and the fine detail of the print may lack precision. The slower the film, the lower its ASA number, the smaller are the halide grains and the less irregular their distribution during development; consequently, the better the resolution of the final print. I have found film rated at 125 ASA or thereabouts excellent for most copying work.

THE EXPOSURE Calculating the exposure on a simple camera can be anything but simple, given the chance—so don't give it a chance. Use bracketed exposures. 'Bracketing' in photographer's language means backing it both ways, by taking three photographs of the original to make sure you have got the exposure right at least once—expensive perhaps, but almost foolproof.

1. Take a photograph at the exposure you estimate is correct;
2. Take a second photograph at half this exposure;
3. Take a third photograph at double the first exposure.

One of these exposures should give you an adequate result and with luck you may even get two.

DEVELOPING AND PRINTING The experienced photographer can now go on to develop and print the negatives, and if need be, to make enlargements as well; but this takes expertise and the

proper equipment. Most family historians will probably prefer to take their film to the chemist's. However, if you do do your own developing, remember that the lack of contrast often found when sepia prints are copied can be avoided by under-exposing the film and increasing the developing time. A 25% increase in developing time gives a moderate increase in contrast; a 50% increase gives the maximum you can hope for. As mentioned above, an alternative is to attach a blue filter to your lens.

RETOUCHING

If an old negative, direct positive or print is in bad condition, you can re-photograph it and retouch the print. As Arthur Pearson says on page 24, a Grade 3 paper-base bromide paper is best for the print—much easier to handle than a resin-coated paper. Scrape as he describes, and retouch with a very sharp pencil for fine lines (2B and 4B give some choice of intensity) and with spotting inks—black and white inks which, mixed with water, can be made to match any tone on the print, and literally spotted on to it with a very fine brush. See pages 28–9 for a good example of various techniques. Re-photograph the retouched print to get an improved negative, using Pan F film and slightly extending the development for adequate contrast.

PHOTOCOPYING

There are many photocopying machines available which will copy prints, to varying degrees of satisfaction. Some of them are excellent and quick, but check before you use one that your original is not going to be damaged by heat or chemical immersion. The permanency of photocopies varies, and though photocopying can be satisfactory as a stopgap measure, the real answer is to have a traditional print from the original or secondary negative. Documents such as newspaper cuttings or old letters should be photocopied as soon as possible, as they suffer from handling.

★ ★ ★

Restoring and copying old photographs needs care and skill but few contributions by the family historian are of greater value. The sense of achievement in re-creating an old photograph which has survived, perhaps, for a century or more, is magical.

3
Identification and Dating
A Survey

DON STEEL

Almost every family photographic archive includes many old pictures for which information is scanty or non-existent. In attempting to identify these, it is important to ask yourself three questions. What information have you inherited with the photograph? What help can you get in identification from other sources? What clues are supplied by the photograph or album?

INHERITED INFORMATION
WRITTEN INSCRIPTIONS
An inscription often provides the best means of identification, but as with paintings it can prove misleading.[1] Never assume automatically that information on the back of a photograph is correct, but try to judge whether it appears to be contemporaneous with the photograph.[2] If so, it is probably accurate. If it was added much later, whoever wrote it might quite simply have been mistaken. Another hazard is that many albums included at the back a numbered 'Index to Portraits'. If you find this has been completed (which is unusual) you are fortunate; but such a list can sometimes mislead more than it helps, for it was not uncommon for pictures to be moved around in the album and for new ones to be added or old ones removed after the index was compiled (see below, page 40).

Though actual errors are rare, pet names or vague descriptions frequently make identification difficult. 'Auntie Lou'—but *whose* aunt? *Which* Auntie Lou? Was she a member of the immediate family or a close friend who held the 'honorary' title of Aunt? Sometimes the writer of inscriptions can be identified from the handwriting. Even if no letters survive written by that person, a signature in a marriage register or a will may provide a clue.

SOURCE OF THE PHOTOGRAPH

As has been emphasized (see above, page 12), when you borrow photographs be sure to try to trace the history of any unidentified pictures. Although Aunt Mabel may not know who is portrayed, she may well be able to tell you that a particular photograph was one she acquired when her maternal grandmother died. This information alone would be enough to prevent useless enquiries among her father's relatives.

HELP FROM OTHERS
RELATIVES

As already suggested, photocopies should be made of all the pictures and distributed to as many elderly relatives as possible in the hope that one of them will be able to identify the persons portrayed. For example, let us consider the case of two old photograph albums located in Salt Lake City, held by the grandson of Thomas Le Breton and his wife Margaret, *née* Honeycombe, who had emigrated from Jersey in the Channel Islands to Utah, USA, in the 1890's.

Photocopies were made of all the photographs and sent to the owner's aunt, a Mrs Florence Fones, aged 85, living in Tooele, Utah. She had not seen the albums for many years, since they had come down another branch of the family with which she was not in touch. No reply was received. However, when I visited Utah the following year, I telephoned Mrs Fones for an appointment and drove the eighty-mile round trip from Salt Lake City. Astonishingly, the old lady was able to identify a fair proportion of the photographs. She explained that in about 1906, when she was ten years old, she had met most of her Jersey relatives when her mother and father went back to the island to visit their parents, brothers and sisters. After a second visit a few days later, I finally emerged with well-annotated photocopies and half a dozen cassette tapes of oral evidence. A few months after my visit, Mrs Fones died. Had she not been contacted when she was, or had I not gone to so much trouble to see her, the identity of many individuals in those albums—not to mention a great deal of information about the family—would have been lost beyond recall.[3]

In trying to identify photographs, work systematically print by print with the people who might remember. Do this in person if possible—if not, send them batches of numbered pictures.

Unfortunately, not all relatives or other potential informants are equally helpful. Your preliminary enquiries will usually

indicate those who are hostile or, though not unfriendly, think it all rather a waste of time, as well as those who are mildly interested or positively enthusiastic. A different strategy is required in each case. Where the informant is enthusiastic and knowledgeable, it may be possible to send a large number of pictures for identification. However, many informants will be elderly and can be very daunted by the prospect of coping with a great many photographs at once. It may be much better to maintain a steady flow over months or even years. If the only survivor who can identify certain pictures is uninterested or even hostile, a carefully prepared personal visit, keeping the number of pictures to the bare minimum, may well yield results. Whenever possible, however, you should take or send copies of *all* relevant pictures to *all* the interested relatives. Do not merely show them copies of the pictures which remain unidentified, unless you yourself can identify a picture with absolute certainty (e.g. your own parents). Some of the pictures may have been wrongly identified, and you may get a rival identification when the next batch comes back. You can now either seek further corroboration or discuss the discrepancy with your two informants. It is very important that you should take or send each relative in turn a completely unannotated set of photocopies. If you reveal, either orally or by annotation, previous identifications which have been made, you may influence your informant to accept unquestioningly someone else's error. Accession numbers, e.g. '2/27' (see above, page 15), are essential, so that both parties know which picture they are discussing.

RELATIVES OF RELATIVES

When you come across an album or collection of photographs in the possession of a member of the family, there is a natural tendency to assume that the pictures must all be of your relatives too. However, the collection is just as likely to include portraits of relatives on another side of their family for whom you hold no records. A 'family' is not a static concept based on a single surname, but a fluid, dynamic one with surnames appearing and disappearing in great profusion on the outer foliage of the family tree. Bearing this in mind, it is a good idea to use oral evidence to compile mini-trees of as many families as possible for each of your elderly relatives, even though the individuals on them are not related to you. These mini-trees can be useful for reference

purposes when considering all the possibilities—and sometimes in jogging the memory of older informants. They may also help you to locate relatives of theirs on other sides who may provide identifications which will enable you to 'eliminate' some of the pictures.

FRIENDS, NEIGHBOURS AND ACQUAINTANCES

It is also important to remember that the average photographic collection includes many pictures of people who were not related to any member of the family. Most of us have pictures of a wide circle of friends and acquaintances. Our ancestors and deceased relatives were no exception, and so you must expect to find pictures of friends, neighbours, workmates and business associates. Whatever problems this causes in identifying family pictures, do not be discouraged, for such photographs may well enrich your family history by providing clues to the social, religious or business lives of your ancestors. As Malcolm Pinhorn has pointed out, just as 'the genealogist thinks in terms of relationship—of the ties of marriage, kinship and friendship and business and career links which result', so should he look at the collection of family photographs as a whole—as a visual record of a period which provides evidence of relatives, friends, neighbours, local personalities, visiting notables and even holiday acquaintances, who are all in the family album for a reason.[4]

Until recently, the strong influence of the genealogical tradition has meant that family historians have spent more time locating relatives than seeking people who *knew* their ancestors. However, in many cases, particularly if a family was rather scattered, relatives knew far less about Grandfather than did friends and neighbours. In reconstructing the biographies of your immediate ancestors and relatives, and their local and social context, it pays to visit the area where they lived or worked and to locate as many people as possible who knew them. Do not confine your enquiries to those still living in the area; obtain the addresses of any who have moved away, and get in touch with them too. Besides uncovering unexpected caches of oral information, this may well assist in identification of unknown people in your photographs. The photographer's name and address will often tell you where to start looking. But this is something that will not wait. With every year that passes, an elderly person who could have identified an old picture in your collection has died.

FAMILY HISTORY AND ONE-NAME SOCIETIES

More and more people are joining family history and one-name societies, so there is now a good chance that members working on families from the same area can identify some of your photographic 'unknowns'. At present, most directories of members' interests concentrate upon surnames. These are obviously useful as you may well find people working not only on 'your' family but also on the families of some of the in-laws on the family tree. The latter, or their relatives, may be able to identify some pictures. But indexes of members by the places from which their ancestors came might well be almost as useful; you could find the names of further people to whom you could send photocopies for identification. Conversely, some of the *identified* pictures of non-relatives in your albums may be just the ancestral pictures some other family historian would give anything to have.

WORKS OF REFERENCE

There is one further pitfall of which you should beware. Portraits of well-known people, such as actresses or politicians, are commonly found in family photographic collections. Be alert when browsing through well-illustrated books on the period. You may find your elusive unidentified 'relative' clearly captioned *Lillie Langtry* or *Lilian Gish*. Even when these have been identified, and perhaps despite a firm family tradition to the contrary ('Lloyd George gave Mother his picture because he enjoyed his stay at the hotel where she was a chamber-maid'), the probability is that there was no connection of any kind! It was fashionable on both sides of the Atlantic to include a few such pictures in the family album. American albums often contain not only portraits of George Washington or Abraham Lincoln, but of the British Royal Family as well, revealing that latent desire for tradition and pageantry which is still strong today. Other themes unrelated to the family sometimes appear in photograph albums, such as Tom Thumb and his bride, or Venus and Cupid. However, few are likely to mistake these for relatives!

INTERNAL EVIDENCE
THE PHOTOGRAPHER

Many studio portraits carry the photographer's name and address. This always supplies a useful lead, and will sometimes solve the problem right away. William Welling's *Collector's Guide*

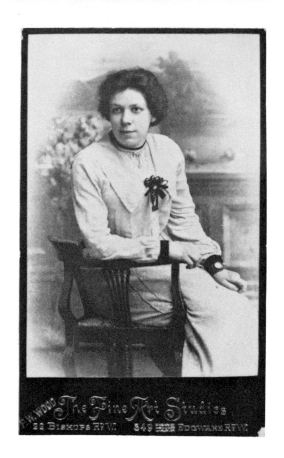

A photograph of Florence Richardson, daughter of a Paddington coachman, taken by F. W. Wood of the Edgware Road. The name 'Flo' is written in faded ink on the back, but there is no indication of any date. The mount has been over-stamped to cross out the number '408' and substitute a new one, '349'. Paddington directories list F. W. Wood at 408 Edgware Road, in 1896, 1897 and 1898; at 347 in 1899; next door, at 349, in 1900; and at 347 again in 1903 and 1905. This suggests a date around 1899 or 1900. However, when a costume expert from the Victoria and Albert Museum saw this photograph, she pointed out that the seaming on the skirt and the style of the cuff indicate a later date, around 1906. This would fit better with Florence's age. Born in 1884, she would have been only sixteen in 1900. Could the photograph have been taken to mark her twenty-first birthday, in 1905? And was the photographer perhaps using up a batch of old mounts?

to Nineteenth-Century Photographs has lists of English, Scottish and American photographers operating in the 1840's and 1850's, but its value is limited because only names are given without addresses.[5] Welling also includes a list of stereographers (see below, page 79) of the 1850's and 1860's by their country of operation, but except for these, very few lists are known for later periods[6] and none at all for Britain. But photographers can usually be tracked down without too much difficulty in trade directories or in census returns.[7] Family historians are so accustomed to using the latter to search for ancestors that, unlike local historians, they tend to forget they can be very useful for locating other people too. The 1881 census is more useful than earlier returns in this respect, as family photographs become much more plentiful in the 1880's.

The local library's photographic collection may also help. Studios tended to be located in the centre of town, so there is a chance that *your* photographer's studio appears in a dated photograph of the main street. Suppose a photographer is listed

The photographer's name and address often provide a valuable clue. In the research for the BBC series on family history, presented by Gordon Honeycombe, two large albums of photographs were located, with all the pictures unidentified. This is one of them, taken, the mount says, by J. H. Haggitt of South Shields. Only one member of the Honeycombe family was known to have lived within striking distance of South Shields, and a search of directories, whilst not confirming the identification, at least showed that the photographer had been in the same area at the same time.

in the 1871 census and in an 1873 directory, but has gone by the 1881 census. When did he go? An 1874 picture of the High Street showing a new occupant's name on the door would narrow down the period considerably, though unfortunately topographical photographs can rarely be dated with such accuracy.

An interesting example of tracking down the photographer is provided by the albums mentioned previously (see above, page 33). One of the pictures Mrs Fones could not identify was a carte de visite bearing the name *J. H. Haggitt, Market Place, South Shields.* Previous searches of the Civil Registration death indexes had revealed the death in Sunderland in 1872 of an uncle of Margaret Le Breton, *née* Honeycombe, called Richard Honeycombe. The certificate showed he had died, aged twenty-nine, on 29 February 1872, from an accidental fall from a staging at a brewery. A search of local newspapers revealed an account of the accident in the *Sunderland Times* for Saturday, 2 March 1872. Since South Shields is only a few miles from Sunderland, it seemed almost certain that the photograph was of Richard.

The evidence from directories would support this view. There is no reference to Haggitt in 1864. In 1865 *J. H. Haggitt, 33 Market*

Place, appears under the sub-title 'Artists'. In 1873 and 1879–80 there is a *John Henry Haggitt, Photographer, 33 Market Place.* In the 1881/2 directory he is gone—at *33 Market Place* we find *Borrow, G., photographer.* Borrow also appears in the 1881 census returns. So the photograph can be dated with certainty as 1865–81, unfortunately a rather long period. However, even this is very useful information. If Haggitt had not appeared in the directory until after 29 February 1872, when we know Richard Honeycombe died, the picture would almost certainly not have been Richard. As it is, the identification may be provisionally accepted until any evidence is found to throw doubt upon it. Not only does this supply a probable photograph of a member of the family of whom no picture was known to survive, but it provides a prima-facie case for an approximate dating of neighbouring pictures in the album.[8]

Many Victorian and Edwardian photographs bear the photographer's reference number, i.e. the number of the negative. It is just possible that the photographer's records survive, and strategies for locating these are discussed in Chapter 8 (page 142). Briefly, it is worth trying all the photographers in the locality today to see if any of them hold any old records of businesses they or their predecessors have taken over. The records of a few firms have been deposited in libraries and museums, while others are held by photographers' descendants. In some cases a key to the negative numbers has survived. The relevant entry usually gives the name and address of the person who ordered the negative, and occasionally the name of the sitter.

POSITION IN A PHOTOGRAPH ALBUM

As mentioned above, the position of a photograph in an album may be a crucial clue. Husbands and wives are often placed side by side, and sometimes children appear in order of age. These photographic elements have been likened to words in a sentence. 'When they are scrambled, their meanings get lost. The compiler, like the author of a book, had a reason, whether conscious or unconscious, for arranging the elements as they are. To destroy this meaning is to lose the opportunity for discovery.'[9] A common arrangement in albums is in order of seniority. Pictures of parents or grandparents sometimes appear first (since the pictures might have been taken many years before the purchase of the album, this is often not self-evident); uncles and

aunts may follow; and then come brothers and sisters and their children. Even when there is no reason to suspect that the subjects of proximate photographs were closely related to each other, if you have succeeded in dating one photograph it often furnishes a clue to the date of its neighbours.

Unfortunately, though, this is by no means always the case. The passe-partout method of slipping photographs into cut-out frames, sometimes six or more to each page, became standard for the Victorian family album. This made it very easy to take photographs out again, either so that new ones could be substituted, or so that the pictures could be re-arranged. Because the capacity of albums was limited, people had to choose very carefully what they wanted to include. Few families owned more than two albums, so once these were filled, for every new picture that went in, another had to be taken out. It is not uncommon to find a later picture among a batch of earlier ones—it was simply too much bother to re-arrange the whole album. Although the very limitations of the album meant that every photograph was there for a reason, those reasons might be spread over a period of years and a new daughter-in-law might find herself next to an aunt who had died many years before.

MATCHING WITH OTHER PICTURES
It is very likely that a family album will include more than one picture of the same person. When you have made one firm identification, try to pick out the same person in other pictures with due allowances for growth and ageing. In some cases it may be possible to build up a life-sequence, such as child—adolescence—young married—middle age—old age. However, there is often very little to connect the parts of a sequence unless you have a good sample of photographs of the same person at different ages—after all, how many balding men with middle-aged spread have any resemblance to the slim, handsome, athletic college students of twenty years ago? And how many of us, unless we are the mother, can tell one baby from the next? Moreover, it is very easy to make wrong assumptions. A general family likeness may prove misleading; fashionably cut beards or moustaches make their owners look deceptively alike, and conceal facial features; sometimes two portraits bearing a marked resemblance to each other are of father and son, or mother and daughter, taken thirty years apart; and more distant relatives

often closely resemble each other. Nevertheless, it may be well worth employing the idea of the family cycle to produce a sequence that can be tested against other known information.

ESTIMATING AGES

Try to estimate the age of the subject. If the photograph can be dated in some way (see below), a short list of possible candidates can be compiled from dates of birth on the family tree. Ages of children are, of course, much easier to judge than those of adults. A group of two youngish parents with three children aged, say, about six, about three and about a year may well match up with a similar group on the family tree. However, remember that a photograph will reflect the family only as it was at a given point of time. Do not confine your attention to couples who had three children; the ones in the photograph may well have been the first three of eight, or the older children may not appear if they were married or away from home. Remember, too, that once photography entered the 'Do-It-Yourself' era, family photographs usually lacked one person, the photographer—perhaps Dad or the eldest son. Finally, as has been pointed out, in scanning the family tree for relatives of appropriate ages and age gaps, do not forget that the people on that photograph may be distant in-laws and not directly related to you at all.

DATING UNIDENTIFIED PICTURES

If it is proving difficult to identify some of the pictures you have acquired, it may at least be possible to arrive at an approximate date by carefully analysing the detail of costume, environmental features or studio conventions and furniture. Write down everything that you see. No particular order is necessary, but it might help to proceed from the general to the specific. Omit nothing, however trivial—the type of skirting-board, the pattern on the linoleum. In the case of an outdoor view, a simple listing of everything visible may tell you much about the subject's background, and there may well be significant features such as dress, buildings, vehicles or machinery.

Holding a print in front of a strong light for a short time will make it easier to distinguish details. The ideal is a light-box of the type used by photographers for viewing and examining negatives. However, any strong light source will do, preferably in combination with a magnifying glass. This will often enable you

to read otherwise illegible signs, posters, nameplates, numerals, advertisements and other clues. Negatives can be examined with a powerful magnifying glass—×6 to ×12. But with prints, too powerful a glass so enlarges the texture of the paper that it can be difficult to see the picture, so ×4 to ×8 is best. It is less tiring to the eyes to use a magnifying glass with a built-in light source. Enlarging a photograph may be another way of clarifying half-perceived detail.

Lastly, it has been suggested that if family photographs have been in one place for a long time, you cease to see them. Changing their position will often help.[10]

COSTUME

As a costume historian demonstrates in Chapter 4, costume can often provide a fairly accurate means of dating, though of course only the well-to-do could afford to keep up with the latest fashion and that 'best' dress worn for a studio portrait might be ten years old or more. Costume will therefore give an earliest date for the picture. Except in the case of the rich and fashionable it can rarely give a latest. Clues may occasionally be given by rings, lockets or other items of adornment, or even by religious customs, e.g. the groom's skull-cap will identify a wedding as Jewish. Photographs of soldiers are common, and can yield a very precise identification if it is known a member of the family was in a particular unit (some examples of techniques involved will be found in Chapter 5). Uniformed workers, such as postmen, railwaymen, policemen or nurses, may also appear; specialists in these occupations may be able to help.

ENVIRONMENTAL FEATURES

With outdoor shots, domestic architecture, telegraph lines and poles, tram lines, cars or prams may all help to date a picture. If a shop sign appears in a photograph, trade directories will often show the years when that business operated at that address. Local research may establish when particular buildings were built or altered. Comparisons with pictures in a local photographic archive can sometimes place (and date) photographs with fair accuracy. Relatively trivial environmental features should not be ignored. For example, May Davis Hill points out that a tennis court in an American picture indicates that it must post-date 1874, when the game was first brought to America.[11]

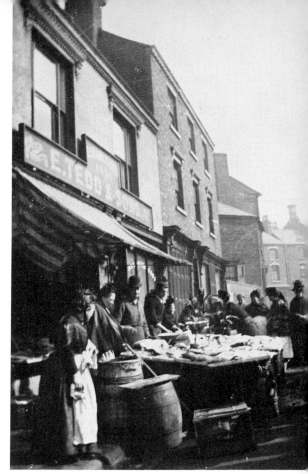

A local photographic collection will often provide useful 'background' pictures for your family history. If you are really lucky, you may even find a picture of a relative. In Wednesbury Library in Staffordshire, family historian Mike Tedd located several 19th-century photographs of his ancestor's fishmongery at 67–68 Union Street, Wednesbury, taken by Dr Dingley, the town doctor. Three men appeared to be serving. The date that library staff had suggested for the photograph was 1900. However, genealogical data pointed to the three men as being Edward Tedd born in 1838, and his two sons, John Robert born in 1866, and Albert born in 1869. From the costume, and in particular the 'upside-down flowerpot' hats, the Victoria and Albert Museum's Costume Department suggested the mid 1880's, a date which better fitted the apparent ages of the three Tedds.

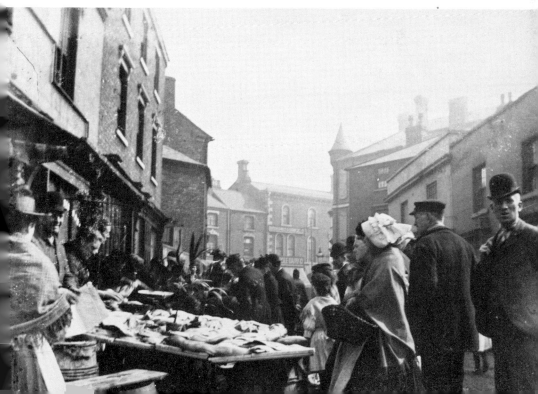

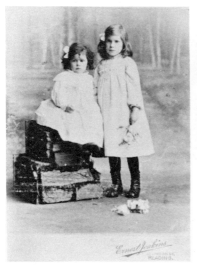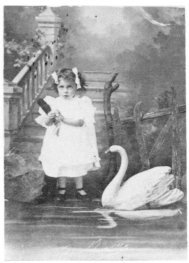

Two studio photographs from the 1870's, showing characteristic 'rustic' settings: left, a realistic sylvan backdrop, with a second-rate cairn that gives the game away; right, a professional backdrop, a convincing rock and fence, and an attractive cardboard swan

STUDIO CONVENTIONS AND FURNITURE

Like clothes, fashions in studio poses, props and backdrops may help to date a Victorian picture. In the 1850's the subject was frequently seated in a chair, holding a book. By the 1860's standing poses were being adopted, perhaps with one hand resting on the chair-back, and a curtain, column or balustrade in the background. A cardboard swan, a font or a flight of steps were characteristic props. The 1870's introduced the rustic bridge and stile, the 1880's an artificial rock, hammock, swing or railway carriage, and the 1890's cockatoos and bicycles,[12] and the practice of posing babies on white fur rugs or inside sea shells. In the early 20th century there were motor cycles and side-cars. However, all these props had a considerable life-span and might be used by the same photographer for many years.

There are also the humorous props found especially at fairgrounds, cut-out holes in painted drops to frame the face.

As well as props, normal studio furnishings such as chairs, linoleum and skirting-boards may also provide clues. These small details varied from one studio to another, and over different periods within a single studio, and can sometimes be compared with those in other pictures for which the date is known.

THE PHOTOGRAPHIC PROCESS

Processes, materials and accessories such as cases or frames, are often a help in dating a picture. They are not always easy to identify or date with certainty but the flowcharts and information in Chapter 6 should help.

<p style="text-align:center">★ ★ ★</p>

In identifying and dating pictures, do not hesitate to seek specialist advice. The amateur family historian with perhaps only a handful of pictures of the same period in a collection cannot hope to rival the knowledge of historians, archivists and librarians concerning architectural and environmental features, or the expertise of curators and specialists with regard to costume, hair-style or transport. However, most experts are busy people. Be specific in your enquiries; when writing, enclose a stamped addressed envelope; and if you take up a significant amount of their time, offer a reasonable fee. You will usually get far more than your money's worth.

This picture, said by the owner to portray two ancestors put in the stocks for arguing, was in fact marketed in the 1870's by the London Stereoscopic Company and captioned 'The Babes in the Wood'

An evocative postcard portrait from the 1920's of Clara Marmoy, née Robertson; taken at the New Times Studio in Bow, 'the largest in the East End', it shows her strumming 'by the light of the silvery moon'!

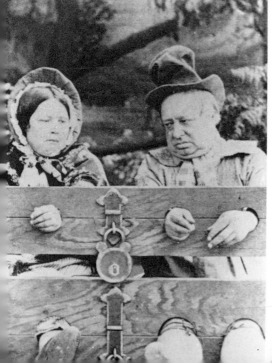

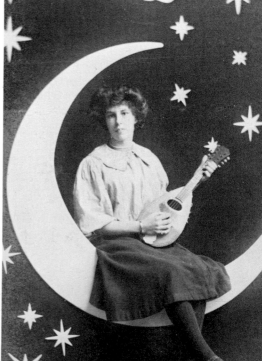

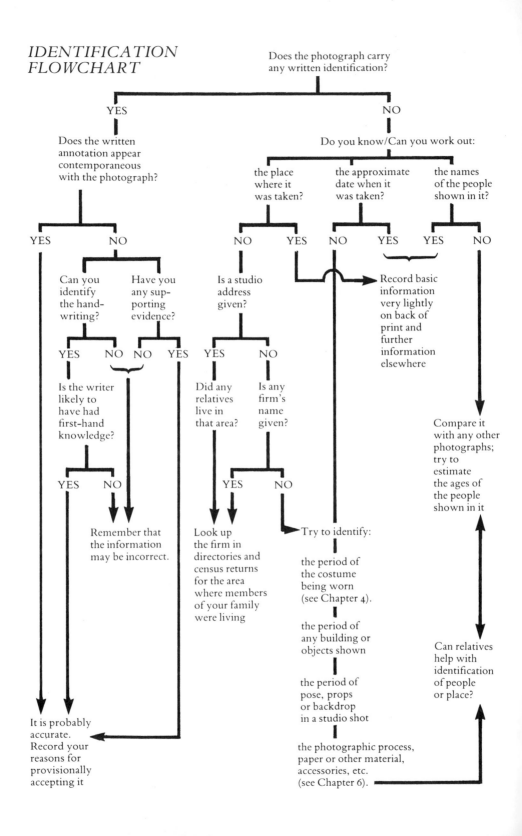

IDENTIFICATION FLOWCHART

Does the photograph carry any written identification?

YES — Does the written annotation appear contemporaneous with the photograph?

NO — Do you know/Can you work out:
- the place where it was taken?
- the approximate date when it was taken?
- the names of the people shown in it?

From "Does the written annotation appear contemporaneous":

YES — It is probably accurate. Record your reasons for provisionally accepting it

NO:
- Can you identify the hand-writing?
 - **YES** — Is the writer likely to have had first-hand knowledge?
 - **YES** — It is probably accurate. Record your reasons for provisionally accepting it
 - **NO** — Remember that the information may be incorrect.
 - **NO** — Remember that the information may be incorrect.
- Have you any supporting evidence?
 - **NO** — Remember that the information may be incorrect.
 - **YES** — It is probably accurate. Record your reasons for provisionally accepting it

From "the place where it was taken?":

NO — Is a studio address given?
- **YES** — Did any relatives live in that area?
 - **YES** — Look up the firm in directories and census returns for the area where members of your family were living
- **NO** — Is any firm's name given?
 - **YES** — Look up the firm in directories and census returns for the area where members of your family were living
 - **NO** — Try to identify:

YES — Record basic information very lightly on back of print and further information elsewhere

From "the approximate date when it was taken?":

NO — Try to identify:

YES — Record basic information very lightly on back of print and further information elsewhere

From "the names of the people shown in it?":

YES — Record basic information very lightly on back of print and further information elsewhere

NO — Compare it with any other photographs; try to estimate the ages of the people shown in it

Try to identify:

the period of the costume being worn (see Chapter 4).

the period of any building or objects shown

the period of pose, props or backdrop in a studio shot

the photographic process, paper or other material, accessories, etc. (see Chapter 6).

Can relatives help with identification of people or place?

NOTES AND REFERENCES

1. C. Kingsley Adams, late director of the National Portrait Gallery, London, convincingly demonstrated how frequently portraits of celebrated figures, such as Lord Burleigh, in country-house collections have been wrongly assumed to be those of ancestors, and captioned accordingly; and how unscrupulous dealers have 'found' portraits of well-known families, confidently 'identified' them, and sold them to their well-heeled and unsuspecting descendants ('Portraiture Problems and Genealogy', *Genealogists' Magazine,* Vol. 14, No. 11, Sept. 1964). The problem is less acute with photographs—well-known figures were usually photographed quite frequently, making mistakes unlikely, and photographs rarely offer the same inducements for profit; and however valuable some old photographs may be, commercial interests rarely take an interest in identifying the man in the street.

2. May Davis Hill cites one American album which began with two photographs labelled *Eliza and Henry Smith, aunt and uncle*—presumably meaning the aunt and uncle of Ethel Fountain, born in 1864, the owner. However, 'the back of the woman's photograph was inscribed in an older hand *Grandmother Fountain* and it was made in Princeton, Illinois, where the Fountains lived. Fortunately the same pictures appear elsewhere in the album and are endorsed on the backs as the grandparents. Thus we are reassured to find that the album begins with the grandparents of Ethel, rather than an aunt and uncle.' ('The Family Historian: Photograph Albums', World Conference on Records, 12–15 August 1980, Vol. 2, Paper 111b, LDS Church, Salt Lake City, Utah, 1980, p. 2.)

3. D. J. Steel, 1982.

4. Pinhorn, Malcolm, 'A Photographer in the Family: Julia Margaret Cameron', *Genealogists' Magazine,* Vol. 19, No. 4, Dec. 1977, p. 137.

5. Welling, William, *Collector's Guide to Nineteenth-Century Photographs,* Macmillan, New York, 1976.

6. An exception is Richard Rudisill's *Photographers of the New Mexico Territory 1854–1912* (Museum of New Mexico, Santa Fé, 1973).

7. Enumerators' returns are currently available for 1841, 1851, 1861, 1871 and 1881, and may be consulted on microfilm at the Portugal Street annex of the Public Record Office, London WC2A 1LR, and in many local record offices and libraries.

8. In 1872, the year of Richard Honeycombe's death, his niece Margaret was only seven years old. How, then, had that picture got into her album? Could she have inherited the whole album from her parents? No, for some pictures definitely showed Le Breton relatives. Would she have taken to Utah in 1894 a picture of an uncle who had died 22 years before? It doesn't seem likely. Yet nor does it seem likely that her parents' collection of photographs would be left to her in Utah when there were other children living in Jersey. But however Richard's picture got into Margaret's collection, it is a fairly safe guess that it was not the only one in the album taken during her childhood, or possibly even before she was born.

9. Hill, May Davis, op. cit., p. 5.

10. Hill, May Davis, 'The Stories behind your Photographs', World Conference on Records, 12–15 August 1980, Vol. 2, Paper 353, LDS Church, Salt Lake City, Utah, 1980, p. 13.

11. Ibid.

12. Gernsheim, H. and A., *The History of Photography,* McGraw-Hill, New York, and Thames & Hudson, London, 1969, and Aperture, Millerton, N.Y., 1973, p. 200.

4
Identification and Dating
Costume

MARY BONE

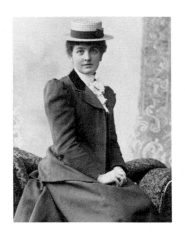

You can usually get a good idea when the pictures in old family albums were taken by dating the clothes worn by the people in them. Clothes also help to place people in their social context, and because the Victorians followed a strict etiquette over what they wore, they are easier to date than the people of today will be. Having your photograph taken was in any case quite an occasion, so you generally wore your best clothes; you were, after all, dressing not just for your nearest and dearest, but for posterity.

To keep this chapter within bounds, it is concentrated on the Victorian and Edwardian eras—the heyday of the family album. Moreover, although you may well be eager to date photographs from the 1920's and 30's, or even later, the majority of your unidentified pictures probably date from the time before the First World War.

Always check details in your photographs. An ordinary magnifying glass will be found very useful for this. Though small, details can be very significant in dating features: for instance, the 'M' notch sometimes seen on a gentleman's collar in the 1840's, but hardly ever after then; the large loose cravat of the 1850's; the square-toed shoes of the 1840's and 1850's, and the more pointed toe which appeared in the 1870's and 1880's. One of the most significant points in women's dress is the length of waist. The draped, bustled dresses of the late 1870's are not easy to distinguish from those of the 1880's unless you take note of the distinctly longer waist of the earlier period.

Fortunately clothes can be dated fairly readily, and there is a great deal of reference material available for the period covered by most family albums. Of course, much of it is concerned with

1840s–50s 1860s 1870s 1880s 1890s

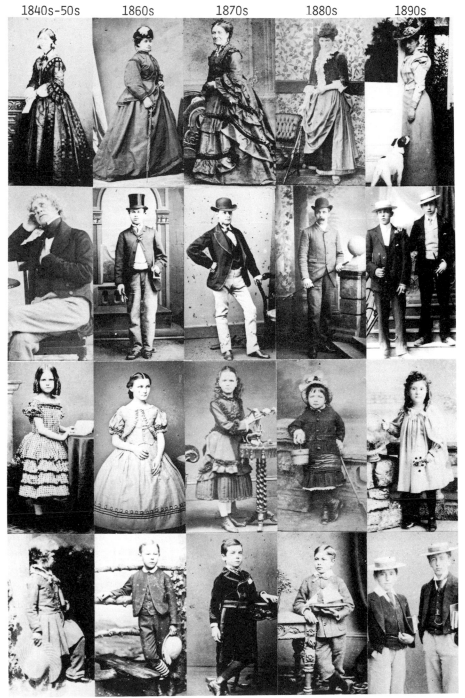

A leaflet from the Kodak Museum, showing a range of photographs from the Kodak collection.

1880 1885 1890 1895

Drawings from the leaflet Synopsis of 19th-century Women's Fashion, *published by the Victoria and Albert Museum, from* The Fashionable Lady in the 19th Century *by Charles Gibbs-Smith (Crown Copyright).*

high fashion, but as the 19th century progressed, so the latest and more fashionable styles became available to ever-increasing numbers of people. Once identified, a new fashion is valuable evidence in giving you a date earlier than which the picture could not have been taken.

A good way of coping with the problem of dating clothes is to compile your own scrapbook using photocopies of fashion plates and illustrations of men, women and children at, say, five-yearly intervals from the late 1840's to the end of the century, and beyond; to save effort you may prefer to concentrate on the period when you believe the album was compiled, but do bear in mind as already mentioned (see above, page 40), that some of the original photographs may have been taken out and others, of different dates, put in their places. It is best to use photocopies, not only because this saves cutting up the books, magazines and papers from which you cull your illustrations, but also because their uncompromising black and white makes for easier comparison with old photographs.

If you lack the time or inclination to make up your own scrapbook, it is possible to buy inexpensive sets of pictures which illustrate fashion changes, and some references for these are given below (page 185). Unfortunately these simplified outline drawings do tend to blur the reality of the clothes and make comparison with family photographs a little difficult. Based on the fashion plates of the time, they represent only one aspect, the

ideal—yet it is the real with which you will be most concerned.

For this reason it is most helpful to collect handy contemporary graphic illustrations of incidents from everyday life and to insert them in a dated sequence, if possible with the original caption, or at least with some note of the incident and the characters shown. *Punch* and *The Illustrated London News* are excellent sources. Aim for as wide a selection of people as possible: the young and the old, townsmen and countrymen, rich and poor, the bride in her finery and the widow in her weeds. Compile a set of professional people: lawyers and doctors neat in their top hats and formal coats; clergy of various denominations; artists and intellectuals with their eccentricities of hair and whiskers. It is important to include silhouettes since the clothes of men, women and children seen in front-on views all tend to share the same proportions. Make sure, too, that your scrapbook includes a large and representative selection of hats and hair-styles for the many occasions when pictures show only the head and shoulders.

You will soon realize that however new and diverse the fashions, or however dramatic the changes, they result from a series of modifications of style and cut.

Observing ladies' fashions will be the easiest way to start since changes in the line and decoration will be simpler to recognize. In men's clothes the prevailing dark colours of the time unfortunately could make the photographic image very difficult to read.

LADIES' CLOTHES

At their extremes dress styles are unmistakable. Those of the 1840's had a restrictive tight-sleeved silhouette with a smooth bell-shaped skirt. In the 1850's they were more exuberant, frilled and flounced. They were very full-skirted indeed by the early 1860's, by which time the artificial crinoline had become fashionable; there was also a liking for rather large-scale geometrical patterns decorating the skirt and the sleeves. After 1865 the skirt became much narrower and developed fullness at the back as the bustle came into fashion between the late 1860's and early 1870's. The hair-style also changed and was often piled high in front and arranged in a large bun at the rear. After the mid 1870's the skirt became tighter in front until the slim silhouette of the late 1870's and early 1880's was achieved. In the mid 1880's the bustle was revived and the line became simpler, having greater vertical emphasis than in the mid 1870's. Hats were impressively high.

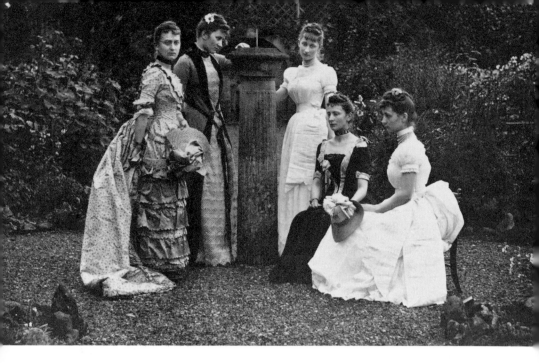

The Scrope sisters, about 1885: the three eldest wear contrasting dress styles—from left to right, day, evening and reform; the two youngest are dressed identically.

By the 1890's the sleeves were the main elements of fashion to note; they became much more rounded and full in outline, with the skirts becoming simpler in cut, and flared. Sleeves and skirts were much more closely cut towards the end of the decade and by 1900 had developed into the sleek and sinuous curves which characterized the Edwardian belle. The line straightened in the years immediately preceding the First World War, with skirts shortening in 1915–16. By 1920 the low-waisted line was unmistakable; skirts became much shorter during the mid decade, and close-fitting cloche hats were introduced. The hemline developed an asymmetric droop at the end of the 1920's, followed by a preference for a more fitted but flowing line.

Clothes in the more formal days before the First World War were silent social labels usually worn with pride. They also help in sorting out status within the family. Sisters, for instance, often dressed alike even when quite mature. Older or married women often wore caps, but as these were frequently white this custom posed a technical problem for the less skilled photographers. So the absence of female headgear should not be considered too significant, especially before the more sensitive photographic

plates were introduced in the last quarter of the 19th century. A new hat was often the cheapest way of updating an outfit, but since many people never changed their hair-style once they passed their prime, the sometimes rather comical visual incompatibility between the two dates can provide a useful 'bracketing' for the period. Just as the photograph cannot be earlier than the latest dated feature in it, so it must be later than the earliest!

MEN'S CLOTHES

Changes of fashion for men were as radical as those for women, but dating a photograph of a man by his clothes can prove difficult. Already mentioned is the problem of seeing the detail of a dark garment on a faded print. Also, older men tended to be more conservative in their dress than the ladies. Since a man's suit was proportionately more expensive, a married working man might keep his wedding suit as his best suit, bringing it out for special occasions for as long as it could be made to fit. The young and unmarried, whatever their class, made a conscious attempt to keep up with the new fashions.

The fashionable suit of the 1840's was very tight, almost moulded to the figure. Coat collars were high at the back, shirt collars high and cravats large. The shoulder line was sloping, and the sleeve narrow and very long with the cuff sometimes unbuttoned at the wrist. Waistcoats often had large fancy patterns. Trousers were fitted, sometimes held beneath the boot with a strap. In the early 1850's, there was a slight relaxation of cut. Collars of both coat and shirt became lower so that the large looser cravat is very noticeable. In the later 1850's and early 1860's, suits began to be made very loose-fitting indeed, the waist seam was low and sleeves and trousers were wide. Many jackets were fastened with their top button only. Since beards and whiskers were fashionable it is sometimes difficult to see the low shirt collars and the narrow ties. There was great variety of style, especially for informal dress. For sports, the Norfolk jacket, pleated and belted and usually worn with baggy knickerbockers, was introduced. It was a fashion which was to become increasingly popular. Tweed suits began to be worn by all classes.

In the 1870's, suits were cut more tightly. The double-breasted fastening can often be seen, either square cut and disconcertingly late-20th-century in appearance, or with a wide cut-away and a marked diagonal line. In the 1880's, the line became noticeably

Three young men photographed at Blackpool in the mid 1890's, in square-shouldered, high-buttoned suits, and typical side partings; the cummerbund was a new nineties' fashion.

straighter and narrower. The 'Masher', the smart young man of the 1880's, was very self-conscious about his appearance, the fit and stiffness of his high shirt collar and the precise slicked curl of hair and moustache. The fashions of the 1890's look much more relaxed. The suits were wide cut with low square shoulders, longer jackets and wider trousers (by the end of the century, these have a central crease; on informal occasions they may also be turned up at the bottom). The blazer, exclusively worn as a sports jacket at its introduction in the late 1870's, had become accepted for most informal summer occasions. A new fashion in the 1890's was the cummerbund.

Hats were generally worn. The top hat, formal headgear throughout the period, is the most difficult to date. The tallest were those of the 1840's, 1850's and 1880's. Quite low ones were worn in the 1860's and 1890's. Consideration must also be given to the degree and type of curve and depth of band. Fortunately other types of hat are easier to deal with. The bowler was very popular from the 1860's. In its earlier form it is very low with a noticeable central knob. In the 1880's and 1890's, it became very high. Less formal were soft felt hats usually worn with country clothes. In the 1860's, they were wide-brimmed but during the 1870's and 1880's, they were made stiffer with a more regular crease. The 'Homburg' was introduced by the Prince of Wales in the 1870's and soon became

popular. For sports, peaked caps and deerstalkers with ear flaps were worn. Any summer photograph from the late 1870's will show most of the men in straw 'boaters'.

THE INFLUENCE OF FASHION

When you come to compare your photographs with your costume references, you will soon appreciate that people differ in the speed with which they follow a fashion. There is not that much difference between our present-day attitudes and those of our grandparents except that they were more conscious of conventions and expressed them more explicitly. The respectable tended to accept the suggestions made by the *Ladies' Treasury* in 1858, 'Propriety must be studied before fashion', and 'No fashion should be adopted until it becomes more singular *not* to adopt than to follow it'. For the average, middle-class, middle-aged woman this might mean a delay of up to two years, but the time lag increased farther down the social scale and away from metropolitan centres. As for men, since *The Habits of Good Society* suggested, in about 1860, 'after the turning point of life a man should eschew the changes of fashion in his own attire', on the whole the middle-aged man, probably to his own great relief, kept to conservative styling. The socialites and stage personalities were the most fashionable, followed closely by the younger members of the aristocracy. Royalty followed the less extreme styles, perhaps a year or so behind the latest modes, and were always closely copied by the middle classes. Provincials and country folk were the slowest to follow fashion, and their lack of poise, or possibly the lack of skill of the average small-town photographer, threw into relief badly fitting clothes or ill-chosen accessories. By the end of the 19th century men in smock frocks and women in shawls and close frilled caps, unless very old, were the exception, for a specifically rural dress was much less evident.

It is important to include pictures of contemporary celebrities in your scrapbook. As has been noted elsewhere (see above, page 36), these relics of 'cartomania'—that carte de visite collecting phase during the third quarter of the 19th century—often lurk unlabelled in family albums and resist identification. But they are useful, since a celebrity often publicized a style. Alexandra, Princess of Wales, is a good example; in her engagement pictures (1862) she wore her hair drawn severely back in a bun, showing

off her fine broad brow and pretty ears. This style was copied by many. So was the fringe she adopted in the 1870's and wore until her death in 1925, a style which Queen Victoria initially disliked, finding it too much like that of a poodle.

Actors and actresses were also influential. Edward Askew Sothern played a caricature of a military man, Lord Dundreary, in the play *Our American Cousin,* in 1858. Contemporaries would have called him a 'heavy swell', languid and given to wearing the baggiest of peg-top trousers and the longest and most lavish of whiskers, forever afterwards known as 'dundrearies'. Introduced in their exaggerated form, they continued to be worn, especially by older men, well into the last quarter of the century. Even easier to recognize is the influence of popular actresses. Lillie Langtry, for example, introduced the small round toque hat in the early 1880's; Lily Elsie the wide-brimmed Merry Widow hat in 1910; and at the very end of many family albums are domesticated versions of the eye-concealing, long-bob hair-styles popularized by Veronica Lake and Lauren Bacall in the 1940's.

OCCUPATIONAL DRESS

Some groups will still be difficult to date and place. Fashion has little relevance to occupational dress where styles have fossilized and become almost a self-imposed uniform for people working in particular jobs and occupations. Fortunately in semi-formal portraits, such as those taken at the conclusion of an apprenticeship, it was conventional to carry the tools of the trade. A traditional set of Happy Families cards will give you an idea of the conventions followed in some of the commonest trades and occupations: professional colleagues of Mr Chip the Carpenter, with paper cap, apron and saw, or Mr Bones the Butcher, with straw hat, striped apron and meat cleaver, are not that uncommon in family albums.

In work groups, clothes are often a guide to status. Managers and foremen tended to wear top hats in mid 19th-century groups, while the men wore caps. In later photographs superiors wore bowler hats. Status is also clearly marked in Servants' Hall photographs. The senior servants, such as the housekeeper, or the butler in his dark formal suit (dark tie for day wear, white tie for evening), did not wear uniform or livery. Footmen might pose wearing livery, or dark tail coats with metal livery buttons; like grooms, for more workaday occasions they wore striped waist-

Right: a young chimney-sweep, photographed carrying the tools of his trade.

Below: Lady Warwick's staff at Easton Lodge, Essex, in the mid to late 1890's. Their clothes are uniform and typical. The maids wear aprons, caps and print dresses with fashionable full sleeves (an aid in dating the picture). The cook has an apron with a bib, the housekeeper a conventional dark dress. Note the footmen's tailcoats with metal buttons, and the butler's black tie for day wear.

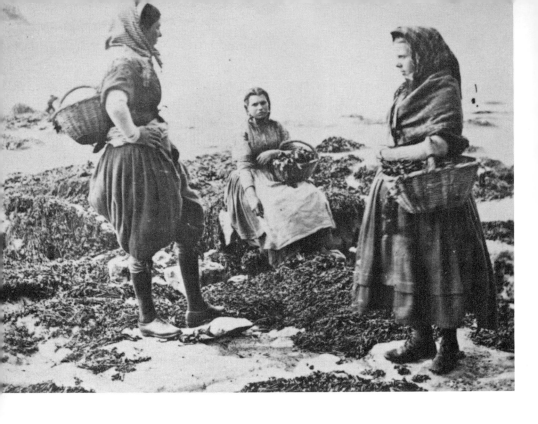

coats. The cook tended to have an apron with a bib, and the more senior the maids the frillier their caps. The actual dating of a group should be possible by considering the shape of the sleeves of the maids' dresses, since these nearly always followed the fashion, however severe or stereotyped the rest of their uniform.

REGIONAL STYLES

Despite the dictates of fashion, even in the late 19th century some regional styles remained, and since the Victorians found them as unusual as we do, they tend to turn up frequently in family albums as holiday souvenirs. There is no particular problem about Highland or Welsh dress, for here the convention was already established and has not changed. But gone are the short-skirted or trousered fisherwomen of the north-east and east coasts, the shawled mill girls of Lancashire, or the picturesque and much-publicized Wigan mine girls in men's trousers and striped aprons. If you come across a photograph of dress that seems very unusual, and the photographer's name and address are given on the print, it is worth finding out if the local museum or record office has a note of any distinctive local dress or customs.

Left: Victorian bait girls from Flamborough in Yorkshire; their shawls and full short skirts draped like breeches were characteristic and picturesque

Right: typical middle-class children of the 1890's, the eldest girl dressed like an adult, younger ones in shorter skirts; note the small boy's sailor suit, his brother's Norfolk jacket

CHILDREN'S CLOTHES

In sorting out Victorian family groups, the almost ritual insistence on altering the form of children's dress according to the wearer's age will be found useful, especially when taken in conjunction with the custom of dressing sisters alike, and brothers in the same type of suit.

To take the older children first: in the 1840's and early 1850's boys wore ankle-length trousers, but from mid century onwards the youngest boys were put into trousers of approximately knee-length, and the older they grew, the longer they wore them, until they reached the early teens. According to their social class, this was either the age at which they were sent away to public school, or the minimum school-leaving age when they could look for work; in either case, they were put into long trousers. This gradation of the length of the garment according to age also affected girls, though they did not reach maturity, as implied by the floor-length gown, until at least sixteen. The youngest girls wore dresses just below knee-length, and their skirts were lengthened by about an inch for each year as they got older.

Below school age, the main problem is telling boys and girls

Above: a Marylebone family group of 1909. Note the men's high shirt collars and small, neatly knotted ties. The younger the lady, the more fashionable her dress—the youngest sister, standing centre back, is the most up-to-date of the three. Compare, below, the Fulham wedding of the second son (far left, above) in 1923—a blend of the fashionable and the conventional. The youngest sister, a bridesmaid, is sitting on the groom's right, the eldest standing behind her, the third seated on the grass by the little girl.

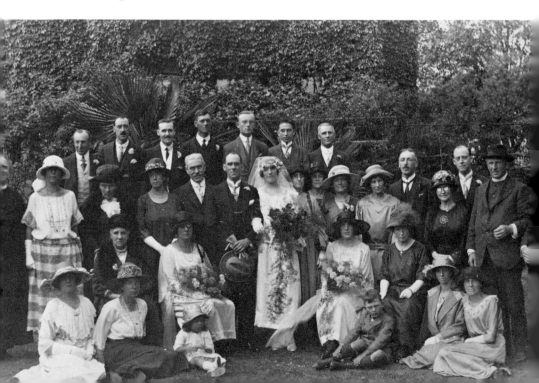

apart, for both sexes wore skirts and had hair of almost equal length. It is sometimes possible to tell the sex by noting the way the hair is parted—side partings for girls were must unusual. A toy held by the child will also assist; Victorian parents welcomed sex stereotypes, so it was dolls for girls, with whips and tops, balls, boats or toy animals for boys. There were also differences in the cut of girls' dresses and boys' tunics, the latter being more stiffly tailored and tending to have a button trim—though this is not easy to see in a small faded print.

Scottish 'Highland' suits, so popular in the 1860's and 1870's, were only worn by boys, but home-made versions can sometimes be confused with that staple garment of Victorian girlhood, the tartan dress. No little girl, however, was ever given a plaid or a sporran. By the 1880's the sailor suit was popular both for boys and girls; half-length views can be confusing as both sexes wore the sailor blouson top, and at this time some little girls had their hair cropped short; in full-length, of course, there should be no problem, because boys wore trousers, girls wore skirts.

The white garments of babies can make an analysis of their clothes very difficult in faded prints, but the main thing to look for is the embroidery, flowery and flowing at mid century, more angular in the later Victorian era. Such sex distinction as there was can be found mainly in the style and adornment of the bonnet—but for photographic reasons this was often removed. Between four and six months, babies were 'shortened', that is, put into shorter gowns, when identification may become easier, not because of any changes in cut or decoration, but because toys were often included.

★ ★ ★

It was the dandified Oscar Wilde who, in *The Picture of Dorian Gray* (1891), wrote, 'It is only shallow people who do not judge by appearances.' For those who are making a consciously profound study of their forebears, the clothes of even the dowdiest, in the most apparently undistinguished of family albums, are a significant index to their tastes and attitudes, as well as an important clue to their place in time. There are few better ways of restoring the humanity otherwise so minimally commemorated in a small, stiff, two-dimensional, monochrome image, than by studying the clothes your ancestor was wearing when the picture was taken.

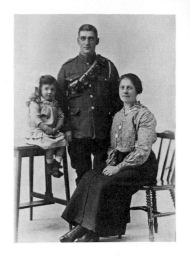

5

Identification and Dating

Military Uniforms

DAVID J. BARNES

It is quite common when researching a family history to come across photographs of members of the armed forces, particularly the army. How can these pictures be made to yield their clues? It is necessary to study the detail minutely; not just the uniform itself, but any cap, collar, trade or qualification badges, medals, shoulder flashes or wound stripes. To do this you may in the end need to enlarge the photograph, or at the very least employ a magnifying glass powerful enough to enable an identification of a badge to be made.

Such a study may help in two ways. Firstly, knowing that an ancestor or relative was in a particular regiment, you may suspect that he is the soldier portrayed in an uncaptioned military photograph. If a careful examination of the uniform confirms that the soldier portrayed belonged to the regiment concerned, you may consider this evidence as sufficient to make a presumed identification, though it is always important to remember that the picture could show a pal in the same regiment; if there are several photographs of one soldier, it is much more likely that the man shown is your ancestor.

Secondly, what if you know the identity of the ancestor in the picture but have found out relatively little about him? A military photograph may be your sole means of identifying the regiment in which he served. Once you know this, you can try to pinpoint the battalion or company to which he belonged; and if you succeed, you can fill out the background with details of the actions in which his unit took part, the places where it was stationed and so on. The National Army Museum, the appropriate regimental museum and, for the period after 1914, the

Imperial War Museum, may be able to supply information, and probably relevant pictures as well, to add interest to your family history (see appendix, page 72).

Army service records for Officers and Other Ranks up to 1900, and Officers' records (Royal Artillery apart) for the period 1900–1954, are in the Public Record Office at Kew.[1] The Royal Artillery keeps its own records.[2] Other Ranks' records for 1900–1913 are being transferred to Kew, but from 1913 onwards are held by the Army Records Centre, to which you should write with any enquiry.[3] Bear in mind that a large number of soldiers' records for the period 1914–18 were destroyed by enemy action during the Second World War, and that the Centre will disclose information only to the soldier concerned or to his next of kin.

IDENTIFYING A RELATIVE

A good example of the value of military uniforms in identifying a relative is provided by the photograph albums referred to in Chapter 3 (see above, page 33). Among the uncaptioned pictures were three portraits of soldiers. It was known from family sources that John Honeycombe, the brother of Margaret Le Breton née Honeycombe who emigrated to Utah in 1894, was a soldier who died of enteric fever in India. He was baptized at St Helier, Jersey, in 1868. Research in the military records at the Public Record Office at Kew showed that John Honeycomb (sic) was a Private in the Hampshire Regiment. He appeared in the Monthly Muster Roll of 'C' Company for the half-year ending 31 March 1889, taken at Chatham, and was recorded as having belonged to the Company since 1 October 1888.[4] However, in the muster taken at Chatham on 1 April 1890, John Honeycomb was 'absent on duty'.[5] His burial—on 12 October 1896—was found in the return of burials at Mooltan, Punjab.

Two of the three pictures were taken in India. One was inscribed *Lucknow, Naini Tal, G. W. Laurie & Co., Mussoorie and Allahabad;* the other had *J. Burke* and *Punjab* on the front and, at the back, *Jno Burke, Artiste Photographer.* Which, if either, was John Honeycomb? John's aged niece, Mrs Fones, of Tooele, Utah (see above, page 33) identified the first. But was she right? Almost certainly, yes. The cap badge on the colonial-pattern helmet is that of the Hampshire Regiment, worn from 1881. The collar badge is not too clear, but it should be a Hampshire Rose within a wreath of oak leaves, again worn from 1881. The two

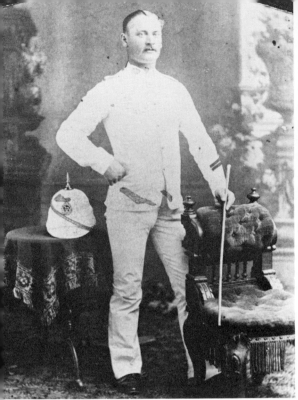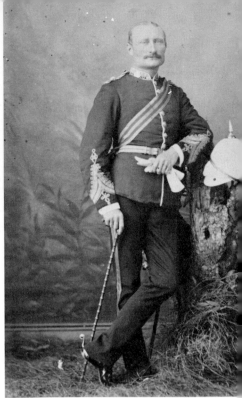

Two photographs from the Honeycombe albums: efforts to identify them are described on pages 63–67. The first, almost certainly, is John Honeycombe, but who is the other?

chevrons worn on the left sleeve are good-conduct stripes indicating six years' service, and were worn in this position from 1 March 1881. Six years' service from 1881, together with the absence of any medal for the Burmese expedition of 1887 in which the regiment took part, brings us to 1887 as the earliest date for the photograph—which is consistent with the documentary evidence showing John as still in England in 1889. The absence of campaign medals for the Niger Expedition of 1897–8 or the South African War, to which the regiment was sent in October 1899, gives us 1897 as the latest date for the photograph, tying in well with John's death in 1896. So the military insignia and the documentary evidence taken in conjunction support Mrs Fones, and unless strong evidence to the contrary comes to light, her identification may be presumed correct. The photograph appears to have been taken between 1889 and 1896. A further check of regimental rolls or station returns to find exactly when

and where John was in India could yield a more precise dating.

The second picture is of an infantry officer in India towards the end of the 19th century. His rank can be found by examination of the cuff insignia, introduced in 1868; the more elaborate the design, the higher was the officer's rank. Until 1880 rank badges were worn on the collar, the ranks being shown in stars and crowns. By a special army order of October 1880, a system of shoulder rank badges was introduced, and a regimental badge was worn on the collar. The officer in the photograph has a very ornate cuff, and a rank badge worn on his right shoulder cord. In addition a row of loops is to be seen on the collar. These were worn only by field officers (i.e. majors and ranks above); his cuff insignia confirm he is a major. Although an infantry officer, he wears spurs on his boots, as being a field officer he would be mounted on parade.

Normally his regiment could be identified from the belt plate, which is unfortunately obscured in this photograph. Nor can a cap badge be seen on his helmet, as is often the case; however, his regimental collar badge appears to be a shield with a scroll below, and as the shape of this shield is uncommon in military insignia, it was easy to trace—it is the arms of Nassau. According to Dress Regulations[6] the collar badge of the Royal Irish Regiment was an escutcheon of the arms of Nassau, with a silver scroll below inscribed *Virtutis Namurcensis Praemium* ('The reward for valour at Namur').

The facing colour worn on the collar and on the cuffs below the insignia should also be borne in mind, though colours in old photographs cannot be identified with certainty, and a number of them, e.g. buff, primrose-yellow and white, will all look very similar in monochrome. Remember, too, that some light colours often appear dark in old photographs—a point to keep in mind when trying to identify a medal ribbon or cloth badge. Here the facing colour seems to be the same dark shade as the uniform trousers, and Dress Regulations confirm that dark blue was the facing colour of the Royal Irish Regiment.[7] If the collar badge and belt plate were not clear you might have to work from the facing colour alone. If so, try to check the period. New facing colours were introduced in 1881 by the Army Reforms which linked regiments, but by 1914 some regiments had received permission to revert to their old facings.

The second photograh is, therefore, that of a major in the

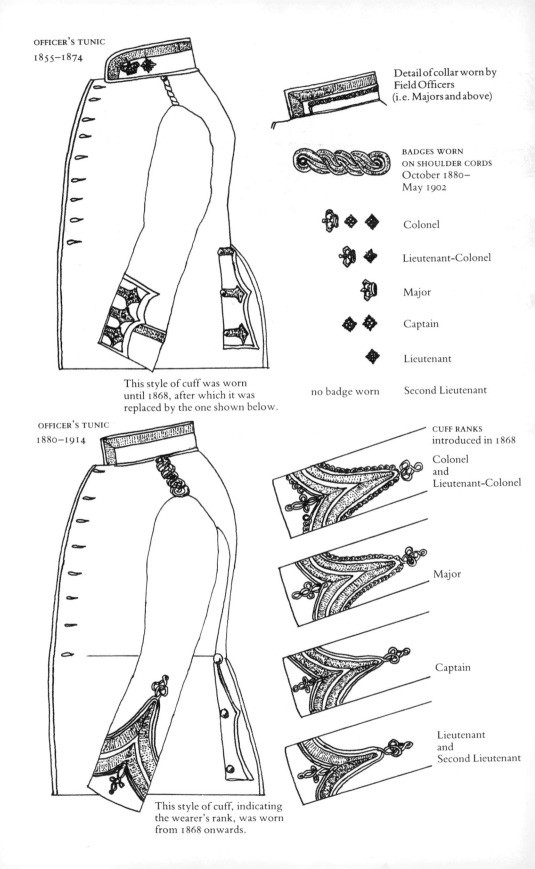

OFFICER'S TUNIC
1855–1874

Detail of collar worn by
Field Officers
(i.e. Majors and above)

BADGES WORN
ON SHOULDER CORDS
October 1880–
May 1902

Colonel

Lieutenant-Colonel

Major

Captain

Lieutenant

no badge worn Second Lieutenant

This style of cuff was worn
until 1868, after which it was
replaced by the one shown below.

OFFICER'S TUNIC
1880–1914

CUFF RANKS
introduced in 1868

Colonel
and
Lieutenant-Colonel

Major

Captain

Lieutenant
and
Second Lieutenant

This style of cuff, indicating
the wearer's rank, was worn
from 1868 onwards.

Colonel

Head-dress badge

Collar badge

Lieutenant-
Colonel

Major

as worn by
Private John Honeycombe
of the Hampshire Regiment

A regimental badge was worn
on the collar, by most regiments, from 1880 onwards.

Collar badge

Collar badge

Captain

Lieutenant

Ensign

as worn by
the Major of
the Royal Irish Regiment
serving in India

As worn by
the bandsman of
the Loyal North
Lancashire Regiment

Royal Irish Regiment. He is wearing the uniform described in Dress Regulations of 1900—though this particular dress would have been worn some years before that date. However, the photograph must have been taken before 1902, when the sash was taken from the shoulder and worn around the waist.

Had it not been possible to identify the uniform by badges or facings, you would have had to bear in mind two possibilities: firstly, that he might have been a British officer serving with an Indian regiment; or secondly, an officer on staff duties. If the former, though the Indian Army used a similar system of ranks and regimental devices, its units operated independently, with separate regulations covering dress, badges and training, which you would have to consult.[8] If the latter, he would have had an aiguillette (loops of plaited cords), worn on the right shoulder by officers on the Headquarters Staff, and on the left shoulder by other staff officers.

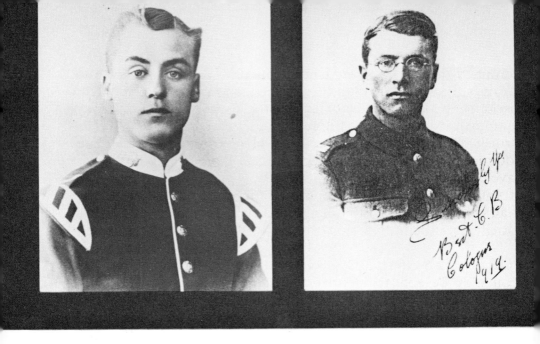

A picture as yet unidentified, though it is at least known to show a bandsman in the Loyal North Lancashire Regiment, probably taken in 1901.

Inscriptions may mislead as much as they help. This message reads: Sincerely yrs Best [*or perhaps* 'Bert'?] C. B. Cologne, 1919', *but the picture has been indisputably identified as E. C. Carter, a stretcher-bearer in World War I. What did 'C. B.' signify?*

The third picture is also, as yet, unidentified. Here the collar badge (actually the arms of the City of Lincoln) is that of the Loyal North Lancashire Regiment and was worn from 1881. The 'wings' on the tunic, introduced in 1871, show that he was a bandsman; this is confirmed by the badge on his arm, introduced in the early 1900's and phased out in 1907. This particular badge carries a Victorian crown, as the tunic buttons also appear to do. The photograph may, therefore, be dated as approximately 1901 (Queen Victoria died in January of that year).

PINPOINTING A UNIT
Using family papers, archival sources or the insignia shown in photographs, you may have successfully identified the regiment in which your ancestor served, but most regiments had many battalions—especially in the First World War, when some had nearly fifty—and unless you can pinpoint the right one, you cannot follow up this important lead. The photograph and any caption or inscription should, of course, be meticulously

examined first. Next come family sources. Where a photograph survives, there are likely to be other items as well—identity tags, discharge papers, pay books, furloughs, odd bits of military equipment such as cap badges or shoulder titles. Is there a tarnished button in someone's button box? Even if you have nothing of this kind in your possession, such bric-à-brac may have come down another branch of the family. So do the rounds of your relations before resorting to more complex procedures. If all else fails, turn to the regimental records, and prepare for a patient search, unit by unit.

PORTRAITS OF INDIVIDUALS

You may be able to identify the battalion from an individual photograph if this is captioned with the soldier's name (*My mate Joe King*). In such a case it is worth going through the casualty rolls of the regiment, usually found in battalion order.[9] A photograph signed with a fairly distinctive Christian name can also provide a strong lead. A First World War photograph of a soldier in the Lancashire Fusiliers, for instance, signed *Your best pal Ezra,* could lead to the discovery of the following entry in the regimental casualty rolls:

LANCASHIRE FUSILIERS—2nd BATTALION
Crooks, Ezra. B[orn] Blackburn, Lancs. E[nlisted] Rochdale, Lancs.
6003 Lance-Corporal
Died F[rance] & F[landers] 26.8.16

Sometimes, though unfortunately not in this example, after the place of enlistment the home town was added. Lance-Corporal Crooks' name appears on Blackburn's Roll of Honour, and it should be possible to seek further information about him from the files of the local newspapers.

Officers' casualty lists do not give as much information (their service details can be found in the Army Lists), thus:

THE QUEEN'S OWN (ROYAL WEST KENT REGIMENT) SERVING WITH 6th BATTALION
Ashton, Cyril James. Temp. Lieutenant (Acting Captain)
D[ied] of W[ounds] 12.3.18

Once you have identified the unit, you can investigate its history. In the case of the Lancashire Fusiliers, reference to the Regimental History showed that the 2nd battalion was in trenches at Verbrandenmolen, near Ypres, from 23 to 28 August

1916. The commanding officer at that time was Major R. R. Willis who had won the VC at Gallipoli. A further rich vein of material was supplied by the War Diary, compiled for each First World War unit and now at the Public Record Office.[10]

A request for information about Captain Ashton of the Queen's Own Royal West Kents was sent to the Curator of the Regimental Museum, and an entry was found in the Regimental History:

> In the half-light of dawn on 9th March 1918, a party of 200 men, commanded by Captain Ashton, raided German trenches after forming up in water-filled trenches and crossing 'No-Man's Land' without being detected. The Germans were taken completely by surprise, a machine gun and 9 prisoners were taken and heavy losses were inflicted on the enemy. Some 25 of our men were killed and Captain Ashton was mortally wounded. Command was taken over by Lieutenant Elliot who stormed a German pill box.

A more detailed report of the action appeared in the unit's War Diary.

If an ancestor of yours was a casualty in the First or Second World War, you could contact the Commonwealth War Graves Commission which marks and maintains the graves of the war dead, and the memorials to those who have no known grave.[11] Taking the two casualties named above as examples, details were sent to the Commission which confirmed that Lance-Corporal Crooks is buried in Woods Cemetery, Zillebeke, Belgium (Plot 3, Row A, Grave 7) and Captain Ashton in Merville Communal Cemetery, France (Plot 7, Row A, Grave 42). The Commission will supply, at a modest charge, a photograph of the headstone, which normally includes a brief inscription chosen by the relatives as well as name, rank, number, age and date of death, though as the photographs are taken by officials on routine tours of inspection, you may have to wait several months.

GROUP PHOTOGRAPHS

If you have a signed photograph of a military group, use the same identification procedure as for a portrait, though remember that the picture may show a friend's unit—not your ancestor's at all. If you have an unsigned and uncaptioned group photograph, the odds are that it *is* a picture of your ancestor's unit—but it may not prove easy to identify!

An unidentified group: there are no cap badges or shoulder titles to help.

Occasionally you may find that a group photograph has been captioned by the photographer, e.g. *'C' Company, 21st Battalion, Manchester Regiment; 17th Battalion, Lancashire Fusiliers; 32nd Field Company, Royal Engineers*—all units which existed during the First World War. Remember, though, that many units or special groups were of short duration. I have a large framed photograph captioned *No. 40 Course, Army Signals School, Dunstable Signal Dept, May 1918*, but despite various attempts to trace further details, I have drawn a blank. The records have vanished.

A posed studio portrait of several soldiers, or a group photograph, was probably taken in the garrison town, or at or near the camp where the unit was based. Occasionally you may find a photograph marked *On the Veldt in South Africa* or *Somewhere in France,* and slight as such a clue may be, it can prove invaluable in making up a list of possible units. Casualty records are particularly useful for locating the units serving in a specified area at a given time.

It may be that after a long search you have found a unit which meets the requirements of date and location, but nowhere can you discover a list of names which will prove conclusively that your ancestor served with that unit. If the group photograph includes a medal-holder or an officer, you could try the sophisticated method of identification developed by Norman Holding.[12]

But lacking visible badges, group photographs may often only be identified by relatives or by pinpointing the unit (page 68).

Though in the space available it has been possible only to look at a few examples and outline some useful procedures, most of these are readily applicable not only to other military photographs but also to those of sailors or airmen, or indeed of civilian uniformed personnel such as policemen, postmen, nurses or Boy Scouts. The guiding principle is always the same: examine each photograph with meticulous care and follow up every clue it provides. To do this you may well need to track down reference books in bibliographies and obtain them through inter-library loan. As a last resort, do not be diffident about seeking specialist help, though please remember that there is no reason why the specialist should be expected to give time and expertise for nothing; send a good copy of the photograph, be as specific as possible in your enquiries, give full details of what sources you have already consulted, include a stamped addressed envelope and express your willingness to pay a reasonable fee.

APPENDICES
I MILITARY MUSEUMS
In addition to the museums mentioned below, there are many Services and Regimental museums throughout Great Britain. For a specialist guide, see Terence Wise's *Guide to Military Museums* (Athena Books, Doncaster, 1982). A comprehensive list is published annually in *Museums and Galleries in Great Britain and Ireland* (ABC Historic Publications, Dunstable, Beds) at a very modest price; it includes information about dates and times of opening, parking, admission charges, etc., and details of the material on display.

Imperial War Museum, Lambeth Road, London SE1 6HZ
National Army Museum, Royal Hospital Road, Chelsea, London SW3 4HT
National Maritime Museum, Greenwich, London SE10 9NF
Royal Air Force Museum, Hendon, London NW9 5LL
Fleet Air Arm Museum, Royal Naval Air Station, Yeovilton, Somerset

The Military Heritage Museum, Regency House, 1 Albion St, Lewes, East Sussex (military uniforms, weapons and related items, 1660–1914)
The Weapons Museums, The School of Infantry, Warminster, Wilts (by appointment only).

II PROFESSIONAL ASSISTANCE

Identification of photographs of soldiers is undertaken by:

David J. Barnes, 21 Bury New Rd, Ramsbottom, Gter Manchester BL0 0BT

Mike Chappell, 24 Cargate Terrace, Aldershot, Hampshire.

For an estimate, send the original or a good photographic copy (*not* a photocopy) and a stamped addressed envelope.

Identification of postmarks and censor stamps is undertaken by:

Alistair Kennedy, 4 High St, Puckeridge, Ware, Herts SG11 1RN (joint author of *The Postal History of the British Army in World War I*).

Send a clear photocopy and a stamped addressed envelope.

NOTES AND REFERENCES

1. P.R.O. Kew Repository, Ruskin Avenue, Kew, Richmond, Surrey; admission by reader's ticket only.
2. Royal Artillery Manning and Record Office, Imphal Barracks, York.
3. Army Records Centre, Ministry of Defence, CS(R)2b, Bourne Avenue, Hayes, Middx.
4. P.R.O. WO 16/2921—Infantry Regimental Districts, 1888–9.
5. P.R.O. WO 16/2945—Infantry Regimental Districts, 1890–91.
6. The first comprehensive set of Dress Regulations, describing in detail the uniforms to be worn by officers of each regiment ('Other Ranks' were not included as their uniforms were supplied by the Government), was officially issued in 1822; since then they have been issued at irregular intervals. The first illustrated set appeared in 1900, and was reprinted by Arms & Armour Press, London, 1970.
7. For facing colours, see Dress Regulations (see Note 6 above); and appendices in the works of Barnes, Carman and Lemonofides (see Book List, page 186).
8. The National Army Museum, Royal Hospital Road, London SW3 4HT, holds comprehensive records of soldiers serving with the Indian Army. When enquiring, write giving all known facts; if possible, send a good copy of the photograph you are hoping to identify; and include a stamped self-addressed envelope (the Museum's funds are very limited).
 The India Office Library and Records, 197 Blackfriars Road, London SE1 8NG, holds army lists, some service records and some family records for soldiers serving in India; the greater part of the material relates to the 19th century, but some is earlier and some later. Consult Ian Baxter's *A Brief Guide to Biographical Sources,* India Office Library and Records, London, 1979.
9. For published lists of casualties, see Book List, page 186.
10. P.R.O. Kew, WO 95; War Diaries were also compiled for the Second World War, again by unit, and may be consulted at the P.R.O., Kew (WO 165–WO 179), subject to a signed undertaking of confidentiality.
11. The Commonwealth War Graves Commission, 2 Marlow Road, Maidenhead, Berks SL6 7DX.
12. Holding, N. H., *World War I Army Ancestry;* see Book List, page 186.

6

Identification and Dating

Photographic Processes
and Papers

DON STEEL

The photographic process can often be of assistance in dating a photograph. Even when it cannot, or when the date is already known, you may well find it interesting to discover the photographic origin of the pictures in your family album.

The first decision to be made is whether the picture is indeed a photograph. Examination with a hand-magnifier will show whether it is continuous in its halftones, and thus photographic, or is broken up by a line, dot or grain structure, the product of a printing process (this does not, however, apply to some older colour photographs, which have a dot structure). If you inspect some typical printed images, such as newspaper photographs, or engravings, the distinction becomes clear.

Next, is it a negative or a positive? In a negative the natural tones of light and shade are reversed: skies look dark and shadows light. In a positive the tones appear in their natural values: light areas are light, dark areas dark.[1]

Positive images are of two kinds: 'direct' positives, where the negative was treated to turn it into a positive; and positives printed from negatives, most commonly on paper, but sometimes also on other materials (see below, Appendix I, page 106).

There are several strategies for identifying positives: the material, the size, the shape, the texture. The best place to start depends upon the most obvious feature of the photograph. It would be absurd to try to identify circular prints by the type of paper used, when the shape identifies them, in the vast majority of cases, as being taken with an early Kodak camera, and the diameter differentiates between the Kodak models. On the other hand, an uncased tintype, being the only photograph on iron, is

74

instantly recognizable by the material. It is hoped that the three charts (two of them kindly contributed by Arthur Gill) will solve most identification problems.

NEGATIVES
PAPER NEGATIVES

PHOTOGENIC DRAWINGS, *c.* **1835–1840** The French pioneers, Joseph Nicéphore Niépce (1765–1833) and Louis Jacques Mandé Daguerre (1787–1851) concentrated on trying to produce a positive image on the plate exposed inside the camera, but the Englishman William Henry Fox Talbot (1800–1877), experimenting at the same time as Daguerre, produced in 1835, on a paper base sensitized with salt and silver nitrate, a negative (the earliest known still to survive) from which he could contact print a positive on a fresh piece of sensitized paper. He thus initiated the two-stage process we still use today, and by the separation of negative and positive made multiple printing possible. However, the 'photogenic drawings' produced by this method required a long exposure, making portraiture impossible.

CALOTYPES, 1840–*c.* **1864** In 1840 Talbot discovered the latent image, i.e. that after a relatively short exposure an image could be brought out on the apparently unaffected sensitized paper by 'developing'. This discovery led to the calotype process which he patented in 1841. A sheet of writing-paper was coated first with silver nitrate and then with potassium iodide to produce light-sensitive silver iodide in the paper fibres. When required for use, this 'iodized paper' was brushed with gallo-nitrate of silver— a solution of silver nitrate, acetic acid and gallic acid. After exposure in the camera, it was given a second brushing with the same solution and was warmed, developing the image. For portraiture the exposure took between thirty seconds and two minutes. The image was fixed with potassium bromide (or, later, with 'hypo'—sodium thiosulphate). Talbot called the pictures 'calotypes' (from the Greek *kalos*, 'beautiful'); they were also known as 'Talbotypes'.

Calotype negatives are dark brown to black in colour. They were usually printed on salted paper (see below, page 88). Strictly speaking, the term 'calotype' applies only to the negative. However, it is commonly used to describe any salted paper print from a paper negative (see below, page 88).

Although the calotype was not often used for portraiture, this fine early example (left) was taken in 1844 by William Henry Fox Talbot, inventor of the process, and shows Matthew Wood.

In France the process was widely used for Government architectural surveys. The calotype below, taken by Gardner c. 1851, shows a house near Boulogne.

Between 1841 and 1852 the calotype became the characteristic English photograph, though it was not widely used for portraiture.[2] It was also extensively used in France, especially for Government architectural surveys. However, largely owing to Talbot's insistence upon royalties, it was virtually unknown in the United States, where the patent-free daguerreotype (see below, page 83) reigned supreme.

WAXED PAPER NEGATIVES, 1851–1865 With the calotype process, the paper texture of the negative was always printed on to the positive. Talbot applied wax to his *finished* negatives before he printed them, thus enabling light to pass more freely through them during printing. In 1851 Gustave le Gray suggested waxing the paper *before* it was sensitized, an idea taken up by many photographers. At present the only method of differentiating between paper negatives waxed before sensitizing and those waxed after processing is by scanning with an electron microscope.[3]

EASTMAN NEGATIVE PAPER, 1884–1885 In 1883 the Eastman Dry Plate Company used thin paper as a base for the recently invented gelatine emulsion. First produced in sizes of up to 4 × 5 inches, in the following year, 1884, it was marketed as 'roll film' (a special roll-holder clipped to the back of the camera was available from 1885), but only a year later was displaced by 'stripping film' (after exposure the gelatine could be stripped off the paper for printing). Negatives made on Eastman paper were usually oiled after development.

REFLECTION PRINTING NEGATIVES, 1920's–1930's Introduced in the 1920's, this process was used in Britain until at least the 1950's. A fast bromide paper (see below, page 95) in the camera produced a paper negative. This could be re-photographed, same size, on to another sheet of bromide, thus producing a positive. Alternatively, a specially constructed enlarger was used, the negative being brightly lit and its image projected on to another sheet of paper. The method was particularly favoured by itinerant street photographers with apparatus which had processing facility within the camera. The image quality is poor. Positives were usually given little fixation and it is unlikely that many have survived.[4]

GLASS PLATES

ALBUMEN PLATE, WET COLLODION AND DRY COLLODION PROCESSES Glass was first used as a base by Sir John Herschel in 1839, but photographers showed little interest in it until Abel Niépce de Saint Victor, nephew of the pioneer photographer, perfected in 1847 his **albumen plate process.** He coated the plate with a solution of potassium iodide mixed with albumen (egg white), which was allowed to dry; it could be sensitized with a silver-nitrate solution when required, and was developed in gallic acid (or, later, pyrogallic acid). Exposures of five to fifteen minutes ruled out portraiture. This process was more popular in France than Britain.

In 1851 Frederick Scott Archer published his **wet collodion process.** He used a scrupulously clean glass plate coated with a solution of collodion and potassium (or cadmium) iodide, sensitized it in silver nitrate while it was still damp and tacky, and exposed it in the camera before it had time to dry. The film was developed by pouring on a solution of pyrogallol containing acetic acid. Archer's process, one of the major breakthroughs in the history of photography, reduced the exposure time to between six and ten seconds in best conditions (though exposures could still be long, and generally were) and brought about the extinction of the daguerreotype (see below, page 83) which required a much longer exposure.

Within three years, ways were found of using collodion dry, but the exposure times of **dry collodion processes** could not match those of the wet collodion process, which reigned supreme for the next thirty years.

It is difficult to distinguish between negatives produced by the albumen plate, wet collodion and dry collodion processes, as differences in formulation and treatment could produce between the results of any one of them variations as wide as between the processes themselves. The most common is the wet collodion process. Viewed by reflected light, a wet collodion plate has a colour varying from dull tan to almost creamy white, but when looked through by transmitted light it shows a full range of dark tones.[5] The coating is uneven, particularly at the edges. Often one corner (where it was held) is uncoated. Wet collodion dark-slides have silver wire across or near the corner, and sometimes this shows on the plates, but is not conclusive as a dry collodion process or gelatine dry plate (see below, page 79) could have been

used with the same apparatus. Dry collodion processes—there were very many variations—produced plates which are often greyish but, being probably prepared with less haste than wet collodion, may be more evenly coated. Albumen plates are often darker and can be differentiated by testing edge scrapings of the coating in acetone, as albumen is less soluble than collodion. The collodio-albumen process cannot be identified in this way.[6]

STEREOGRAPHS Stereographs were based on the principle that when looking at an object, the left and right eyes see slightly different views, so that a three-dimensional effect can be achieved by pairing in a special viewer two pictures, one for each eye, taken from slightly different viewpoints. Popularized by the Great Exhibition in 1851, twin stereoscopic photographs, or 'stereographs', were produced in vast numbers.[7] There were four main categories—travel (by far the largest), news, social scenes and comedy. The craze declined in the late 1860's. Although stereograph prints (stereo-cards) are common, negatives are relatively rare.[8] Some stereographs were direct positives—daguerreotypes (see below, page 83) or, more commonly, transparencies.

GELATINE DRY PLATE PROCESS, 1871–1975 In 1871 Dr Richard Leach-Maddox showed the feasibility of using gelatine emulsion[9] on a glass plate—the so-called 'gelatine dry plate'. Though the early gelatine plates were actually less sensitive than wet collodion, in 1874 an amateur photographer, Richard Kennett, put on sale a dried gelatine emulsion, to be reconstituted with water by the photographer. The drying (by heat) produced a great increase in sensitivity and reduced exposure time from the six to ten seconds needed by the wet collodion process, to 1/25th of a second, ultimately making portraiture more naturalistic and paving the way for the snapshot. Gelatine plates were mass-produced in England from 1879 (by, among others, the firm later to become Ilford Ltd) and in America from 1880 by George Eastman, founder of the Eastman Dry Plate Company (eventually to become the Eastman Kodak Company).

NEGATIVES ON FILM

GELATINE NEGATIVES 'Roll film' of gelatine emulsion on a paper base was introduced by the Eastman Dry Plate Company

(see above) in 1884. However, a year later the Company switched to 'stripping film'—after exposure and development, the transparent gelatine emulsion film could be stripped off the paper, transferred to another support, and then printed.[10] In 1888, with the slogan *You press the button, we do the rest,* the company launched the first Do-It-Yourself hand-held camera for the amateur, the Kodak, using stripping film and producing circular pictures, 2½ inches in diameter. The camera was loaded and unloaded, and the film developed at the factory, but negatives were returned to the customer and so are sometimes found in private hands. Usually, however, only the prints survive.

CELLULOID NEGATIVES (NITRO-CELLULOSE OR CELLULOSE-NITRATE FILM) Celluloid, a highly inflammable plastic formed by mixing nitro-cellulose with camphor, was first made in 1861 but its thickness and unevenness prevented its being used as a photographic base until the late 1880's. In 1888 it was marketed in sheet form by John Carbutt of Philadelphia and a year later the Eastman Company patented a celluloid film which replaced the less practical stripping film in its Kodak camera. The Kodak was soon followed by other Do-It-Yourself cameras, especially the Brownie, a six-exposure box camera marketed in 1900, and one of the main instruments in the explosion of photography as a pastime. Roll-film cameras were also produced by other manufacturers, and celluloid negatives of this period are fairly plentiful. However, despite the wide use of celluloid film in cameras designed for the amateur, there was no significant professional use of either sheet or roll film until after the First World War.

From 1903 Eastman Kodak marketed a 'Non-Curl' film with gelatine on both sides. In fact, non-curl negatives do sometimes curl slightly—the difference is that their predecessors always curl considerably! Negatives with square-notched edges were made from 1892 to about 1910 for the Frena camera, which had a rotating magazine to remove one film at a time from the exposed pack.[11] When 35-mm photography was popularized by the Leica, produced by the German company E. Leitz Optische Werke in 1925, it was designed to use the 'short ends' of cinematographic film.

Nitro-cellulose was in use up to about 1950. It had, however, two major defects. It was highly inflammable (its use in the infant

Although the wet collodion process, introduced in 1851, considerably reduced exposure times (to ten seconds or less in ideal conditions), the photographer was encumbered by the need to trundle a portable dark-room around with him. When Roger Fenton (see page 188) arrived in the Crimea in February 1855, to photograph the British army at war, he had with him a cook, a driver, and an ingenious van (right) which served as his dark-room by day and his sleeping quarters by night, complete with chemicals, cisterns, cameras, tripod, camp-bed, books, cooking utensils, and 700 glass negatives packed in sturdy chests.

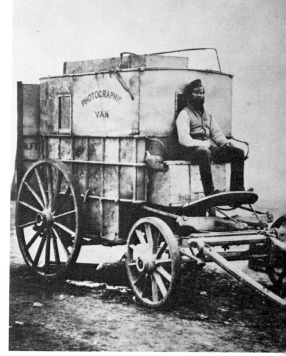

The introduction of the gelatine dry plate process in the early 1870's cut exposure times dramatically to 1/25th of a second, opening the way to street photography and snapshots. This print (below) from a gelatine dry plate negative shows Londoners dancing to a barrel organ in Lambeth. It was taken in the 1890's by Paul Martin, a pioneer of documentary photography.

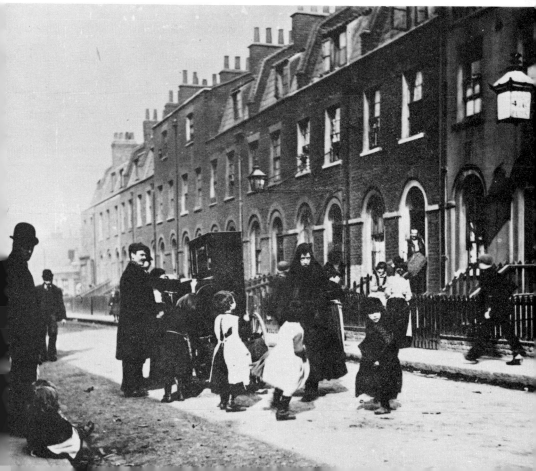

CHART 1

IDENTIFYING NEGATIVES *compiled by ARTHUR GILL* ★

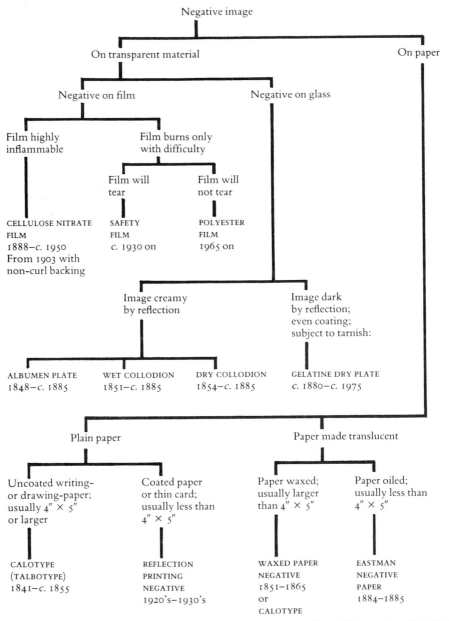

★ *Compiled by Arthur Gill: based on the work of a sub-committee (Arthur Gill, Brian Coe of the Kodak Museum and Tom Collings of the Camberwell School of Arts) on the conservation of photographs, of the Technical Committee of the Society of Archivists, published in the Royal Photographic Society Historical Group pamphlet* Recognition of Photographic Processes *(1976), and the Museums Association Information Sheet IS No. 21* Photographic Processes *(1978); reproduced with minor alterations, by kind permission.*

cinema industry led to some tragic fires) and it had poor keeping properties. Cellulose nitrate film may be identified by setting light to a thin sliver; it will flare up.

SAFETY FILM From about 1930 onwards cellulose-nitrate film was gradually replaced by safety film. This was made of cellulose acetate in the early 1930's; of cellulose di-acetate from 1937 to 1948; and of cellulose tri-acetate from 1948 onwards. Safety film will burn, but only with difficulty.

POLYESTER FILM In the late 1950's polyester film was introduced. Tougher than cellulose acetate, this was at first produced, in large sizes, for graphic artwork, but later became general.

POLAROID NEGATIVES With the Polaroid camera, invented by Dr Edwin Land in 1947, the processes of developing, fixing and printing were completed within the camera.[12] Ten seconds after the picture had been taken, the finished print could be peeled from the negative in light. At first this destroyed the negative, but in 1961 a modification was introduced which left the user not only with a positive, but also with a negative suitable for future printing by conventional means.

POSITIVES
DIRECT POSITIVES
DAGUERREOTYPES, 1839–c. 1860 A daguerreotype is a direct positive on a silvered copper plate. Its creator, Louis Jacques Mandé Daguerre, worked in association with Joseph Nicéphore Niépce, the inventor of photography, from 1829, and made his and Niépce's discoveries public in 1839. With Daguerre's process, a silvered copper plate sensitized with iodine vapour was exposed in the camera, and the picture was developed with vapour from warm mercury, forming an image on the silver surface. Fixing with 'hypo' removed the unaffected silver iodide. Later daguerreotypes were gold-toned to produce a stronger image.

In its early years the process needed a very long exposure (up to thirty minutes), but after 1841 a combination of a wider aperture lens, letting in more light, and a more sensitive photographic surface (in modern terms, a 'faster film'), reduced this to twenty seconds, and by the mid-1840's it had been reduced still further. The family portrait had ceased to be the prerogative of the rich.[13]

The standard plate sizes still used today derive from the 8½ × 6½-inch plate used by Daguerre. Most daguerreotypes were fairly small, eighth-plate (2⅛ × 3¼ inches) and sixth-plate (2¾ × 3¼ inches) being the most common. As the plates were cut by hand, the sizes are necessarily approximate.

The daguerreotype has a distinctive, mirror-like appearance. The polished surface of the silvered copper plate, sometimes tarnished to brown- or blue-black, forms the dark areas; whitish silver-mercury amalgam forms the light areas and highlights. As long as the polished silver reflects a dark field, the picture looks like a positive, but held at a slightly different angle in bright light, it will look like a negative.

Because it is merely a treated negative, the daguerreotype image is normally laterally reversed, as in a mirror. This is not too apparent in a portrait, except perhaps for hair-styles being parted or coats buttoned on the 'wrong' side (traditionally men's and boys' jackets button left over right, women's and girls' right over left), but is more noticeable with street scenes—signboards, for instance, are reversed. To overcome this, photographers sometimes fitted a prism over the lens, even though this increased the exposure time.

The surface of a daguerreotype is very fragile—the merest touch can remove part of the image. Moreover, if left exposed to air the polished silver soon tarnishes. So protective framing under glass is essential, and daguerreotypes are also often cased (see below, page 104).

The daguerreotype enjoyed a boom for over a decade during which time photographic studios offering portraits sprang up all over France, Britain, the United States, Canada, Australia and New Zealand. Few daguerreotypes were made in Britain or France after 1855 since Archer's wet collodion process (see above, page 78) needed shorter exposures. However, some were still being produced in America during the Civil War (1861–1865).

AMBROTYPES OR COLLODION POSITIVES, 1851–c. 1880 An ambrotype is an under-exposed collodion negative on glass, with a black backing. First made by Scott Archer in 1850 and becoming more widely available from 1851 onwards, these photographs were known as 'collodion positives' in Britain and as 'ambrotypes' in America, but in recent years the latter term has been more widely adopted and is here preferred, being shorter

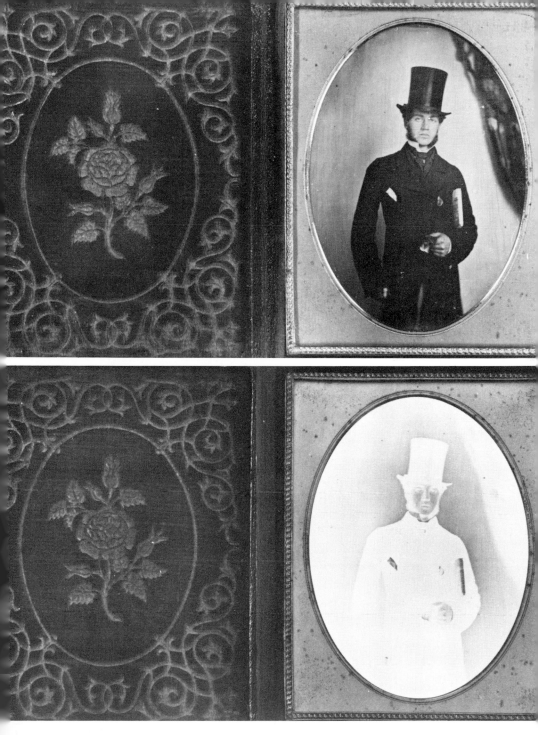

Turned towards the light a daguerreotype looks like a negative. Note the indications (e.g. the handkerchief in the breast pocket) of lateral reversal, and the decorative case with a thin brass matt (see page 104) to separate the image from the cover glass.

and, since tintypes and other variants (see below) were also positive collodions, less confusing.[14]

When a thin, under-exposed collodion negative is laid on a black surface and viewed by reflected light, it looks like a positive because the light areas of the negative, backed by black, appear black, and the dark areas, being silver, reflect light and by contrast appear bright. The black background may be velvet, paper, japanned metal, or black varnish brushed on to the glass itself; some ambrotypes were made on dark glass. Since the plate was transparent, it *could* be mounted so that the image was viewed through the glass base; but rather than thus reduce its brightness and detail, most photographers preferred to mount it laterally reversed.

There are three varieties of ambrotype, depending upon how much care was taken to protect the image:

1. The image side of the glass plate is coated with balsam of fir and a cover glass is hermetically sealed on top ('Ambrotype' was, in fact, originally merely the trade name for this variant of the process);
2. The glass plate is backed with black and the image is given a protective coating of varnish;
3. The glass plate is merely backed with black material.

Ambrotypes were made in a variety of sizes, quarter-plate ($3\frac{1}{4} \times 4\frac{1}{4}$ inches) and sixth-plate ($2\frac{3}{4} \times 3\frac{1}{4}$ inches) being most common (these would fit into daguerreotype cases). For framing and casing, see below (page 104).

Ambrotypes declined in popularity after 1860 with the rise of the cartes de visite (see below, page 90), but some were still being made in the late 1870's.

TINTYPES OR FERROTYPES, c. 1860–c. 1940 A tintype is a collodion positive made directly on black or dark brown enamelled sheet-iron (*not* tin). First described by the Frenchman Adolphe Alexandre Martin in 1853, and patented in the United States in 1856 by Hamilton L. Smith, the tintype was originally produced under the names 'melanotype' (from *melas*, 'black') or 'ferrotype' (from *ferrum,* 'iron'), but the term 'tintype', though inaccurate, became the most common, particularly in the United States, and is therefore preferred here. Tintypes were very popular from 1860 onwards, especially in America. In Europe

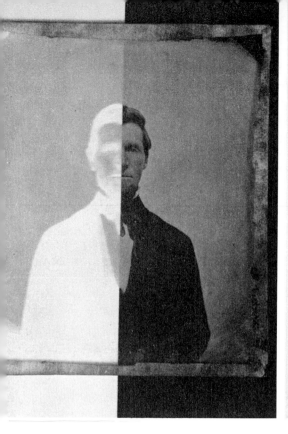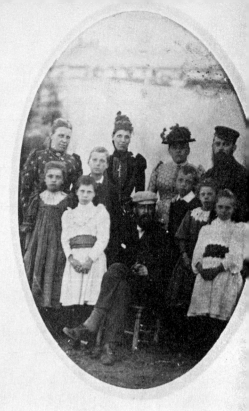

Above left: an example from the United States of an inexpensive ambrotype (collodion positive) with half the black backing removed to show that it is merely an under-exposed glass negative.

Above right: tintypes were the cheapest 'likenesses'. Favoured particularly by beach and street photographers, they were made directly on sheet-iron, which had been enamelled black or brown. Sometimes they were glazed or cased to imitate the daguerreotype and ambrotype. This unusually good example, taken by F. Price, shows a family group on the beach at the popular English resort of Ramsgate, Kent.

they were principally produced by beach and street photographers. Some were still being made in the 1930's.

Like the daguerreotype and ambrotype, the tintype is usually laterally reversed. Though it was much cheaper, its overall drabness and lack of tonal contrast made it far inferior to either. To try to offset this, it was sometimes hand-coloured and might be glazed or cased to resemble its more expensive competitors.

Tintypes came in a variety of sizes, ranging from miniatures small enough to be worn on a ring, up to whole-plate (6½ × 8½ inches). The most common tended to be either carte de visite size

(see below, page 90) or about 1½ × 1 inch. Many tintypes were made with a multiple-lens camera which took four pictures simultaneously. **Gems** were small tintypes made by using a multiple-lens camera and moving the plate to produce up to 36 separate exposures.

OTHER COLLODION POSITIVES, *c.* 1860–*c.* 1940 Drab, poor-quality collodion positives similar in appearance to tintypes were also made on oilcloth, patent or enamelled paper, or cardboard.

PRINTS

SALTED PAPER (OR SALT) PRINTS These prints were made on writing-paper which had been dipped in a weak salt solution and then brushed with a silver nitrate solution (this process being repeated several times), thus producing in the paper the light-sensitive silver chloride. Salted paper prints can usually be recognized by their colour—red-brown or sepia (yellow if badly faded). Most were made by the calotype process from paper negatives and, as noted above (page 75), these are usually referred to as 'calotypes'. It is also possible to find albumen prints (see below) from paper negatives, or salted paper prints from negatives produced by one of the later processes, but the term 'calotype' cannot be used for these. Calotypes are often characterized by soft outlines and lack of sharp detail because the texture of the paper negative printed on to them. It is not really fair to call them 'fuzzy', an adjective often used; there is, in fact, a wide range of definition in salted prints, and though some are poor, others are indistinguishable from prints made from wet collodion negatives. That the pictures sometimes petered out at the edges was due to a defective lens or a badly focused camera.

If a salted paper print derived from a calotype negative, a magnifying glass may reveal the slightly mottled effect caused by the paper fibres. However, salted prints from waxed paper negatives do not have quite such a fibrous appearance and resemble prints made from glass plate negatives more closely than they do earlier salted paper prints. Henry Collen, Talbot's first licensee for the calotype, initiated the retouching of salted paper prints of portraits, a practice sometimes followed.

Salted paper prints were abandoned by the mid 1850's but there was a slight revival in the 1890's.[15]

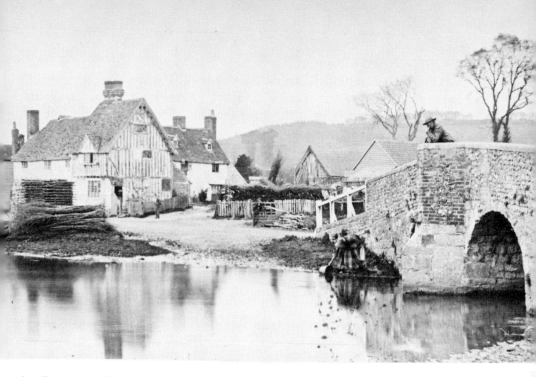

An albumen print from a collodion negative, taken by Francis Bedford (see page 188) and first published in 1859, showing Eynsford in Kent, with rustics posed to add interest

ALBUMEN PRINTS Albumen prints were introduced in 1850 by Louis-Désiré Blanquart-Evrard. Archer printed his first wet collodions (1851) on salted paper but soon switched to the new albumen paper.

To prepare it, the paper was first floated on a solution of a halide—usually common salt (sodium chloride) or ammonium chloride, but sometimes potassium iodide and potassium bromide—in albumen (derived from egg white). When required, it was sensitized in a bath of acidified silver nitrate solution, rinsed and dried. It was then placed in close contact with the negative in a printing frame, exposed to strong sunlight until the image was visible, and fixed in 'hypo'.

For book illustration, Blanquart-Evrard exposed the print for only a few seconds and then developed the latent image with a solution containing gallic acid. This enabled him to make a large number of prints in a very short time. However, for normal use most photographers preferred to wait for the image to appear without using developer. They allowed it to darken further than required as fixing reduced the density.

Ready-coated albumen paper was first sold in the 1850's, and by 1872 several brands were available. Like the production of ready-coated gelatine plates a few years later, this was an important step in taking the preparation of the materials out of the photographer's hands.

Albumen paper reproduced fine detail particularly well. The prints range in colour from faint yellow to rich chocolate. They tended to fade (though less than salted paper prints) and many were toned with chloride of gold to improve their permanence and colour. This produced shades such as warm brown, purple or bluish black. The surface varies between a slight sheen and a high gloss (though usually less than modern prints).

Sometimes the coating shows signs of cracking, due to the application of a thicker layer of albumen to achieve a more uniform coat.

Albumen prints were made until about 1900. Unmounted, they are on thin paper; but they were often mounted on card as cartes de visite, cabinet cards or stereographs which merit more detailed consideration.

CARTES DE VISITE AND CABINET CARDS The most popular photographs of the Victorian era were undoubtedly cartes de visite. Made to the size of a visiting-card, 4¼ × 2½ inches, these portraits were first popularized by André Adolphe Eugene Disdéri, a Parisian photographer, in the 1850's. Introduced to England in 1857, they rapidly displaced daguerreotypes and ambrotypes, and from 1859 to about 1905 were the stock-in-trade of almost every photographer in Britain and the United States. Their price, usually 12s. 6d. (62½p) a dozen, or £1 for 20, put them within reach of almost everybody.

Cartes de visite were produced in three ways: with a single-lens camera taking two or four photographs in succession on a plate moved between exposures, in which case there was a variety of poses; with a multiple-lens camera exposing four, six or eight pictures simultaneously, all virtually identical; or with a multiple-lens camera exposing each lens in succession, with a shift for a second set of exposures, also resulting in practically identical pictures.

Cabinet cards, measuring 4 × 5 inches, and mounted on 4¼ × 6½-inch cards, were introduced in 1866 and lasted until about 1914, being used not only for popular portraiture but for

Backs of two cartes de visite and a cabinet card, elaborately decorated: all offer not only enlargements but also hand-colouring. Useful leads are the reference number (if order books survive), the variety of addresses, and even perhaps the royal client—when was he deposed?

theatrical publicity photographs.

Produced in their thousands, cartes de visite and cabinet cards are the most readily accessible of all old photographs. The negatives were produced on glass by the wet collodion process until the 1880's, and thereafter by the gelatine dry plate process. As noted above (page 80), professional photographers rarely used celluloid film until after the card-collecting craze was over. Earlier ones were printed on albumen paper or, from 1864, occasionally by the carbon printing process (see below, page 92); some later ones were printed on gelatino-chloride paper (see below, page 95). They were pasted on specially printed cards bearing the name and address of the photographer on the back. Coloured mounts, particularly maroon or dark green, usually date from the 1880's.[16] Squared corners generally indicate the 1860's, although cabinet cards with straight square corners were

also produced in the 1880's.

From 1 September 1864 to 1 August 1866 American photographs were subject to tax. A carte de visite produced in the United States during this period carried an American postage stamp on the back.

STEREOGRAPHS Introduced in about 1849 and in use up to 1914, stereographs were at the height of their popularity between 1851 and 1865 (see above, page 79). Some were produced as daguerreotypes, others as albumen and collodion transparencies, but most were albumen prints. Stereographs made before 1858 are generally on extremely thin card, and English or French ones often bear no photographer's name. From 1858 to 1865 the cards usually have the photographer's or publisher's name on the margin of the image side, and after 1868 a series of views may be listed on the back.[17] Until 1870 they were flat with squared corners; from 1868 onwards flat with rounded corners, and after 1879 curved with rounded corners. Before 1860 most were mounted on light grey card; yellow mounts were popular from 1860 to about 1867; and other colours, including green, blue and orange, were used in the 1870's.[18] Too much reliance cannot, however, be placed upon styles of mount as there were many exceptions. Towards the end of the century stereographs were printed on gelatino-chloride, silver bromide or collodio-chloride paper (see below, pages 94–5).[19]

CARBON PRINTS, 1864–c. 1936 With the carbon process, devised by Sir Joseph Swan in 1864, the image was obtained by *hardening* to light rather than by darkening, as had been the case with the previous silver salt processes.[20] When a tissue of gelatine containing carbon or colour pigment was sensitized in potassium bichromate and exposed under a negative in daylight (or, later, arc light), it hardened in proportion to the penetration of the light; the tissue was then inverted on to a temporary support (usually paper) and washed in warm water which melted the unhardened gelatine, leaving a positive, though laterally reversed, image in hardened gelatine, varying in thickness according to the variations in tone, on the temporary support. A fine gradation of tones was possible, and pigments of any colour could be used. The print was usually transferred to a final support, which could be practically any material. However,

single-transfer prints (the tissue being inverted straight away on to its final support) were not uncommon.

Carbon transfer prints may be difficult to distinguish from other photographic prints, though when you have compared a number with salted paper or albumen prints, you will find their image colour distinctive; moreover, unlike their rivals, they do not fade.

Variations were the **ozotype** print, devised in 1899 and indistinguishable from a carbon print; and the **ozobrome** or **carbro** process, devised in 1905, which needed daylight for printing[21] and with which enlargements were possible.

PLATINUM PRINTS, 1873–1930's The platinotype process was invented by William Willis in 1873 but was not used commercially until the formation of the Platinotype Company in 1879. A print was made by impregnating the paper with sensitized platinum salts. Grey or sepia, platinum prints have a very subtle tone range and, as the surface is matt, are completely free from reflection. Like carbon prints but unlike salted paper or albumen prints, they were stable and did not fade; unlike most carbon prints they were produced by a single-stage process. Platinum prints were produced in fair numbers until the First World War when increases in the price of platinum gave rise to an alternative process using another metal, palladium, and producing **palladiotypes,** which were slightly warmer in tone than platinum prints. Even after the war, although the Platinotype Company advertised Platinum Printing Paper until 1937, it was so expensive that relatively few platinum prints were produced.

CYANOTYPES Invented by Sir John Herschel in 1842 and popularly known as 'the blueprint process', the method was principally used to reproduce line drawings on tracing paper by contact printing them on paper coated with a mixture of ferric ammonium citrate and potassium ferricyanide. However, in the 1880's and 1890's amateurs used it to make intense blue prints from negatives.

EMULSION PAPER PRINTS, 1864 onwards There were two kinds of emulsion paper: Printing Out Paper and Developing Out Paper. Both were manufactured on a large scale and could be

bought ready for use. Printing Out Paper needed several minutes' exposure to sunlight, but the image was produced directly and had only to be fixed. Developing Out Paper is used with artificial light. The exposure takes only seconds, but developing as well as fixing is necessary.

Printing Out Paper was in general use from the 1880's to 1930.[22] It was a little thicker and slightly more opaque than albumen paper. Many early prints were brownish-yellow, but increasingly gold chloride was introduced into the emulsion, making the prints 'self-toning' and giving a colour range from warm brown to maroon. Negatives made for printing with POP do not print as well on modern papers.

There are two types of **Printing Out Paper:** collodio-chloride and gelatino-chloride. It is difficult to see a difference between the two, but collodion emulsions may be more brittle and likely to show tiny cracks.

Collodio-Chloride Paper was invented as early as 1864. The surface was coated with collodion emulsion which was used as a vehicle to support light-sensitive silver chloride. Early collodio-chloride prints are relatively unusual. They were generally warm sepia colour, but replacement of the pre-wash with salt solution gave colder tones, from dark brown to purple. The paper's popularity was limited by three drawbacks: it was susceptible to yellow spots; toning was difficult; and it was not suitable for hand-colouring. But from 1903 'self-toning' papers, described above, gave extra richness, producing chocolate brown prints, and made it as popular as gelatino-chloride paper (see below). It continued in use until about 1940, though latterly used almost exclusively by professionals for proof printing.

Gelatino-Chloride Paper was introduced in 1882. The emulsion contained free silver nitrate and this produced a paper on which the sepia image printed out visibly. From 1903 'self-toning' papers (see above) deepened the sepia image to chocolate brown. Some self-toning papers were available on tinted paper bases—pink, blue, mauve, cream, green and grey. Gelatino-chloride paper continued in use until the 1930's. The trade name of Eastman Kodak's gelatino-chloride POP was 'Solio Paper', and this was so common that any POP prints were often called 'Solio prints'.

Developing Out Paper has been in use since about 1879. Popularized by Eastman Kodak, it gradually superseded POP

(which required sunlight) and from 1900 became the standard printing paper for black and white photographs.

There have been four basic types. The first, **Silver Bromide Paper,** also known as **Gelatine Bromide Paper** or simply as **Bromide Paper,** was introduced by Mawdsley in 1875; it was rare in America until marketed by Eastman Kodak in 1886. It allowed fast printing and this encouraged enlargement work. The paper varied from very thin to card thickness, and there was a wide range of surfaces (from matt to glossy), textures (from rough to velvet) and degrees of lustre. Generally, however, it tended to be much thicker and more opaque than albumen paper. Early bromide prints are a soft slate-black but later they were sometimes toned to other colours. Fading was common and many old prints appear bronzed due to the slow action of atmospheric sulphur tarnishing the silver.

The second of the three types, **Chloro-Bromide Paper,** was first manufactured about 1883; it became popular in about 1920 and was used until about 1950. Slower than Bromide Paper, it had a long tone range—brown, brown-black, and black, or even red and blue with toning—which made it a favourite with pictorial photographers. It is still stocked by a few suppliers.

Thirdly came **Chloride Paper** (also called **Silver Chloride Paper** and **Gelatino-Chloride Paper,** causing some confusion with gelatino-chloride POP) which became generally available about 1889 and was widely used until the 1950's. It was known as 'Gaslight Paper' because it was slow enough to be handled in subdued light. The image is blue-black. Eastman Kodak's trade name for this paper was 'Velox', so chloride prints are often termed 'Velox prints'. The surface of early Velox prints is smooth; later, both gloss and matt surfaces became popular. Most family albums from the early 1900's are full of them.

Since 1970 **Polyethylene** or **Resin-Coated Papers** have tended to displace earlier Developing Out Papers because of their speed and convenience. The resin prevents the substance of the paper becoming wet, and processing times for developing, fixing and washing have been reduced to about eight minutes in all, compared with about thirty-five minutes, plus drying time, for earlier Developing Out Papers. However, there is some debate as to whether polyethylene prints will last as long.

POLAROID PRINTS See above, page 83.

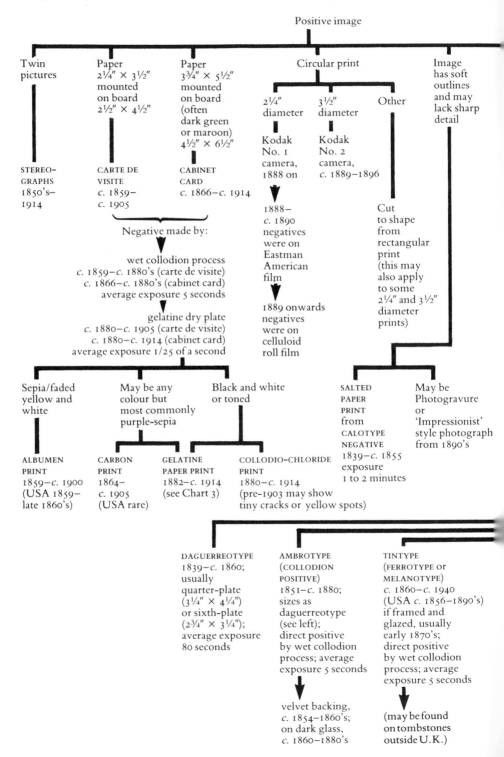

CHART 2 *IDENTIFYING POSITIVES BY MOST EASILY RECOGNIZABLE FEATURES*

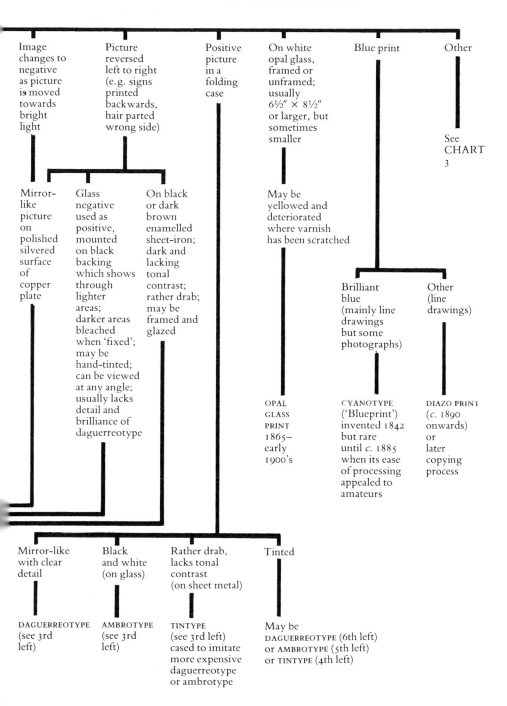

Image changes to negative as picture is moved towards bright light

Picture reversed left to right (e.g. signs printed backwards, hair parted wrong side)

Positive picture in a folding case

On white opal glass, framed or unframed; usually 6½″ × 8½″ or larger, but sometimes smaller

Blue print

Other

See CHART 3

Mirror-like picture on polished silvered surface of copper plate

Glass negative used as positive, mounted on black backing which shows through lighter areas; darker areas bleached when 'fixed'; may be hand-tinted; can be viewed at any angle; usually lacks detail and brilliance of daguerreotype

On black or dark brown enamelled sheet-iron; dark and lacking tonal contrast; rather drab; may be framed and glazed

May be yellowed and deteriorated where varnish has been scratched

Brilliant blue (mainly line drawings but some photographs)

Other (line drawings)

OPAL GLASS PRINT 1865– early 1900's

CYANOTYPE ('Blueprint') invented 1842 but rare until *c.* 1885 when its ease of processing appealed to amateurs

DIAZO PRINT (*c.* 1890 onwards) or later copying process

Mirror-like with clear detail

Black and white (on glass)

Rather drab, lacks tonal contrast (on sheet metal)

Tinted

DAGUERREOTYPE (see 3rd left)

AMBROTYPE (see 3rd left)

TINTYPE (see 3rd left) cased to imitate more expensive daguerreotype or ambrotype

May be DAGUERREOTYPE (6th left) or AMBROTYPE (5th left) or TINTYPE (4th left)

compiled by ARTHUR GILL ★

Positive image

Positive on paper

Coated paper

Uncoated paper, matt

Coating thin to medium; surface sheen to gloss; yellow to sepia, with highlights yellow

Coating thick; surface matt to high gloss or texture; black and white, sepia or toned; subject to surface tarnish

Other

GELATINE PAPER PRINT
1882 to date

ALBUMEN PRINT
1850–c. 1900
common as cartes de visite, cabinet cards and stereo cards

COLLODIO–CHLORIDE PRINT
1864–1930's
(brownish yellow to c. 1903, warm brown to maroon thereafter)

POLYETHYLENE or RESIN–COATED PAPERS
c. 1970 on

Warm sepia image; may be wholly or partly faded to pale yellow, especially at edges

Very subtle tone range; silver-grey image; may be warmer tone or full sepia; no fading

Chocolate brown, red, green or other colours; pigment print; no fading

Light ima on bright blue grou

Print may be any colour; usually mounted; may be marked 'Permanent' or 'Autotype'; may show slight relief image

Print often chocolate brown; always mounted on/tipped in card or book; shows distinct relief image; usually named—

CARBON PRINT
1864–1930's

WOODBURYTYPE
1865–1890's
(French, *PHOTOGLYPTIE*)

SALTED PAPER PRINT
1839–c. 1855
(revival 1890's)

PLATINUM PRINT
c. 1880–1930's
or
PALLADIOTYPE
c. 1914–1930's

CYANOT
1842 on
(rare for pictures drawing 'bluepri

★ *Compiled by Arthur Gill: based on the work of a sub-committee (Arthur Gill, Brian Coe of the Kodak Museum and Tom Collings of the Camberwell School of Arts) on the conservation of photographs, of the Technical Committee of the Society of Archivists, published in the Royal Photographic Society Historical Group pamphlet,* Recognition of Photographic Processes *(1976), and the Museums Association Information Sheet IS No. 21* Photographic Processes *(1978); reproduced with minor alterations, by kind permission.*

NOTES

Colours Black and white includes all shades of grey, 'halftones'. Brownish-black is termed 'warm', bluish-black 'cold'. Photographically, sepia is rather warmer, more reddish, than the artist's pigment. Chocolate brown is colour of plain chocolate. Photographs may be toned chemically, the image appearing in the range of tints of the colour. Paper may be coloured: early this century pastel tints were used; now metallic, bright and fluorescent colour papers are available.

Textures Paper without surface shine is called 'matt'; with high reflection, 'glossy'; intermediate terms are 'lustre' and 'sheen'.

Fading Many photographic images are subject to fading due to the action of light, chemical reaction within the photographic substance or its support, or the adhesive, or any of these and atmospheric pollution. The effect may be partial or all-over; the image tones are lightened and there may be a change of colour, usually towards yellow, brown or the colour of the mount.

CHART 3 *IDENTIFYING POSITIVES BY MATERIAL*

Positive on metal

Positive on glass

Positive on other materials

Opaque glass positive

Transparent positive (often as lantern slides or stereo-transparencies)

Positive image on opal glass

OPALTYPE
mostly
1890 on
(carbon
transfer print,
or print on gelatine-/
silver-coated opal glass,
Transferotype)

Negative image, positive when viewed by reflected light against dark ground or on dark glass

AMBROTYPE
(COLLODION
POSITIVE)
1851–1880's

Print stuck on glass; normally coloured from rear

CRYSTOLEUM
1880's–
1930's

Image creamy by reflection; black and white by transmitted light

COLLODION or
ALBUMEN
TRANSPARENCY
1851–1900's

Image dark by reflection; black and white, or sepia, or other colours

GELATINE
TRANSPARENCY
1880 on

Image dark by reflection; usually chocolate brown; will show relief

WOODBURYTYPE
1865–1890's
or
CARBON TRANSFER
1864–1930's

Picture on silvered surface of copper plate; image changes from negative to positive when moved towards bright light

Picture on other metal

On aluminium, copper, etc.; sepia, or black and white, or colour

On black or brown enamelled iron; dark, lacking tonal contrast; rather drab

DAGUERREOTYPE
1839–c. 1860

CARBON TRANSFER
PRINT 1864–1930's
or
TRANSFEROTYPE 1884–1930's

TINTYPE (FERROTYPE)
c. 1860–1930's

China, enamelled plate porcelain, fired-in glaze

PHOTOCERAMIC
1860's on

Wood, stone, etc.

CARBON TRANSFER
PRINT 1864–1930's
or
TRANSFEROTYPE
1884–1930's

Fabric

CLOTH PRINT
1850 on
or
TRANSFEROTYPE
1884–1930's

Synthetic ivory

IVORYTYPE
1855–c. 1910
or
EBURNEUM
1865–c. 1910

Black leather, oilcloth, etc.

PANNOTYPE
(COLLODION
POSITIVE)
1851–1900

COLOUR PHOTOGRAPHS
HAND-COLOURING
Until the 1950's many colour prints were produced by hand-colouring. Daguerreotypes were coloured (often inexpertly) with stencils and powder, ambrotypes and tintypes with oils, water colours and wax crayons as well as powders; the colours may well have faded, but the gilding of buttons, watch-chains and bracelets remains bright. Salted paper and albumen prints (including cartes de visite, cabinet cards and stereographs) were often coloured with water colours or transparent oil paints, but the gelatine-based papers were particularly suitable for it.

Most professional photographers from the 1880's onwards offered coloured photographs as part of their service—the larger studios employed one or more full-time colourists, while the smaller establishments would put the work out.[23] Wedding photographs were among the most popular subjects for colouring and the photographer would record the principal colours of dresses in a notebook, marking up a proof print for the colourist.[24] Such overpainting, however, required great skill if the fine details of the photograph were not to be obscured. In the early years of this century commercially produced photographic postcards were often coloured, using stencils.

Hand-coloured prints are also found glazed. Laloue's misleadingly named **daguerreotype a l'huile** process (it has nothing to do with the daguerreotype), of the mid 1850's, involved painting over a portrait on albumen paper with oil paints and then sticking it with a film of varnish face downwards on to glass. The picture thus received a high gloss surface which enhanced the brilliance of the colours.[25] **Crystoleum photographs,** patented in 1876 and produced between about 1883 and 1915, were made by sticking albumen prints to the inner (i.e. concave) face of a small convex-curved glass. Most of the paper was rubbed off, the back was either waxed or coated with Canada balsam and fine details were painted on. A second glass was then used to back the first, with a thin layer of gummed paper strip between the two so that they did not touch. Areas of bold colour (costume, background, etc.) were painted on the back of the second glass, and the whole was backed with white card and framed. It looks like a painting done directly on the glass, but has the detail and accuracy of the original photograph. Some **opal glass prints** (1865–1900) (see below, page 106) were given a delicate colour wash.

ADDITIVE PROCESSES: 'SCREEN-PLATE' COLOUR SLIDES

In 1855, using the discovery made by Thomas Young in the early 1800's, that all colours are combinations of red, green and blue, James Clerk Maxwell successfully created a colour photograph. He had three separate black and white negatives taken, one through a red filter, the second through green and the third through blue. He then projected them, through filters of the same colours, on to a screen, in register (i.e. so that the three pictures exactly corresponded), to create a single coloured image. This additive principle was successfully developed by the American Frederic Eugene Ives and his successors from 1889 onwards. However, the first fully practical additive process to reach the general public was Autochrome, patented by Louis and Auguste Lumière in 1903. This was a 'screen-plate' process, i.e. both exposure and projection took place through the glass plate and a 'screen' affixed to it—beneath the emulsion—consisting of minute red, green and blue filters of dyed potato starch.[26]

Although a landscape took an exposure of one to two seconds and a portrait one of ten to thirty seconds, the Autochrome plate became a great success—by 1913 the Lumière factories were making up to 6,000 a day. They were made in many sizes. Larger examples were viewed directly in special viewing boxes; smaller ones were used for stereo work. A popular size was quarter-plate ($4\frac{1}{4} \times 3\frac{1}{4}$ inches) which when processed was cut to produce a $3\frac{1}{4}$-inch square slide for the magic lantern. Other firms soon produced screen plates and, from 1910 onwards, screen film. Lumière did not produce their first screen film, Filmcolor, until 1931 but by the mid 1930's it had virtually replaced the Autochrome plates. Screen-plate transparencies have tended to last much longer than modern ones, but are sensitive to heat and light and should not be viewed in a projector longer than is strictly necessary.

SUBTRACTIVE PROCESSES

1. PRINTS FROM SEPARATION NEGATIVES These, also pioneered by Ives and developed as a more convenient means of producing multiple copies (i.e. prints), derive from the subtractive principle described by Ducos du Hauron in 1862, of splitting up white light, in which all colours are present, and *removing* colours to achieve an accurate reproduction of the original scene.

Ives made three separation negatives, the first by red light, the second by green, the third by blue, but instead of projecting them through coloured filters to reconstitute the original (as in an additive process), he printed each as a positive in the colours complementary to that by which its negative was made: the first giving a blue-green (cyan) positive, the second a blue-red (magenta) positive, and the third a red-green (yellow) positive. These three partial images were superimposed in register, creating a colour reproduction of the original. Colour separation negatives, which were usually taken in a special three-lens colour camera, could be printed on glass in the complementary colours and superimposed to give a composite colour transparency or, more commonly, on paper, printing one colour on top of the other in register. Most photographically produced colour prints were made this way until about 1950, using at first the carbon process and, after 1905, the ozobrome, or carbro, process (see above, page 93), except in the United States where Kodacolor was on the market from 1942 (see below).

2. SLIDES FROM TRIPACK FILM The modern 2-inch square colour slide goes back to the Kodachrome film of 1936. With this film, which could be used in an ordinary 35-mm camera, Eastman Kodak applied the subtractive principle not just to printing but to making slides. Developed by Leopold Mannes and Leo Godowsky and first produced in the previous year for 8-mm and 16-mm cine film, it was a tripack film,[27] carrying on one support three separate emulsions, the first sensitive to blue light, the second to green and the third to red.[28] By the dye coupling process, first suggested by Rudolf Fischer in 1912, the three negatives were dyed *in situ* to form yellow, magenta and cyan images. Since these were *negative* images of the *complementary* colours, the result was a colour picture. Like the slides produced by the (additive) screen-plate process, modern colour slides are direct positives, the three negatives—one on top of the other—together forming the positive. Because the processing required complex machinery and precise control, Kodachrome films had to be returned for this to the manufacturer, and the cost of development was included in the price of the film. From 1936 to 1938 the processed 35-mm film was returned to the customer as a filmstrip still needing to be cut and mounted. From 1938 Kodachrome transparencies were returned in 2-inch square card

mounts. Kodachrome was followed by Agfacolour Neule (German) in 1936, Ansco-Color (American) in 1942 and Ektachrome (also American) in 1946, and by the 1950's had ousted the old 3¼-inch square screen-plate magic-lantern slide.

3. PRINTS FROM TRIPACK NEGATIVES In 1940 the German firm Agfa developed a negative-positive version which made it practicable to produce colour prints using tripack film, and this method is still in use. The layers of the tripack are dyed the complementary colours to create a negative of colour as well as shade, e.g. a blonde appears with blue hair and green lips. From these negatives any number of prints can be printed on special tripack paper.

The first negative-positive process to reach the public was Kodacolor, launched on the American market in 1942, and by the mid 1950's prints from a colour negative had replaced both hand-colouring and prints from separation negatives, on both sides of the Atlantic. Not only were they much cheaper than either but unlike most of the latter they could be taken using an ordinary 35-mm camera and the exposure time was very much shorter.

Two recent landmarks were the introduction of Polaroid colour film in 1963, and of Kodak's instant colour prints in 1976.

Today, 92% of all film sold is colour. However, this is a mixed blessing. Not only are most colour photographs not as sharp as black and white, but some of them deteriorate after as little as twenty years and archivists are experiencing technical problems in storing them. Others, though, do last much longer—Kodachrome, for instance, has a life of at least fifty to a hundred years.

Most of the colour prints in your collection will probably not be older than the 1950's. However, it is highly likely that you will come across earlier hand-coloured prints, and quite possible you will discover older prints produced from separation negatives. 2-inch square colour slides cannot be earlier than 1936. 3¼-inch square slides may be hand-coloured, but they may equally well have been produced between 1903 and 1950 by a screen-plate process. If on glass they date between 1903 and the mid 1930's, if on celluloid between 1926 and about 1950.

More details on the various colour processes, including several which space has precluded mentioning in this short summary, will be found in Brian Coe's *Colour Photography*.[29]

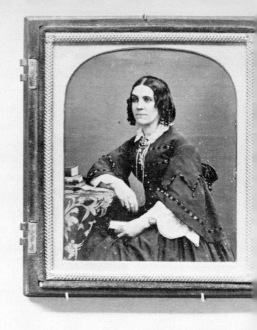

Tinted ambrotype, c. 1860, in a Union case—copied from a romanticized hunting scene?

FRAMING, CASING AND DISPLAY

It is usually a simple matter to remove a photograph from its frame, and indeed a family historian would be foolish not to try as there may be unsuspected information on the back. However, if a picture is cased, it is not always possible to identify the material used as the base. A daguerreotype is usually in a plush-lined hinged case, made of wood or papier mâché (sometimes inlaid with mother-of-pearl, tortoiseshell or silk), covered with leathercloth or paper embossed with a design such as flowers or fruit,[30] and fastened with a small metal clasp. Ambrotypes were also usually cased but might be hung in decorated or carved wooden frames. Some cases were designed to hold two ambro-types face to face—portraits of husband and wife, for instance. Tintypes were sometimes cased to imitate the more expensive daguerreotypes and ambrotypes.

In 1854 an American, Samuel Peck, patented the Union Case, the first commercial use of plastics,[31] bringing in complicated moulded designs, including natural or historical scenes, and patriotic or religious motifs.

Apart from the case itself, the styles of matt and preserver may be helpful in dating. During the 1840's a thin brass matt, perhaps

oval or octagonal, but basically simple in design, was placed between the image and the cover glass, holding the latter clear of the surface. When inserted into the case, plate, matt and glass were held in place by glued paper or by a thin rim of velvet-covered cardboard. A fourth item, the preserver, was regularly used after 1850 and sometimes before: it was a thin, pliable, ornate frame of gilded brass or pinchbeck, a metal made to imitate gold, its corners being bent round to the back of the plate. Daguerreotypes and ambrotypes are often found separated from their cases but still in their preservers.[32]

Dating the case does not necessarily date the picture as many daguerreotypes and ambrotypes, handed down over several generations, may have been removed from their original cases and placed in different ones.

Tiny photographs were not infrequently mounted in Victorian brooches, lockets, pendants, rings, tie-pins and cuff-links, sometimes accompanied by a lock of hair and an inscription in memory of a departed loved one.[33]

Elaborate albums, often bound in red velvet or leather with brass clips, were introduced in the late 1850's. Many had ornate covers made of mother-of-pearl, plush, tooled leather, carved wood, or Japanese lacquer. Some had built-in clocks; others were musical boxes which played as the leaves were turned. The pages were constructed so that card photographs could be slipped into cut-out openings. Around the turn of the century, cheaper albums became available with blank pages on which to paste family photographs. Now all the dim, out-of-focus snaps could be squeezed in somewhere, making for greater quantity but far less quality. Later, more specialized albums might be devoted to a holiday or a baby's first year.

★　★　★

The identification of the photographic process or print paper may seem too technical a task for the amateur. However, although there are bound to be problems or errors, in many cases it is possible to make a definite identification. Use the charts in this chapter to make a series of decisions. Thus:

A positive—Chart 3—on paper—coated paper—coating thin to medium, glossy surface, yellow ALBUMEN PRINT 1850–c. 1900

It is certainly well worth a try.

APPENDICES
I POSITIVES ON MATERIALS OTHER THAN PAPER
Although positives were most commonly printed on paper, a wide variety of other materials was also employed.

GLASS was often used. The first photographic slides—albumen on glass—were made by the Langenheim Brothers of Philadelphia in 1849. From 1850, after Blanquart-Evrard's process became known, they were produced in vast numbers. They were not printed out but developed and fixed after a brief exposure. American and European slides usually measured 3½ × 4 inches, and British slides 3¼ inches square. They were sold in sets (travel sequences, storybook illustrations, etc.), many hand-tinted, and were popular up to the 1950's.

Albumen continued to be widely used for commercial slides up to the First World War. Collodion was used also, from the 1850's; collodio-chloride emulsion (see above, page 94) from 1864; and gelatine-silver halide (usually gelatine-silver chloride) from the 1860's. Collodion transparencies may be distinguished from later gelatine ones by their creamy colour when viewed by reflected light. Some stereographs were produced as albumen, collodion and gelatine transparencies from 1852 onwards.

Between 1865 and 1900 **opal glass** was often used for large prints (usually 6½ × 8½ inches) to be framed and displayed in the home. In the early days, the opal was coated with collodio-chloride of silver and the image printed by contact with the negative plate. It was then protected with copal varnish, but could still easily be damaged by scratching. A more satisfactory method was to strip an ambrotype from its glass, coat it with flux and fire the opal in a furnace so that the collodion was destroyed and the silver nitrate image was burnt in. Later, carbon prints (see above, page 92) were used instead of collodions. However, most **opaltypes,** especially in the 1890's and early 1900's, were printed on opal glass plates coated with bromide emulsion.

PORCELAIN was also used as a base. Between about 1854 and 1886, ambrotypes were stripped off their glass and transferred to porcelain plates, dishes and vases by a process similar to the 'firing' method for making opal glass prints (see above). From 1867 carbon transfer prints (see above, page 92) were used instead of ambrotypes. Photographic prints on porcelain should not be confused with photo-mechanical reproductions of photographs transferred to plates, dishes, mugs, etc., from the Edwardian era onwards—recognized by the dot or line structure of the image.

ENAMEL was used in the form of plaques decorated with carbon prints. Very popular from about 1880 to 1914, they were made up into brooches, lockets and pocket watches.

IMITATIONS OF IVORY, coated with albumen or collodion, were used for **ivorytypes** (1855–*c.* 1910) or **eburneums** (1865–*c.* 1910).

LEATHER was suggested as a photographic base by C. R. Berry, a Liverpool photographer, in 1854 (its main advantage was that photographs could be sent through the post without fear of damage or breakage). Between about 1858 and 1880, ambrotypes of views and buildings were transferred to the covers of books, photograph albums and blotters.

WOOD and **STONE** were similarly used with ambrotypes.

From the late 1860's the carbon transfer process (see above, page 92) was used on leather, wood and stone; and from 1884 the **transferotype** process. A transferotype—an Eastman trade name—was a gelatine/silver bromide stripping emulsion capable of being transferred to any surface.[34]

FABRIC has a long history as a printing base, ante-dating photography. Photographic prints on cloth were made as early as 1850. Based on the process Fox Talbot used to produce his photogenic drawings (see above, page 75), the simpler methods involved filling the texture of the surface with a size containing salt, sensitizing with silver nitrate solution, and contact printing. Another method was to dye the cloth and use a 'diazo' printing process. From 1880 onwards the Platinotype Company sold fabrics (silk, sateen, linen, muslin) ready-sensitized for platinum printing.

II BOOK ILLUSTRATION AND PUBLISHED PRINTS

Photographs were relatively rarely used for book illustration before 1856, partly because of the labour involved and partly because all silver-salt printing processes (salted paper prints, albumen prints) were liable to fading. In 1844–46, Talbot had used salted paper prints as illustrations in his book *Pencil of Nature,* each picture being individually pasted into each copy. Other publications followed from his printing establishment at Reading. Similarly, from 1851 onwards Blanquart-Evrard, inventor of albumen paper, produced a large number of books with photographic illustrations at his printing works in Lille; to save time, he used short exposures followed by developing, rather than printing out by long exposures (see above, page 89). Much more commonly, however, photographs were laboriously copied on to a wood block which was then cut away and used as the mould for a metal block.

In 1856 Paul Pretsch developed the **photo-galvanographic process** which remained in use into the 1860's. This process caused collodion to accept water in varying degrees according to the image depth; the plate was then used as a mould to produce a copper printing plate. Fenton, the Crimean War photographer, took many photographs for printing

by this process. Its main disadvantage was that the copper plate deteriorated rapidly, so the number of good copies was very limited.

Photogelatine methods, which included the collotype, Albertype, heliotype and artotype, used an inked gelatine printing surface secured on glass or metal. The printing surface was ink receptive in some parts and ink repellent in others. Coloured inks were used. These methods produced prints in delicate halftones. Impressions were limited to between 1,500 and 2,000 before deterioration of the printing surface.

Photogravure was introduced in Vienna in 1879, the copper printing plate being engraved by photographic sensitizing means. The use of transparent inks of soft colour instead of the harsher black or burnt umbre inks of ordinary engravings made it possible to produce much softer and more glowing prints.

The invention of the carbon process in 1864 (see above, page 92) not only led to the widespread use of carbon prints as illustrations but also paved the way for the **Woodburytype** (1865–1890's), a variation developed by Walter Bentley Woodbury, which facilitated the making of large numbers of copies and hence was particularly suitable for book illustration.[35] However, prints still had to be trimmed and mounted by hand. The process was also used for printing large quantities of cartes de visite.

By the 1890's the Woodburytype was obsolete, displaced by the **halftone plate** which was invented in the 1880's. This represents an image by varying sizes of minute dots, and enables photographs to be printed in the same press as text type.

Colour pictures are reproduced by printing a number of separate printing plates, inked in different colours and all printed in exact register. **Colour printing** was sparingly used before the Second World War, but since 1945 colour magazines have multiplied; because of the expense, it is still far less frequent in book illustration where print runs rarely match those of popular magazines.

III SOME MOUNT SIZES

Carte de visite	4¼ × 2½ inches	introduced c. 1859
Cabinet	4½ × 6½ inches	introduced in 1866
Victoria	3¼ × 5 inches	introduced in 1870
Promenade	4 × 7 inches	introduced in 1875
Boudoir	5¼ × 8½ inches	date unknown
Imperial	6⅞ × 9⅞ inches	date unknown
Panel	8¼ × 4 inches	date unknown
Mounted stereo prints	3 × 7 inches (approx.)	introduced in 1850's (rounded corners)

NOTES AND REFERENCES

1. These introductory suggestions are taken from the Royal Photographic Society Historical Group pamphlet *Recognition of Photographic Processes* by Arthur T. Gill. The author is grateful to Mr Gill for permission to include material from this pamphlet, and in particular to use the charts.

 He further expresses his gratitude to Mr Gill, and to Mr Brian Coe of the Kodak Museum, for their generous assistance with numerous problems and queries throughout this chapter.

2. A list of the principal calotype practitioners, and London members of the Calotype Club, will be found in William Welling's *Collector's Guide to Nineteenth-Century Photographs* (Macmillan, New York, 1976, p. 117). An important exception to the generalization that the calotype was not extensively used for portraiture was the series of portraits produced by the Scots, David Octavius Hill and Robert Adamson, between 1843 and 1847.

3. Gill, Arthur T., *Photographic Processes, a Glossary and a Chart for Recognition*, Museums Association Information Sheet, IS No. 21, 1978, p. 9.

4. The author is grateful to Mr Gill for assistance with this description.

5. Gill, op. cit., p. 9.

6. Adapted from the Notes to Arthur T. Gill's Negative Chart in the pamphlets cited in Notes 1 and 3.

7. Welling, op. cit., pp. 122–3, lists American, British, Canadian, German, French, Swiss and Italian stereographers.

8. Sets of *three* glass or celluloid negatives, either on three different square plates, or on one plate, are not stereographs but colour separation negatives (see above, page 101).

9. Sometimes called a gelatino-bromide emulsion. Cadmium bromide and silver nitrate were mixed in a warm solution of gelatine to form an emulsion of silver bromide in the gelatine.

10. It consisted of a paper base coated with a soluble gelatine layer, collodion, and then a sensitized gelatine emulsion. When treated with hot water the gelatine layer melted and the image layer could be transferred to a glass sheet and then back to gelatine. Some stripping film negatives transferred to insoluble gelatine sheets do survive, but are rare.

11. Gill, op. cit., p. 3.

12. In the conventional negative-positive system, silver halide grains are suspended in gelatine. Those grains which are exposed to light are converted to silver by the action of the developer. Those not exposed to light are dissolved in hypo and washed away. With Land's diffusion process the *unexposed* silver salts dissolved by the hypo are not washed away but transferred to a receiving sheet and there converted to silver by the developer. The negative and positive are simultaneously processed inside the camera by spreading the processing agents in jelly form between the negative and positive sheets when they are pulled through a pair of rollers.

13. Welling, op. cit., pp. 117–21, includes lists of American and British daguerreotypists.

14. Strictly speaking, the term 'ambrotype' should be confined to specimens in which the glass plate is sealed to the cover glass with balsam of fir, as patented by James Ambrose Cutting in America in 1854; but the term is now used so generally that the wider meaning can be deemed established.

15. *The American Journal of Photography* noted the revival in 1888 (Welling, op. cit., p. 77).

16. Welling, op. cit., p. 71.

17. Ibid., p. 54.

18. Howarth-Loomes, B. E. C., *Victorian Photography, a Collector's Guide*, Ward Lock, London, 1974, p. 75.

19. A useful chart for dating stereographs

appears in Welling, op. cit., p. 53.

20. 'Silver print' is the term given to any print—salted paper, albumen, gelatine—which has been created by the action of light on certain silver compounds. Carbon prints, platinum prints, palladiotypes and cyanotypes are different in kind from any variety of silver print.

21. It depended on the discovery that bichromated gelatine (i.e. gelatine treated with potassium bichromate), brought into contact with finely divided silver, hardened without exposure.

22. All the early processes 'printed out'. However, the term 'Printing Out Paper', coined by the Britannia Works Company (later Ilford Ltd), and abbreviated to POP, was not used until 1890 and initially only for gelatino–chloride paper. Later, however, it came to be used for both the papers then current which required exposure in sunlight, i.e. for collodio–chloride paper as well as gelatino–chloride paper. Though the latter had been invented in 1864, the term POP is not normally used even retrospectively for papers before the 1880's. The question is largely academic since the early versions of collodio–chloride paper were very little used and are unlikely to turn up in family albums.

23. Coe, Brian, *Colour Photography*, Ash & Grant, London, 1978, p. 17.

24. Ibid.

25. Ibid., p. 14.

26. Also a yellow filter to correct the excessive blue sensitivity of the emulsion.

27. From 1916 in America and 1928 in England tripacks were available which could be exposed in any plate camera. These consisted of three layers of film on the one base, the first sensitive to blue light, the second to green and the third to red. The three negatives were separated for development and printing. Although some tripack films yielded satisfactory prints, others gave colours bearing little resemblance to those of the subject. In 1931 90% of colour prints were still made by the ozobrome process (see above, Note 21).

28. The red and green layers were, in fact, also sensitive to blue but this was overcome by putting a yellow filter below the top coating and above the other two.

29. See above, Note 23.

30. Motifs popular during the American Civil War were the eagle, the flag, and religious crosses (Welling, op. cit., p. 19).

31. The plastic consisted of shellac, black or brown colouring and excelsior, ground wood or sawdust (Welling, op. cit., p. 23).

32. Ibid., p. 25. For examples of styles of matt, see also Welling, op. cit.

33. Ibid., p. 85.

34. A stripping paper was used which was a specially prepared bromide paper with a coating of soluble gelatine between the paper base and the emulsion. The print was made in the usual way and placed on any smooth surface. When it was washed with warm water, the gelatine melted and the paper could be peeled off, leaving the image on the support (Gill, op. cit., p. 9).

35. A carbon print was placed under pressure in contact with a sheet of lead which took the contours of the print. The lead mould was used to cast pigmented gelatine films which were mounted on paper or glass.

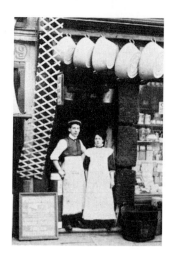

7

Illustrating Your Family History

The Photograph
as a Social Document

LAWRENCE TAYLOR

Since the revolution in technology that produced the camera as we know it in the late 19th century, countless millions of photographs of individuals, groups, places and events have been carefully staged or taken by chance. The result of this iconographic and topographical flood can be found elaborately framed, hanging on walls or displayed on cabinets and mantelpieces, carefully arranged in albums, carried lovingly in jacket pockets and handbags, or incarcerated in cupboards, drawers and attics. Evidence for the prodigality of our ancestors in preserving their likenesses can also be found in the unwanted collections of anonymous and long-deceased ancestors offered for sale amongst the bric-à-brac of second-hand shops and market stalls.[1]

While the science, technology and aesthetics of the photograph are fascinating, as a family historian you are bound to be more concerned with its social impact. And 'revolution' is not too strong a word to describe a process which enabled those far too impoverished to have their portrait painted, to afford a direct 'copy of nature'; a photograph could be sent to mothers and fathers, friends and sweethearts, thousands of miles apart—after all, this was the time of the great migrations from the Old World of Europe to the New. Men, women and children were dispersed around the globe as they sought to escape from poverty and oppression to a new life, above all in America, Canada, Australia and New Zealand.

Here, for example, is an extract from a letter written in 1863 by a widowed mother in Cornwall to her son in Wisconsin. It displays all the anguish of separation made just a little more bearable by the exchange of 'likenesses':

Mary Ann too has no husband at home as Joseph is gone to New Zealand where he has got a capital situation, he has taken their eldest boy with him, so it seems very lonely up there now. You may in fact hear from Mary Ann soon and her little Maria is going to send Sarah Jane her likeness which I daresay she will be glad to get. I intend to have my likeness taken in a week or two and will send it to you in Mary Ann's letter. I will also send one to John if you will write to him and find out whether he is still in the same place as he was it will not be too much for you to write to him from where you are but I cannot afford the risk of a shilling on uncertainties. I have felt it very much that he has never written to me since dear father's death. I hope he has not forgotten me. I assure you that you are all as dear to me now as you ever were and I am always anxious to know how you are getting on.[2]

Just as the photograph accompanying a letter became a more tangible means of keeping in touch with friends and relatives, so it was to become a universally important way of recording group solidarity as expressed in kinship rituals. Thus a very large category of surviving photographs catch in their time-trap family reunions on such formal occasions as weddings, christenings and funerals. It is even possible to find rather macabre photographs of the dead in a family collection and some 19th-century photographers include a reference to 'portraits after death' in their publicity material.[3] Some of these 'posthumous portraits' have survived; others were destroyed perhaps by later generations for whom this aspect of the 'funerary art' became less acceptable.

Photographs also served an important function for members of the rising bourgeoisie, acting as 'vicarious tokens of a world of potential possessions'[4] and making a powerful public affirmation of class and status within the community. Thus a factory owner might be photographed at his works with his co-directors, workmen and clerks grouped deferentially around him; or at home, with the family artistically spaced around him on terrace or lawn, and servants discreetly hovering in the background.

However, the photograph was destined to serve much wider social purposes than those just described. To use a phrase later employed by the newsreels, photographs opened a 'window on the world'. The earliest example of this was the mass-produced portraiture of the 1860's made popular by the cartes de visite or 'portraite cartes' which brought photography into family albums and led to a Victorian collecting craze, cartomania (see above, page 36).[5]

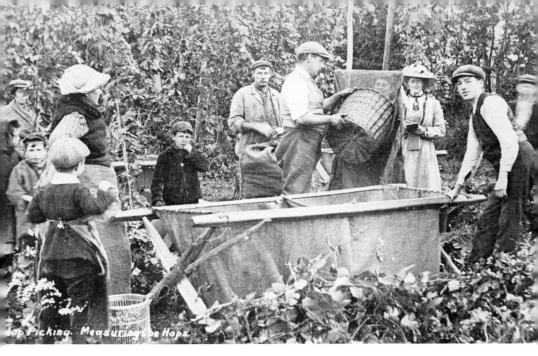

A working-class 'holiday' in the Kentish hopfields, c. 1906—produced as a postcard

The cartes also included views and architectural subjects, although by the turn of the century this aspect had been taken over by a more popular manifestation—the postcard.[6] The postcard gave even the poor, who were unlikely to travel further from their East-End London slums than to nearby seaside resorts like Margate or the hop fields of Kent, a chance to send friends a record of their visit. It also enabled families whose relatives had emigrated, or whose sons were serving in 'foreign parts' with the Army or Navy, to glimpse some of the exotic places of the world. Thus the photograph had the power 'to colonize new experiences and capture subjects across a range never envisaged in painting'.[7]

For the man in the street the real breakthrough came with the Brownie camera in 1900—'a simple box camera' costing five shillings (25p), and taking pictures 2¼ inches square on roll film.[8] The introduction of this cheap 'Do-It-Yourself' camera established the basis of modern photography. More significantly, from the point of view of the family and social historian, it enabled people throughout the world to afford the equipment necessary to make permanent and unbiased 'action' shots of ordinary families in all their varied activities. This new economic

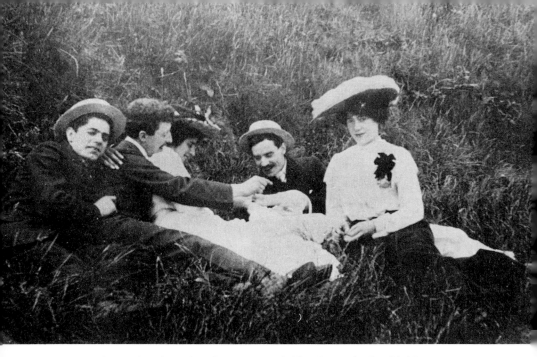

An informal shot of an Edwardian picnic, probably taken with a hand-held camera

possibility also led to a sudden increase in the sales of film and cameras during the First World War which, because of long and enforced family separations, stimulated the trade still further.[9] Unfortunately, as with the earlier studio portraits, most families did not seem too concerned about the difficulties their descendants might have in identifying Great-Grandmamma or a second cousin twice removed: thus the anonymous 'snapshot', more often than not, poses a considerable challenge to the ingenuity of the modern researcher. 'On the other hand it did lead to pictures showing ordinary men and women, not in their Sunday best in the portraitist's studio, but in their street or working clothes, relaxing on the beach or about their business. Through them we have a detailed picture of everyday life of a kind never previously available.'[10]

FAMILY SOURCES

For the Victorian and Edwardian period the bulk of photographs consist mainly of 'portraits' of members of the family. Where 'group portraits' survive they tend to be celebratory, depicting weddings, baptisms and anniversaries, as well as the occasional holiday picture where the family was a wealthy one.

Almost all the pictures are the work of professionals and many of the backgrounds indicate that they were posed in the formal setting of a studio. Some of the photographs are the reverse of the natural and reflect the photographer's belief in what a photograph should convey, rather than the subject's own view of him or herself. Thus the image of our ancestors bequeathed to posterity is often an extremely formal one; the subjects seem to maintain either an expressionless, neutral pose, or one which, to our eyes, appears unnaturally stiff and tight-lipped. No doubt the austere grandeur of many such photographs helped to establish the myth of the strict and strait-laced Victorians.[11]

In contrast to these more stylized products, from which it might be dangerous to make inferences about character without corroborative evidence, are the rather more 'relaxed' pictures taken by wealthy amateurs whose hobby was photography. For middle- and upper-class families there are thousands of pictures which, as the 19th century progresses, increasingly celebrate festive occasions such as fêtes and garden parties, and leisure pursuits like croquet and tennis.[12]

Also of great interest to family historians are photographs of Victorian and Edwardian interiors, every corner crammed with bric-à-brac. Unfortunately, these do not survive in any quantity, although this is perhaps hardly surprising given the difficulties over lighting and exposure. Furthermore, it was not until the advent of the documentary camera in the 1870's that any but the more prosperous homes were recorded in this way.[13]

PLACES CONNECTED WITH THE FAMILY
It is possible to detect a clear class bias in the number and variety of photographs which connect places to families. Not unnaturally, if you were the proud owner of a mansion with extensive lawns, gardens and encompassing parkland, you wanted to record the fact; just as in the previous era landowners had prospects of their estates painted, which were placed alongside the portraits of their forebears and paintings of their champion horses, cattle and sheep. (On some estates, animals, particularly race-horses and hunters, lived in rather more comfortable and hygienic surroundings than those who tended them!) Similarly, members of the bourgeoisie would keep a record of their summer holidays on the coast at places like Paignton and Newquay—opened up by westward extensions of the railway

A view from the sea of a Victorian resort, obviously popular: note the hotel names—Albemarle, Pier—the electric railway and the bathing-machines. The angle of the shot suggests that it may well have been taken from the pier.

system. Such photographs had earlier parallels in the late 18th and early 19th centuries, when the very wealthy, accompanied by their artist friends, described in painting, poetry, letters and diaries their travels amid the romantic scenery of the Lake District and Scotland, or abroad on the Continent.[14] By the 1850's and 60's the photograph was to become to the rising industrial, commercial and professional classes what portraiture and land-scape painting had been to the aristocracy, gentry and haute-bourgeoisie of the immediate past.

Amongst the lower middle classes, and more particularly the rural and urban poor there was less reason to adorn the living-room walls with pictures celebrating where they lived. The back streets of a crowded London borough like Lambeth or Hoxton had little to recommend them aesthetically or environmentally, and as the majority of workers rented their homes there was little sense of property.[15] Indeed, this probably did not develop until the early 20th century when home ownership began to spread amongst the expanding lower-middle-class groups like junior civil servants, teachers, local government officials and other petty functionaries. Nor did the mass of the population have the disposable income to enjoy holidays in the sense that we use the

word today. However, with the coming of the railways there was a rapid growth of popular holiday resorts like Brighton and Southend which served London and the South East; Blackpool was thronged with families from the Lancashire cotton towns, and Skegness was a magnet for Yorkshire and the North East. So hundreds of thousands or urban dwellers were now able to escape from village, town and city either for day trips or short holidays, to visit one of these holiday meccas, to paddle in the sea, and to enjoy a few hours of fresh sea air and sunshine. Not unnaturally, besides consuming beer and fish and chips, and walking along the sands, holiday-makers celebrated the occasion by having their photographs taken on the pier and purchasing postcards as mementoes to send to their friends. The postcards in particular are extremely valuable. Besides the postmarks they often carry messages on the reverse which enable you to identify both the recipient and the sender. Not only can they pinpoint where the individual was staying and with whom, but the destination of the card may well indicate a place of residence. They can also provide you as a family historian with valuable insights into the social history of your subject. Most resorts are well-described and books like *The English Seaside Holiday* provide interesting accounts of holidays of the time.[16]

INSTITUTIONS CONNECTED WITH THE FAMILY
The range of photographs falling within this category is potentially very large indeed, and there are certain kinds that recur time and again.

THE CHURCHES The institutions of Church and Chapel continued to play a highly significant role in the lives of people of all social strata during the early era of the photograph, whether performing the services of baptism, marriage or burial, or providing spiritual support and elementary education—although in this latter respect the Anglican and Nonconformist churches were in open competition with one another. The churches also organized fund-raising for charities and thus became the natural focus for a wide range of social events ranging from fêtes to jumble sales, bazaars, bun-fights, lantern-lectures, and the ever-popular Sunday-school outing.

The photographic evidence may still be found in family collections, amongst church records or in the possession of older

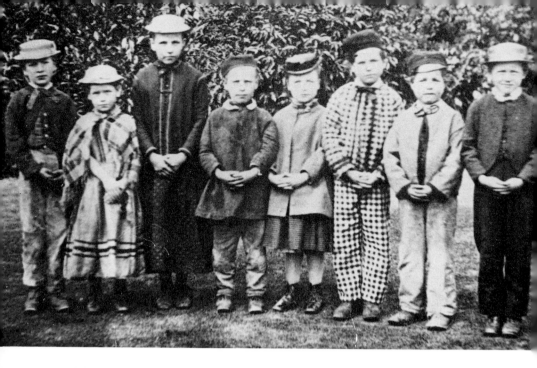

The second class at Sulham Village School, Berkshire, in 1870, was photographed by the Rev. John Wilder, the local squire. Left to right: George Brooker, aged nine; Mary Wigmore, six; Mary Parsons, ten; John Brooker, eight; Ann Lamden, six; Henry Wigmore, nine; Charles Wickers, eight; James Read, ten. Henry Taylor was absent! The album containing captioned photographs of the school from 1863 to 1919 survived only because an inquisitive local historian rescued it from the dustbin when the school was closed down. Not only have the children been identified, but their family histories have been traced in the parish registers, the national census records, and the graveyard next door to the school.

members of a congregation. Entries in late-19th-century church magazines recording an outing may well be paralleled by privately owned photographs showing people setting off in horse-drawn wagons; later ones reflect the revolution in transport associated with the advent of the charabanc and motor car.

SCHOOL Until the passage of the 1870 Education Act the experience of school for the majority of working people had been brief, brutal and seldom educational. After 1870 schools as a major social institution rapidly became the target of photographers. The first photographs of groups of grubby-looking back-street urchins may well have been taken at school. From the 1870's there are numerous surviving photographs of whole schools or of individual classes; by the end of the century there is also a surprising number of pictures of classrooms and school interiors.[17]

SPORT AND RECREATION 'Huntin', shootin' and fishin'' are well documented from the 18th century onwards, not the least because they were the exclusive preserve of a landed élite and protected by 'game laws' which inflicted severe punishment on those who infringed them.[18] The upper classes also perpetuated sporting privilege through the public schools. These provided not only a classical education which carried boys on to the universities, Inns of Court, Parliament, the Army and Navy and careers in the diplomatic and colonial service, but also a physical education which taught them to 'play up, play up and play the game'.

By the time photographers had arrived on the scene, the sporting life was raised almost to the level of a religion for scions of the upper classes, as is portrayed in the countless photographs from the 1860's onwards of oarsmen and cricketers, and football and rugby teams. In school 'house' matches and inter-school games, sport was apotheosized. It was no longer a question of winning and losing with manly grace, but of 'playing the game of life'.

If shooting on a Scottish grouse moor (from which the tenants were sometimes evicted to make way for the birds) or yachting at Cowes were beyond most purses, the working classes were no less enthusiastic about sport.[19] As witnessed by the camera, most towns and villages up and down the country had cricket and football teams, and by the 1880's association football was drawing huge and, at times, rather unruly crowds.

The picture on page 120 showing a village football team in Northumbria is part of a collection relating to the history of North-East England collected by Professor Norman McCord at the University of Newcastle upon Tyne.[20] His commentary on the photograph indicates how valuable evidence about a picture can often be collected through oral evidence and material sifted from contemporary club accounts and the newspapers; and shows very vividly how a collaborative effort to expose the history of an area can throw up a number of names and associations which previously might have been thoroughly mystifying. Thus:

It shows a colliery village's football team. The team is the Barrington Village team of 1906–7, winners that season of the local Wansbeck Valley League championship. At top right, wearing cloth caps, are Jack

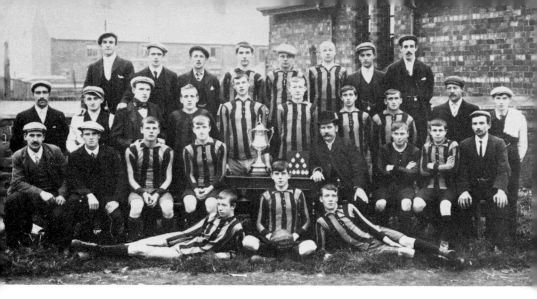

The Barrington Village championship team, 1906–7: the identification of some of the players (see below) is a good example of how local and family historians can benefit one another.

McNally and Henry Dunsmore, two of the top hewers in that colliery; they were not heavy drinkers, but crack hewers, keen gardeners and football mad. Immediately to the left is Jack 'Wire' Rutherford, who left the pit to become a professional footballer for a London club shortly afterwards. His two brothers, Jimmy and Tommy, are in front of him and slightly to the right. They appear from oral memory in that area to have been something of a harum-scarum trio. The man with the bowler hat seated to right of the trophies is Edward Carr, under-manager of Barrington Colliery for about forty years till he retired in 1923.[21]

The recreational activities and hobbies of our ancestors are well worth investigating and if followed up are likely to convey a great deal about the kind of social milieu in which they moved. It might not always be flattering to find that your ancestor was a drunken roisterer frequently in trouble with the police. On the other hand it might indicate a good deal about contemporary social conditions and the structure of the community.

FESTIVALS Some of the events connected with the family are survivals of ancient customs like May Day, Christmas Day, or the celebrations of the Harvest. May the first, a traditional holiday, has been captured by both amateur and professional photographers with pictures of children dancing around garland-strewn maypoles. A more recent aspect of May Day has been

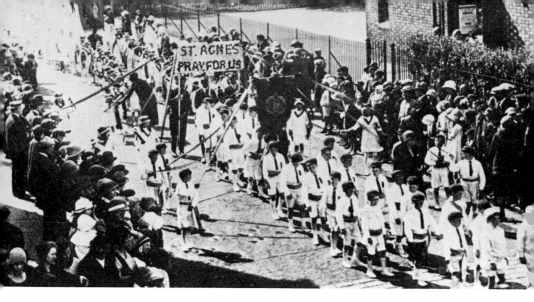

St Anthony's Whit Walk, Trafford Park, Manchester, c. 1922: the owner's widowed mother, a dressmaker, worked till one in the morning in Whit Week, making children's outfits.

the adoption of the essentially rural festival by urban workers to express their political solidarity, with trade unionists and members of the Labour movement, banners held high, marching to their rally ground.

Other festivals, such as Empire Day (24 May), are purely secular and recent in origin. Started in 1902 to celebrate the expansion of the British Empire, it became a rigidly observed occasion, particularly in the schools, where, amidst fluttering flags and bunting, the pupils, dressed up to represent the different races of a far-flung empire, paraded in pageants and tableaux. The headmaster of many a grimy back-street school would then make a loyal address, reminding the pupils of their duty to 'King and Country'. Then, to mark the event, and to the great joy of the pupils, a half-day holiday would be declared. But not before a photograph had been taken!

OCCUPATIONS Some of the most evocative and rewarding photographs are those which connect an ancestor or group to an occupation. At the upper end of the social scale it might be a rather starchy picture of a group of bankers in their boardroom, or of a figure such as Isambard Kingdom Brunel, the brilliant Victorian engineer, standing by one of his amazing creations like the steamship *Great Eastern,* cigar in mouth, looking slightly

raffish, but every inch the inventor-entrepreneur. At the opposite end of the scale it might be a photograph of a gang of navvies at work digging a canal, or building a railway. Photographs of people at work are quite rare and their value to you as a family historian does not depend on finding an ancestor in the picture.

By the early 1850's the British economy was booming and the country was preoccupied with increasing production and maximizing exports.[22] This interest undoubtedly encouraged manufacturers, businessmen and landowners to start recording their workpeople and workplaces.

THE ARMED SERVICES For those who could not find work in the town and countryside there was always the Army and Navy. To police its empire, Britain had to keep large numbers of men stationed all over the world—particularly in India; to guard its seaways, large fleets had to be constantly afloat.[23] Many families have photographs of their nearest and dearest in uniform, often taken in military cantonments in India, or against the ever-popular backdrop of the Pyramids in Egypt. There were bush wars like that against the Zulus in 1879, and the Somalis in 1899; and major conflicts such as the wars in the Crimea (1854–6) or against the Boers (1899–1902); leading up to the two World Wars with their legacy of countless poignant pictures of embarkation trains and troopships, as well as innumerable battle scenes.[24]

POLITICS Unless you are a Kennedy or a Churchill, politics is not always an obvious facet of a family history. Yet many families have political connections, either through party organizations or trade unions; and though family photographs of direct political activity are fairly rare, in a more generalized way there are associated events—for instance, the General Strike of 1926. For some families this meant an active participation because its members were on strike; others may have been involved as policemen or special constables, as employers, as trade union officials, or even as student strike-breakers. Even those who did not participate directly in the strike may have memories and anecdotes to contribute which are significant enough to find a place in the general account of your family. Thus General Strike pictures relating to the area in which your family lived may be relevant to the background history. Such photographs can evoke atmosphere and the throb of living history very powerfully.[25]

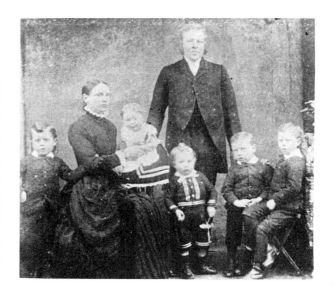

A studio portrait of a well-to-do Victorian paterfamilias with fashionably dressed wife and closely spaced family. The children's clothes are clearly depicted — the older boys in suits with calf-length trousers, stockings and boots, hair carefully brushed for the occasion. Is the baby a boy or a girl? The arrangement of the group is typical of the mid Victorian period, and the father's central position conveys a very strong sense of male dominance.

CONTEXT AND INTERPRETATION

Very often you will have to struggle towards identification and verification of your photographs using all the techniques described in the previous section. At the same time you will need to try to interpret them. What does each picture tell you about the people shown in it and the society in which they lived? As John Tagg has written in another context about the photographs of two American couples, the first a prosperous middle-class couple from Union Point, Georgia (1941), the second recipients of Government aid at home in Hidalgo County, Texas (1939), 'the photographs are dense with connotation as every detail—of flesh, clothes, postures, fabrics, furniture and decoration—is brought fully lit to the surface and presented'.[26] Looking at the photographs, one is impressed by their naturalism, while almost simultaneously they evoke in a very powerful way a universal sense of family and home at a particular moment of time. But they also contrast people of very different social class. As John Tagg, in discussing the ideological meanings of the photographs, points out, they carry a major connotation of class difference. Much can in fact be read back from this kind of evidence. It can provide us with clues as to socio-economic status, particularly with respect to the degree of security or levels of privation experienced by the subjects. In addition, it may also imply something about cultural levels, value systems and expectations, or the lack of them.

Thus, using photographic evidence, it is possible to begin to

reconstruct life-styles and attitudes—and in this task it is perfectly valid to utilize literary and other types of historical evidence which tell us about comparable groups at other times and places. However, photographs can be manipulated—they enable individuals or groups to portray themselves in ways which are consistent with their self-images. Similarly, official photographs—like those of the Farm Security Administration in the United States in the 1930's—present the image that officialdom wanted to use for its own political ends.

A more speculative field of enquiry and interpretation is the extent to which the relative positions of people in group photographs and the distances between them can tell us about the psychological relationship of the family or group portrayed. Is the Victorian paterfamilias given pride of place, with his wife in a less prominent position? Are the boys considered demonstrably more important than the girls? Can degrees of affection between individuals be judged by whether they hold hands or touch in some way? Such questions have excited the interest of several American writers on family history,[27] but there are difficulties in using photographs as evidence of family structure and individual status; in most cases the group was probably posed by the photographer and, until the 1880's at any rate, long exposures meant that the arrangement and spacing of the group were more probably determined by the need to conceal supports and clamps or by the use of visible studio props, such as a balustrade or an arbour on which to lean. The number of times an individual is featured in a family album or the prominence given to particular photographs must not be taken as indicating relationships and feelings, unless we know that the present order of pictures in the album was the original one and that duplicates of well-loved relatives have not been removed to make way for new members of the family. Such analyses are obviously still in their infancy as far as family history is concerned, and unless other independent evidence—autobiographies, letters or diaries—supports them, deductions drawn from surviving photographs must rest on very shaky ground.

★　★　★

As family historians we must learn ways of exploiting to the full the historical and genealogical potential of the pictorial record which can provide a unique view of people, places and things in

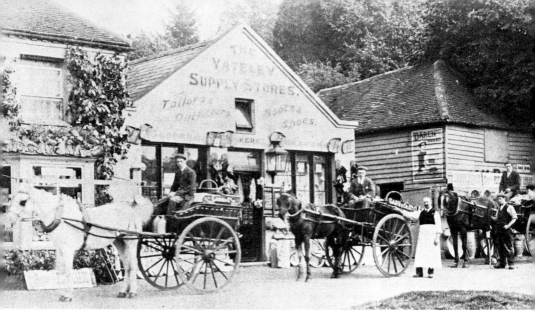

Yateley Village Stores at the turn of the century, with delivery vehicles and owner (centre)

the past. Even where photographs are blurred or damaged, they can still yield a glimpse of an individual, a group or an event, of which we would otherwise have no visual impression. Thus the picture of the Village Stores at Yateley, Surrey, shown above, is hardly a work of art, but for anyone interested in the area it reveals an everyday world in sharp contrast to the one with which we are familiar. The horses, the carts, the store-front, the oil lamp over the door, the signs and advertisements, the tin baths for sale outside, the dress of the proprietor and his drivers, the roadway, all are redolent of a 'yesterday' that can never be adequately captured in words alone. Besides which, there is always the exciting possibility that new or corroborative information about persons, places or dates can be won from the material. However, to do this you may need to acquire new skills with which to 'decode' or 'read' the evidence. An example of one such interpretative skill is given by John Gorman:

Asking Rosemary Allen, the Keeper at Beamish [see below, p. 135], how she would date a particular photograph of a lead miner seated at the hearth in his cottage, she was quick to point out the art nouveau finger-plate on the cupboard door next to the kitchen range. That not only gave a good indication of the date but led me to question the assumptions we are all too ready to make on how people lived. The beautiful figured plate which would now make a ready sale at Sotheby's

is surely not readily associated with door furniture for a miner's cottage in Northumberland.[28]

Few of us will acquire as intimate a knowledge of the various elements of the material culture as is communicated to the museum specialist by such a picture. None the less, once we have begun to understand the variety of methodologies photographic analysis demands, we can seek specialist advice, or go to the appropriate reference works. Many pictures hide far more than they profess to show and to get at the objective reality of what we can see in front of us we may have to penetrate the richness and sheer variety of the photographic record over the past one and a half centuries; we cannot afford to neglect what the photograph can often unwittingly betray about the characters, relationships and life-styles of our ancestors.

NOTES AND REFERENCES

1. For a fascinating piece of family history reconstruction, based on several hundred old photographic negatives purchased at a market junk stall, see Colin Gordon's *A Richer Dust* (Elm Tree Books, London, 1978).
2. Mary Ann Honeycombe of St Cleer, Cornwall, 26 April 1863, to her son Charles in Shullsburg, Wisconsin.
3. Braive, M. F., *The Era of the Photograph*, Thames & Hudson, London, 1966, pp. 61, 82.
4. Tagg, John, 'The Currency of the Photograph', *Screen Education*, No. 28, Autumn 1978, p. 53.
5. Braive, op. cit., pp. 93–4.
6. Harker, M. F., *Victorian and Edwardian Photographs*, Charles Letts, London, 1975, p. 22.
7. Coe, B., *The Birth of Photography*, Ash & Grant, London, 1976, pp. 80–81.
8. Tagg, loc. cit.
9. Coe, op. cit., p. 58.
10. Coe, op. cit., p. 124.
11. For a discussion of the 'naturalism' versus 'realism' argument, see Braive, op. cit., p. 104.
12. See Gordon, op. cit.
13. Britain's most famous early documentarists were John Thomson, whose *Street Life in London* was published in 1877–8 (reissued by E. P. Publishing, Wakefield, Yorks, 1973), and Thomas Annan, whose *Photographs of Old Closes and Streets of Glasgow, 1866–77* was commissioned by the City of Glasgow Improvement Trust and showed condemned slums in the 1860's and 1870's (reissued by Dover, New York, and Constable, London, 1977). Beaumont Newhall's *The History of Photography* (see below, Book List, p. 187) has an interesting discussion of this genre (p. 139).
14. For an extraordinarily rich, early photographic record of the romantic poet Alfred Tennyson and his circle, as seen by friends and contemporaries, see Andrew Wheatcroft's *The Tennyson Album: A Biography in Original Photographs* (Routledge & Kegan Paul, London and Boston, 1980).
15. Nevertheless, a surprising number of 'mean' streets have survived in photographs and on postcards; check with local libraries and archives.

16. Hern, A., *The English Seaside Holiday,* Cresset Press, London, 1967.

17. In 1970 a number of local education committees in Britain commissioned histories of education in their areas to celebrate the centenary of the 1870 Act; see *Education in Bradford since 1870,* Bradford Corporation, Yorks, 1970 (numerous photographs); *A Century · of Education 1870–1970,* The North of England Open Air Museum, Beamish, Co. Durham; Maclure, Stuart, *One Hundred Years of London Education 1870–1970,* Allen Lane, London, 1970; Seaborne, Malcolm, *Education,* Studio Vista, London, 1966.

18. Thompson, E. P., *Whigs and Hunters: The Origins of the Black Act,* Allen Lane, London, 1975; and Bovill, E. W., *English Country Life, 1780–1830,* Oxford U.P. 1962, pp. 174–96.

19. For a very interesting discussion of the role of sport in all sections of society, see Geoffrey Best's *Mid-Victorian Britain, 1851–75* (Weidenfeld & Nicolson, London, 1981), pp. 149–227.

20. McCord, Norman, 'Photographs as Historical Evidence', *The Local Historian,* Vol. 13, No. 1, pp. 28–9.

21. Ibid., p. 30.

22. This period heralded the popularization of photography. By 1861 the number of commercial photographers had grown from 51 to over 2,000. See Bryan Brown's *The England of Henry Taunt: Victorian Photographer* (Routledge & Kegan Paul, London, 1973), p. ix.

23. The British Empire has been the subject of numerous photographic essays, e.g. Charles Allen's *Raj: A Scrapbook of British India, 1877–1947* (Deutsch, London, 1978), and the BBC TV/Time-Life Books series, *The British Empire,* in 98 parts (Time-Life Books, Amsterdam, 1972), a rich source of excellent photographs and prints.

24. The camera was quickly used as a 'faithful' witness of war, though considered 'dull' because it did not use the 'conventional fantasies of romantic battle painters': see Fenton's famous photographs in *Roger Fenton, Photographer of the Crimean War,* by Helmut and Alison Gernsheim (1954). Other fine-quality pictures of 'bleak landscapes and the combatants of both sides' were James Burke's photographs of the Afghan Wars, 1877–9, by which time 'the records of the war correspondent and artist were supplemented increasingly by the work of the photographer' (Coe, op. cit., p. 80).

25. For the inter-war period, see Julian Symons' *The Angry 30's* (Eyre Methuen, London, 1970) and *Britain between the Wars: Britain in Photographs* (Batsford, London, 1972).

26. Tagg, op. cit., pp. 60–61.

27. Eakle, Arlene, *Photographic Analysis,* Family History World, Salt Lake City, Utah, 1976; Challinor, Joan, 'Family Photographs', in Lichtman, A. J., *Your Family History,* Vintage Books, Random House, New York, 1978; Hill, May Davis, 'The Stories behind your Photographs', World Conference on Records, 12–15 August 1980, Vol. 2, Paper 111b, LDS Church, Salt Lake City, Utah, 1980.

28. Gorman, John, 'The Beamish Collection and Photographic Archive', *History Workshop,* No. 6, Autumn 1978, p. 203.

8
Illustrating Your Family History
Picture Researching

LAWRENCE TAYLOR

The family photographic archive, so painstakingly built up by visits to relatives and the pursuit of slender clues, is usually strong on portraiture; it can also help to establish a sequence of significant family events such as weddings, christenings, childhood activities, and leisure-time pursuits, particularly outings and holidays. It is generally very much weaker on documenting the everyday experiences of families, particularly the routine activities connected with work—an area in which oral recollections can supply such vivid evidence. So that all too frequently for, say, the Edwardian period—a time still remembered by many an alert octogenarian—we may have fascinating accounts of daily life and work, but without any accompanying visual material. Here, for example, is Alice Steel's account of her father Boaz Goodman, an Edwardian cab-driver:

Dad never came home until the small hours of the morning and was off again soon after 9 o'clock. He worked in all weathers, wet or fine, and as there was no shelter for him, he had to dress for the part. He usually wore a flannel vest, a material shirt, long pants, and at least two waistcoats in winter. Underneath he wore a thick layer of newspaper, cut like a breastplate, and coming well up over the shoulder, and a similar one at the back. This, he declared, made a great deal of difference to the warmth. Over his waistcoats he wore a woollen cardigan and over this his coat and overcoat. Sometimes when it was very cold he wore an extra jacket under his overcoat. A bowler hat, or hard hat as it was sometimes called, and woollen gloves completed the outfit. We used to laugh at him and tease him that he would not hurt himself even if he fell off the dicky.[1]

No photograph of Boaz to match this description is known, although, besides some conventional studio portraits, with him

looking suitably bourgeois, an informal 'backyard' picture has survived which is probably more true to life. However, a little picture researching unearthed not only a photograph of a cab-driver who, though not Boaz, is not dissimilar in appearance, but also some of cabs of all kinds, thus neatly complementing the oral description.

The main problem is deciding how far from strict authenticity a picture may depart before it is unacceptable. Here is Alice's account of a street-market in Edwardian London:

We had stalls all along the gutter in Wandsworth Road facing the shops. They were illuminated with flares attached to them and sold all kinds of merchandise, not forgetting the live eels which were in a small tank of water. No one bought dead eels—live ones were eightpence a pound—and it was surprising how clever the fishmonger was in catching them. I have seen one slither along the gutter with someone in pursuit, but this was unusual. They make very tasty eating with parsley sauce. We never bought a rabbit as people do now; they were there, propped up individually on the stall, in their skins, and just slit open down the front so that the buyer could examine what he was purchasing. We paid a great deal of attention to choosing which we thought was the best, and would look at several before parting with our tenpence or a shilling. The best ones, of course, were the Ostend ones, which were a little dearer, but larger and quite superior to the English ones. We realized twopence on the skin when we took it to the rag-and-bone shop which stood in Wilcox Road.[2]

Picture researching has so far failed to turn up any illustration of the Wandsworth Road street-market. The Minet Library at Lambeth, however, has a picture of the New Cut, another local street-market, which at first sight illustrates the account very

The New Cut street market—is it close enough in time to Alice Goodman's memories?

well—even the rabbits! Closer inspection, though, shows that costume may be dated a generation earlier than the period which Alice was describing. So this picture is not quite right as regards place, and a long way out as regards time. In default of anything better, will it suffice? Only you can decide, but the essential thing is that if you do use it, you must not misrepresent it. The status of the picture must be made clear in your caption.

MAJOR CONCENTRATIONS OF PHOTOGRAPHS

Apart from the photographs held by relatives and friends, the bulk of which are likely to be personal to a particular family or group, and which rarely pre-date 1870, there are many available sources of photographs, historic, modern, and contemporary.[3]

PRINTED SOURCES

Examples from the work of many early professional and amateur photographers, such as Julia Margaret Cameron and James Mudd, have appeared in print.[4] You can also obtain a sense of the sheer volume of this output from the recent crop of books devoted to reproducing historic topographical views as well as

photographs connected with particular themes, such as entertainment, the navy, railways, or crime and punishment.[5] Few of these, however, are as comprehensive in terms of chronological, thematic or geographical coverage as Reece Winstone's pioneering, multi-volumed *Bristol As It Was* series, covering the years 1850 to 1959.[6] In so monumental a collection as this, there is a good chance that you will eventually find what you are looking for; in general, however, such books have two principal uses. Firstly, they will provide a visual sense of what a village or town or area looked like in the past; secondly, the list of acknowledgments for the pictures will help you to trace the public or private collections from which they were gleaned.

Here it is worth mentioning one very important commercial photographic archive: the Francis Frith Collection of Victorian photographs. In 1854, aged thirty-four, after making his fortune in the grocery business, Frith began a second career as a photographer. After a perilous but highly successful expedition photographing scenes around the Nile, in 1860 he set out with his family, and a pony and trap to carry his equipment, to record photographically every village, town and city in Britain. By the time Frith died, in 1893, the firm had a collection of over 40,000 glass plate negatives, covering an enormous range of topics, from all over the country—not just bucolic scenes, such as 'The Smithy at Lyme Regis', but also impressive industrial subjects, like the Frodingham Iron and Steel Works at Scunthorpe. His sons continued to add to the collection which currently contains 66,000 views. It is now handled by the publishing firm of David & Charles, and on request their Mail Order Division (Brunel House, Newton Abbot, Devon TQ12 4PU) will send you a catalogue of 5,000 views from which to select.

Similarly, the Blandford Press Group handles 'Railprint', an archive of over 250,000 historic photographs, many rivalling Frith, which were originally taken for display in passenger carriages on the old Great Western Railway. The majority date between the 1870's and the 1940's. They include town and country views (mostly from Wales and the West), and pictures of docks, shipping and road transport. Write for details to Alan Brock, 302 Holdenhurst Road, Bournemouth, Dorset.

Bear in mind, too, that 'views' photography, popular in the mid-Victorian era though quite expensive—in the 1860's and 1870's, landscape photographs cost anything from sixpence

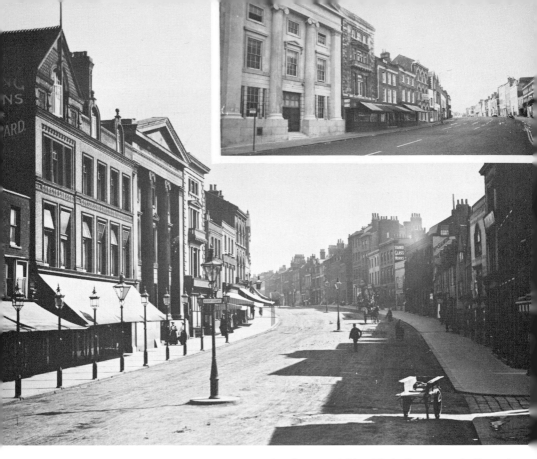

London Street, Reading, between 1897, when the Stained Glass Works first appears in directories, and 1901, when 'Wm Salmon, photographer' at No. 54 was replaced by 'Wm Bradshaw (late Wm Salmon)'; inset, today Salmon's top-storey window is still visible

(2½p) to three shillings and sixpence (17½p)—was to culminate in the postcard.[7] This required specialist photographers, numerous retail outlets, and fast, cheap reproduction. The format was developed on the Continent in the 1880's, but did not come into use in Britain until 1901 when it became possible to send postcards through the Royal Mail. This led to a very rapid expansion of firms like Frith's and Valentine's—another household word in postcards and greetings cards. When searching for topographical photographs, it is always worth finding out whether the local library or museum holds a postcard collection or can direct you to somebody who does.[8]

Local histories are an obvious source of topographical photographs, although some are poorly illustrated; you might also scan any published proceedings of local history societies or the files

of local or county magazines, which often include illustrated articles on a surprising variety of subjects. Old guidebooks may also contain quite a wide selection of pictures of main streets, public buildings, parks, rivers and canals, as well as local industrial and commercial sites—places which may well be mentioned in the memoirs or oral evidence supplied by your relatives, even if the street in which they themselves lived does not appear.

A related source is newspapers, discussed in more detail below (page 139). However, remember that these did not carry photographs until quite late, so that they will be most useful from the inter-war period onwards.

Once an ancestor's trade or vocation is known, it is well worth looking for specialist and popular monographs, many of which contain pictures of men, women and children at work, as well as showing conditions in the workplace. For example, anybody with an ancestor employed at Huntley & Palmer's famous biscuit factory in Reading would find only limited references to the firm in local histories, magazines and guidebooks. However, if you came across T. A. B. Corley's history of the firm[9] you would find a wealth of background information as well as a number of photographs. This would also lead you to the firm's archives, where it is not inconceivable that you might find a picture of Great-Great-Grandfather who spent his working life, boy and man, in the factory. A bibliography which will help to track down some, but not all, relevant academic publications is W. H. Chaloner's and R. C. Richardson's *British Economic and Social History: A Bibliographical Guide*.[10] This is organized by period from 1066 to 1970, and is divided into sections which cover major topics, such as agriculture, food and drink, engineering, coal, textiles, and many more.[11]

Lastly, if you do not know whether any topographical or local history books have been published for your area, never be afraid to enquire. As Howell Green shows in Chapter 9, 'It pays to ask around.' Contact the relevant library or museum, and remember to be specific when asking for information.

REPOSITORIES
COUNTY RECORD OFFICES[12] County archives receive systematic collections of records, so photographs found there tend to be those taken by a local photographer who at some time

The entrance of Huntley & Palmer's biscuit factory in Reading, in 1867; a photograph from the firm's archives

has carefully recorded the area. Alternatively, there may be collections relating to particular families (often landowners) or, increasingly over the past decades, to commercial firms which have deposited their records.

LIBRARIES As most borough and city libraries pre-date by many years the establishment of county record offices, they tend to have collected photographs, prints and paintings of local interest for much longer. Many libraries have photographs from the 1850's onwards which illustrate the changing landscape and townscape, just as they have pictures of disasters (floods, fires, wartime raids) and celebrations (royal visits, civic ceremonies, victory parades), and of important sources of local employment (mining, brewing, boat-building) and popular entertainment (particularly press photographs of local sports teams and events).

The scope of such collections may be considerable—Manchester City Library, for instance, has 120,000 photographs in its care. The Reference Library, Birmingham, contains well over 20,000 social documentary photographs and 14,000 negatives of the late Victorian and Edwardian periods. Many libraries also possess scrapbooks of press cuttings and pictures, built up by the staff or donated by local residents. These are invaluable—particularly where the original press photographs no longer exist. Some also have collections of local views on postcards, often surprisingly comprehensive in their coverage of an area. Lastly there are the miscellanea—odds and ends which have been rescued by the staff or donated by members of the public who value the preservation of visual records.

MUSEUMS A number of specialized museums are mentioned in the text, but there are many others which have incidental or systematic collections of photographs relating to their holdings, like the Photographic Department of the Imperial War Museum which has two million photographs from the First World War onwards, indexed and available to the public. Thus there have survived in different regions of the country collections which relate to indigenous industries.[13] At Reading University in Berkshire, for instance, the Museum of Rural Life houses a collection of some 750,000 photographs relating to agriculture. A small selection of these largely unpublished photographic riches can be found in Gordon Winter's *A Country Camera*.[14] Another important collection, this time relating to northern industrial life, is at the Beamish Open Air Industrial Museum, near Chester le Street, in the centre of the Durham coalfield. A collection of 15,000 photographs, which grows at a rate of about 3,000 acquisitions yearly, it is redolent of the area:

> The names of the towns and villages around are magic, synonymous with pit life and struggle, evocative of hardship and heroism, filling the mind with folk tales of Tommy Hepburn, Martin Jude and poor Jobling. This is the land of Shields and Jarrow, Follingsby and Wardley. If you live your history, you must hear again the tramp of pit boots over the town moor, the rasping sounds of silver and brass, and see with your inner eye the silken ripple of the lodge banner as you journey to the former home of the Shaftos.[15]

If there is an appropriate museum in the area where your family lived, it is always worth making an enquiry. The reasonably

priced, annual publication *Museums and Galleries in Great Britain and Ireland,* and the much-used, comprehensive and expanded *Libraries, Museums and Art Galleries Year Book,* both contain information about major collections (see Book List, page 188). Museums which have local history collections and displays, or which concentrate on particular industries or facets of life, will nearly always hold associated documentary and pictorial material. Thus in the *Year Book* the entry for each museum is subdivided; one section refers to the scope of the museum, another to any special collections or exhibits. By studying these, the holding of photographs can be inferred, even if not specifically mentioned. So that under the entry for the Stoke Bruerne Waterways Museum in Northamptonshire, the *Year Book* notes that it has material on canal transport, the Grand Union Canal, and the lives of men and women who worked on the canals. You should not be dismayed if no mention is made of photographs. Space does not permit every aspect of this museum's work to be described, but its photographic collection is vital in communicating the way of life of bargees and their families from the late 19th century onwards. The golden rule is to ask. Enquire, too, whether there are any photographs in the relevant reserve collection. Sometimes you will find yourself browsing through long-deposited collections of glass plate negatives that have been neither sorted nor listed.

Providing a comprehensive guide to the photographic cornucopia of museums is beyond the scope of this book, but *The Directory of Museums* by Kenneth Hudson and Ann Nicholls (Macmillan, 1975) contains information about museum photographic collections world-wide, and though not particularly useful for Britain, does have the merit of providing an index of specialized and outstanding collections, country by country. The index unfortunately combines photography with printing, but despite this can help you to locate repositories in other parts of the world—and establishing some sort of link is usually a step forward in running your quarry to earth. *The Directory of British Photographic Collections* (see below, page 143) may also be of help.

Some mention also needs to be made of those museums devoted to the art of photography itself. Both the Victoria and Albert Museum, and the Science Museum, London, have important photography sections, and the latter has opened a new department in Bradford, Yorkshire. Kodak Ltd have their own

extensive collection at the Kodak Museum, Harrow, Middlesex, covering the history of photography and cinematography. The other major museum of photography is the National Trust's Fox Talbot Museum, at Lacock in Wiltshire.

COMMERCIAL COLLECTIONS In the main, collections like the BBC's Radio Times Hulton Picture Library, the Mansell Collection or the Mary Evans Picture Library, cater almost exclusively for the needs of the media—particularly book and magazine publishers—and do not encourage the non-commercial or non-professional user. Because they are operated as businesses, they make a fairly substantial charge for researching and supplying pictures, so even if they were open to the general public, many individuals could not afford to use them. With the rapid development of interest in family history, it is clear that, in the very near future, individuals or research groups from family history and one-name societies may wish to go into the business of private or commercial publishing, in which case it should become possible, both technically and economically, to use the resources of such collections. An invaluable guide is the international *Picture Researcher's Handbook* which provides data on the specific nature of each collection and the number of items held, as well as information about the terms under which the service is offered.[16]

INSTITUTIONS Whatever the institution—a home for retired seamen, an Oxbridge college, or a London livery company— whether large or small, prestigious or notorious, it has to keep records: financial, personal, administrative. In the United Kingdom, for instance, family historians are increasingly turning to school records to discover not only genealogical information, but also indirect evidence such as that contained in their log-books about living-conditions, local recreations and sport. Amongst the records of an institution you may well find photographs of the children of Standard IV in 1908, the college cricket team in 1922, or the nurses of Windsor Ward in 1947. The advantage of institutions is that being bureaucratic by nature they tend to accumulate records where other people throw them out. There is often no automatic right to view the records (which may, or may not, be in an archivist's charge). Tact and persuasion are called for.

THE ARMED AND PUBLIC SERVICES Many records have been

maintained by regiments and corps, squadrons and ships—often written up into official, or semi-official, histories complete with photographs. Besides the national collections mentioned in Chapters 5 and 9, there are many scattered in smaller museums, particularly those relating to regiments and corps such as the Royal Armoured Tank Museum at Wareham, or the Airborne Forces Museum at Aldershot (see above, page 72).

There are also many 'unofficial' photographs held by members of the Services. These in aggregate may be much more extensive even than official photographs, and cover a much greater diversity of topics (such as sport and recreation, as well as places servicemen passed through on campaign or on peacetime postings). Try to get in touch with members of the regiment, corps, wing or ship through informal contacts or letters in the press in order to see what survives at this level. Some surprising finds do occur—the diary and photographs of an RAF pilot who served in the campaign against Somali tribesmen in the 1920's, a 'police' war that rarely hit the headlines but was an interesting aerial extension of 'gunboat diplomacy' in our colonies, became a very vivid chapter in a family history.

Public services such as the police, fire brigades or the ambulance service, also have their own chronicles, and photographs may be found in local histories. Once again, it is very much a matter of ferreting out information from libraries and record offices, and making personal contacts.

REGIONAL STUDIES DEPARTMENTS IN INSTITUTIONS OF HIGHER EDUCATION There is a growing interest amongst local and regional organizations in the photograph as an aid to historical interpretation. For example, at the Manchester Studies Department of Manchester Polytechnic, Bill Williams and his team have developed tremendous expertise in the popular history of the city and its region. Apart from an archive rescue programme organized on a house-to-house basis in selected areas, the team has built up an extensive photographic and sound archive on local matters. The evangelical nature of their work has produced impressive results; a display in 1978 led to over 200 responses, and brought in a superb collection of 92 photographs taken by a local newspaper photographer between 1898 and 1902, including the only surviving shot of the children of Angel Meadow, Manchester's most notorious slum.[17] In 1982 they

Children of Angel Meadow, Manchester, photographed by Robert Banks when the Duchess of Sutherland opened an extension to Charter Street Ragged School in 1900

organized a fine travelling exhibition, 'Family Albums', which drew on some 1,400 surviving individual albums to recapture the texture of working-class life in the area.[18]

NEWSPAPER OFFICES Press photographs and other forms of illustration constitute a very rich source of pictorial evidence, particularly from the First World War onwards when more photographs appeared in newspapers. In some areas, newspaper collections have suffered from a combination of take-overs, salvage collections, war damage, accidental fires and assaults by rodents. Where they have survived, press photographs are a valuable asset, and many newspapers have recently begun to republish them. On the whole, newspapers do not give access to their photographic libraries, but may be willing to undertake research and produce copies for a reasonable fee. Press agencies which deal with news and current events, such as the Press Association, are listed in the *Picture Researcher's Handbook* (see

Note 16), but access to nearly all of them is restricted to their own staff, and fees for searches, handling and reproduction are payable. Family historians can, of course, use the British Museum Newspaper Library at Colindale Avenue, London NW9 5HE, where a photographic and photostat service is available.

COUNTY PLANNING OFFICES Because of the large-scale redevelopments taking place in many older town and city centres, the planning departments of local authorities are increasingly aware of the need to make a visual record of the original sites. Some have built up, for their own use, collections which may contain the only surviving photographs of the streets, or even of particular buildings, where your ancestors once lived. The National Building Record, London, formed at the beginning of the Second World War, contains about 800,000 photographs of English buildings and sculptures of historical interest.

PRIVATE MUNIMENT ROOMS Large numbers of photographs still lie (in some cases long undisturbed) in private repositories, from archive rooms to attics, up and down the country. Many of them are not in the public domain, so access is not automatic, and persuasion will be needed if you know, or suspect, that among them are photographs of interest to you. Important repositories of such photographs are those landed estates which, having survived the scourge of death duties and high taxation, still retain collections of documents and allied material necessary to the running of their farms. Amongst such miscellanies, photographs of properties, employees, prize cattle and harvest scenes are not uncommon. Again, many an 'improving' 19th-century landowner was proud of his 'closed village' and so photographed it. Moreover, it is wrong to think only in terms of the Victorian and Edwardian eras; many farmers took photographs of landgirls at work during the two World Wars, of their first tractor in the 1920's or their first combine-harvester in the 1950's. For the family historian, recent photographs may be just as relevant as the 'classical' late-19th-century picture of a ploughman and his horses on a downland field silhouetted against the early morning sky or, an equally idyllic image, of a haycart fording a glittering sun-caressed stream. If your ancestor was employed on one of the great estates, it might be worth enquiring of the present owner whether any records have been retained. If the papers have

This photograph of a fishmonger's shop in Porth, Rhondda Valley, taken in Empire Shopping Week, c. 1920, was saved from the bonfire by family historian David May

migrated, they may be at the county record office, or in the keeping of a previous owner. It is always worth following up clues.

Much the same is true of commercial and industrial enterprises such as banks, breweries, mills, ironworks, retail establishments, railways, docks, mining companies, motor vehicle plants—the list is endless—most of which have come into being during the photographic age. There are very few establishments, from the humblest boot and shoe workshop in the East End of London, to the most prestigious engineering works in the Midlands or the deepest mine in the North-East, which have not been chronicled by a photographer at some time or other. And even after the demise of some great mill, mine or shipyard, there are enthusiasts investigating its past and uncovering its story. The researches of such groups are often extremely valuable. Your nearest industrial archaeology society will tell you whether any work has been done on your particular area of interest.

Of course, there is always the possibility that you will be the

first person to follow up a particular line of enquiry. You may have to search around for yourself. But there has been a growing interest in business history for at least three decades, and many published histories contain a good photographic section, as well as clues to the whereabouts of other, unpublished pictures. A good indication as to whether illustrative matter survives is if the firm has published a centenary or anniversary booklet.

PHOTOGRAPHERS' COLLECTIONS Some long-established firms of photographers have excellent and well-catalogued files of negatives. Ramsey & Muspratt of Oxford, for instance, has a vast collection of Oxford college groups and portraits going back to the late 19th century. Even if a firm is no longer in business, its records may have been retained by the company which bought it out. Some firms have deposited their negatives in local libraries and museums, while other collections have remained in the possession of the photographer's family. At Romsey in Hampshire, for example, the son of a local photographer inherited many thousands of negatives from his father's business. Almost everyone who lived in Romsey from about 1930 to 1970 (including incidentally Lord Mountbatten and his family) probably appears there, though locating the right negative is a problem as the quality of the accompanying records does not match that of the photographs.

Despite the surge of interest in business archives in recent years, little attention has been given to photographers' records which are still, no doubt, being destroyed in many countries. This is partly because historians of photography have been concerned, in the main, with famous photographers or with pictures of artistic merit. But the family historian is more interested in locating a likeness of his great-great-great-grandfather, however uninteresting photographically and however poor the picture quality. National indexes of photographers and their records—pre-1914, even pre-1939—are sadly lacking.

PHOTOGRAPHIC SOCIETIES A list first published in 1892 shows that there were at least 240 photographic clubs and societies active in Britain by this date.[19] Most had been founded in the mid 1880's or later, although some, like the Amateur Photographic Field Club (1852) and the Exeter Amateur Photographic Society (1860) were much earlier. A number were offshoots of

existing societies and organizations like the Blackburn Literary Club's photographic section or the Birkenhead Young Men's Christian Association Camera Club; others, for example the Leeds Photographic Society or the (Regent Street) Polytechnic Photographic Society, appear to have been founded in their own right. Not all had a geographical or institutional base: the strangely named Sun and Company (1886) was one of a number of postal photographic societies. Limited to forty amateurs, it was founded to circulate monthly, and criticize, photographs taken by members, and to encourage a general interchange of ideas, with a view to 'mutual advancement in the science of art and photography'. Names and addresses given in the list can be followed up in local directories, and it may be possible to discover the whereabouts of lost records and photographic items—many of which will undoubtedly record local scenes, events and people.

THE NATIONAL PHOTOGRAPHIC SOCIETY Open to members and students, the Society's permanent collection, now located at Bath, falls into three categories: apparatus, books and photographs. The collection of apparatus, including the exhibits on view in the Science Museum, London, and the library are major collections. The photographic collection contains a large number of fine late Victorian and Edwardian photographs (not catalogued up to 1964). The National Photographic Record, a department of the Society, holds references to all the collections in Britain, public and private, the majority of which are documentary in nature. It has published a very helpful Directory of British Photographic Collections.[20]

EVOLVING A METHODOLOGY
Picture researching is, in essence, the search for visual material which will most appropriately complement oral and documentary evidence. There is no infallible or established 'science' of the subject. However, in most cases where you are looking for particular kinds of photographs, it is possible to plan your research strategy, bearing in mind that, as in any research, the unexpected may well cause you to redirect your efforts into an apparently more fruitful avenue of enquiry. And even if this proves to be a cul-de-sac, you can always return to your main plan. The strategy suggested here is designed to help you to

develop a more systematic approach to your research; it should not, however, inhibit you from devising alternative strategies to meet your own specific requirements.

Besides the photographs that appear in printed sources (see above, page 130), there are three major areas to consider: private, semi-public and public.

As has been emphasized elsewhere (see above, page 35), exploring the private area involves not only talking to relatives but to anyone who may have known members of your family: friends, neighbours, fellow-pupils, workmates—and, of course, their descendants. In innumerable cases, the locating of a school photograph, a snapshot of a military unit, or a portrait of a football club or cricket team, has provided the only known visual evidence for one facet of an ancestor's life.

The private area merges into the semi-public one. Although contacting your ancestor's friends and relatives may well lead to the chance discovery of pictures showing him or her engaged in various communal activities, you will usually have to search for these more systematically among the archives of local organizations. In most communities, amazing numbers of societies and associations flourish, ranging from those which are many thousands strong, such as clubs for football supporters, pigeon fanciers or pop fans, and bodies like the Women's Institutes, the British Legion or the Scouts, to smaller and more esoteric groups like bird-watching or camera clubs—not to mention family history societies! There are few people who do not express their interests and hobbies through some form of mutual association. Membership of one or more of these groups usually involves informal snapshots and more formal photographs of meetings or social functions, which appear in newsletters, journals or magazines. The acid test is the survival of coherent records. So search for any clues leading you to organizations of which your ancestor was a member, and then try to locate their records. If the organization still survives, contact its present officers; if not, try the appropriate libraries and record offices, remembering always that local records of a defunct branch may have been sent to the county or national headquarters. If you are fortunate enough to locate records, do not despair if (as is often the case) there is not a photograph in sight. Careful study will often produce a list of functions which may have been reported in the local or specialized press, perhaps, after 1900 or so, with a picture.

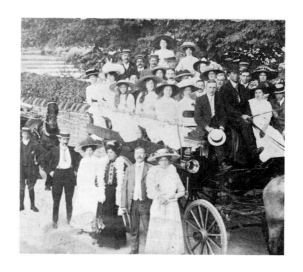

An example of the 'semi-public' type of photograph, this is a postcard shot of a stylishly dressed party in a waggonette, setting out for (or arriving at?) a festive event. Though there is no other evidence to suggest what the occasion might be, the presence of a professional photographer to record it suggests something more than a day at the seaside. Unannotated photographs like this one always raise questions. No small children appear—were they in another vehicle? And did the photographer take a series of shots of a whole line of vehicles of which this one alone survives?

The public area of our lives, subject to official control, or governed by the need to earn a living, is recorded by bureaucracies of one sort or another. This means that in many instances photographs have not been maintained consciously as a distinct class or category of record but are lumped in with others—which is why hunting for photographs will often turn up other records, and vice versa. Because of this, photographs have tended to suffer the same indignities as other classes of record: shredded in wartime salvage drives, burned in fires, made sodden in floods, eaten by rats, or dumped in 'spring-cleaning' attempts to create space for more recent documents. *Tended,* because photographs have an immediacy which derives from the people, places and events recorded, and so are sometimes rescued from obliteration by those ordered to destroy them. This may explain the presence of unidentifiable 'intruders' in an otherwise coherent collection.

★ ★ ★

You may well begin your researches on the premise that, given the ubiquitous presence of photography by the 1870's, *some* visual record of the sort you want probably exists somewhere, though of course you cannot be certain that if there was once such a picture, it still survives. Nevertheless, as Howell Green demonstrates in the next chapter, careful preparation, intuition and luck can bring results, and like any other aspect of family history, picture researching can occasion that gratifying surge of adrenalin when the elusive quarry is finally run to ground.

NOTES AND REFERENCES

1. Steel, D. J., and Taylor, L., *The Steels,* 'Family History Patches', Nelson, Walton on Thames, 1976, p. 25.
2. Steel, D. J., and Taylor, L., *Family History in Schools,* Phillimore, Chichester, 1973, p. 53.
3. Our chronological classification would run roughly as follows: historic 1840–1900's; modern, 1900's–1970; contemporary, 1970 to date.
4. See Book List, page 188.
5. Ibid., page 188.
6. Ibid., page 188.
7. Thomas, Alan, *The Expanding Eye: Photography and the Nineteenth-Century Mind,* Croom Helm, London, 1978, p. 121.
8. For postcards, see: Staff, Frank, *The Picture Postcard and Its Origins,* Lutterworth Press, Guildford, 1979 (revised edition); Carline, R., *Pictures in the Post,* Gordon Fraser, London, 1971; Holt, T. and V., *Picture Postcards of the Golden Age,* MacGibbon, 1971.
9. Corley, T. A. B., *Quaker Enterprise in Biscuits: Huntley & Palmer's of Reading, 1822–1972,* Hutchinson, 1972.
10. Manchester U.P., Manchester, 1976.
11. A good example of the kind of book included is Frank Atkinson's *The Great Northern Coalfield 1700–1900; Illustrated Notes on the Durham and Northumberland Coalfield* (Frank Graham, 1966). It does not, of course, include many useful books published since 1976, e.g. Robin Gard's *Northumberland Yesteryear: A Selection of Old Photographs Illustrating Life in Northumberland.* (Frank Graham for the Northumberland Local History Society, 1978) which has numerous mining pictures.
12. For an up-to-date detailed list of major record offices, see the Royal Commission on Historical Manuscripts, *Record Repositories in Great Britain,* HMSO, London, 1979 (6th ed.). For a very useful, inexpensive companion booklet, see Gibson, Jeremy, and Peskett, Pamela, *Record Offices, How To Find Them,* Gulliver Press and the Federation of Family History Societies, 1981; may be ordered from the author, Hart's Cottage, Church Hanborough, Oxford OX7 2AB.
13. See above, Notes 10 and 11.
14. Winter, Gordon, *A Country Camera 1844–1914,* David & Charles, Newton Abbot, 1972.
15. Gorman, John, 'The Beamish Collection and Photographic Archive', *History Workshop,* No. 6, Autumn 1978, p. 195.
16. Evans, Hilary and Mary, and Nelki, Andra, *The Picture Researcher's Handbook: An International Guide to Picture Sources and How to Use them,* David & Charles, Newton Abbot and Vancouver, 1975.
17. Linkman, Audrey, and Williams, Bill, 'Recovering the People's Past: The Archive Rescue Programme of Manchester Studies', *History Workshop,* No. 8, Autumn 1979, p. 117.
18. For catalogue, see Warhurst, Caroline, Stephens, Christine and Linkman, Audrey, 'Family Albums', Manchester Polytechnic, Manchester, 1982.
19. Welling, William, *Collector's Guide to Nineteenth-Century Photographs,* Macmillan, New York, 1976, pp. 147–71.
20. Wall, John (compiler), *The Directory of British Photographic Collections,* Heinemann, London, 1977; details of 1,580 collections, and 5 indexes (by subject, owner, location, title and photographer).

9
Illustrating Your Family History
A Case Study

HOWELL GREEN

My story begins in 1964 when I discovered, in my grandmother's home, a small leather-covered diary—nothing out of the ordinary, except perhaps for the date, 1900. It had been the property of my grandfather, Fred Green, who had gone to the Boer War in that year, and these were his impressions, experiences and memories. They were, however, rather brief—very much so considering the size of the diary—and since at that time I was not very concerned with family history, after a cursory glance through the pages I returned it to its drawer. I lost track of the diary after that visit and it was not until 1974 that it surfaced again and came into my possession.

I decided to transcribe the contents.

That simple six-word sentence was to be the start of one of the most interesting projects I have ever undertaken.

I began, as anyone would, by reading right through to see what the 'old man' had got up to. I found that not only had he been in the Boer War but also he had gone to China in the summer of that year—the Boxer Rebellion. Obviously there was more to this than I had thought. Having read through the diary I decided not only to transcribe it, but to try to find a few photographs which would complement the entries, and to send copies to my two uncles, Fred Green's sons.

In February 1974 I started the job of transcription, and in doing so to *learn* the contents rather than just reading through. What an epic that was! The handwriting often seemed completely illegible. To make matters worse, there was the problem of idiom, for I found that the English of 1900 differed considerably from the English of today. I just was not on my grandfather's wavelength. I was to learn that the only answer was patient study of the

The diary for 24 March 1900 begins: 'Very busy taking bedsteads out of ward & transferring patients. Bert very much worse. I volunteered for permanent night duty was on No. 12. Got 9 letters 10 PM. Hurriedly sent for to see Bert & he died about 10.10. Doctor Clergyman & 2 sisters were with him. He sang Suffer little children to come to me . . . Wrote, or tried too write to his friends but could not . . . we buried him at 5 o'clock.'

doubtful words and their context. Additionally, there were names which, at that time, no amount of gazing could decipher; people, places, ships. If *Vaalkranz* or *Elaandslaagte* are difficult to recognize (let alone spell) when printed, imagine the problems when trying to read them in a barely decipherable hand.

I handwrote the diary on to lined foolscap leaving gaps where the script was unreadable. I wrote a week's entries at a time and then faced the problems which that week posed. One week finished, on to the next, and so on. Having overcome the handwriting and the idiom, I then typed the contents.

It was at this point that I realized how little I knew of the Boer War, so I started to read all the books on the subject that I could lay my hands on. The diary recounted life in a field hospital in Cape Province, but it started in London at Christmas-time, 1899; described the voyage to Cape Town, the incidents at the hospital, the voyage back to England; and dealt finally with the expedition to China. Given all that, I concluded that Fred Green had enlisted in the Army and had probably served in the Royal Army Medical Corps. How wrong I was. But I am jumping the gun. Without

exception, the books I read in those early days dealt with the campaigns, the battles, the mistakes, the victories. Thus although I learned nothing specific about my grandfather, the exercise was certainly justified in so far as I gained a background to his life in South Africa and an insight into the mores of the time.

To make the copy I was producing more manageable, I decided that the natural divisions within the narrative were the ships—the trooper which took Fred Green to South Africa, the ship which brought him back, the hospital ship in which he went out to China. To try to find something out about these ships I started upon the long road of letter-writing which I am following still.

The troopship in which my grandfather had sailed to South Africa I read as the *Kildonan Castle*. Castle? That sounded as if it could have belonged to the Union Castle Steamship Company so, on the off-chance, I wrote to them. Remember . . . I was enquiring about a ship which *perhaps* was theirs, I wasn't certain of the name, and to top it all, the voyage was back in 1900. The answer was marvellous. I received, almost by return, confirmation of the name, a potted history and, glory be, a photograph. I thought the job would be a piece of cake!

The name of the first ship had provided a clue, but the second ship was a mystery. What clue exists in 'Banarion'? More detective work. I wrote to Lloyds of London but they could give me no information about any such ship. Since I knew both the *Kildonan Castle* and the *Banarion* were being used as troopships, I thought it worth trying the Imperial War Museum. Much to my surprise, I found that their records commence only in 1914. For information prior to 1914 I would have to try the National Army Museum. They recommended a book covering the history of troopships and, lo and behold, there was an account not only of the *Kildonan Castle* but also the *Bavarian*—NOT the *Banarion*— blast that man's handwriting! Back to Lloyds and, again by return, a charming letter giving dimensions, tonnage, builders, dates, all the relevant details. The third ship, the *Maine,* proved the most difficult, which seems strange now, for it has since been featured on television in *Jennie,* the series on the life of Lady Randolph Churchill. But at that time it was *the* problem, and it was solved in the luckiest manner imaginable. Browsing along the history shelves at my local library I found the book of Winston Churchill's dispatches from South Africa, *Young Winston's Wars.* I flipped through and a name came right out at

me—'Hospital ship *Maine*, March 5'. The *Maine*! It was unbeliev-able luck, but Churchill had gone aboard the ship after his escape from the Boers and had written a dispatch whilst there. My opinion of the local librarian went sky-high!

A fourth ship was mentioned in the diary, HMS *Terrible*, a protected cruiser which Fred Green visited in China.

Having identified the ships beyond doubt, the next move was to obtain detailed histories and photographs. Lloyds gave me chapter and verse on the *Kildonan Castle, Bavarian* and *Maine*, and my local library provided a similar service for HMS *Terrible* in the form of *Jane's Fighting Ships, 1904*.

The Union Castle Steamship Company had already supplied me with a history of the *Kildonan Castle*. The *Bavarian* had been a ship of the Canadian Pacific Line, inherited in one of their take-overs (yes, take-overs, even in those days!). They could provide neither picture nor story but they suggested a magazine with the unlikely name of *Sea Breezes* as my best source. The *Maine* was a hospital ship, so I wrote to the Red Cross in London. That proved to be one of my better moves. They sent me the complete Red Cross report on the South African War—a most valuable book. It was this book that provided the first clues regarding Fred Green's work in the Boer War, as through it I discovered the activities of the St John Ambulance Brigade in South Africa. Not only did it bring the Brigade into the reckoning, but also gave me my first hints regarding the field hospital in South Africa, and the history of the *Maine*. At about the same time, in a reprint of a Boer War newspaper, I was reading a list of casualties and there, almost incredibly, was a name I knew. I recognized it from the diary—a friend of my grandfather's. According to the casualty report, he had died of typhoid at the Orange River, Cape Province. His name was Jack Sawford and he was a member of the Brigade. This was the strongest lead yet. Not only did it make it virtually certain that my grandfather was in the Brigade, but it also suggested the field hospital's whereabouts—nowhere mentioned in the diary. Recourse to the St John Ambulance records at their headquarters in London duly turned up a membership roll listing my grandfather and Jack Sawford within a few lines of each other.

The mists of intangibility were thinning.

But what about pictures? I already had the photograph of the *Kildonan Castle* which the Union Castle Steamship Company had

Above, the ship that began my long voyage of discovery! This is the photograph which the Union Castle Steamship Company sent me, showing the troopship Kildonan Castle.

Below: the hospital ship RFA Maine, out of Swansea, in 1901; this photograph came from a small specialist maritime library, a great piece of luck. Lady Randolph Churchill raised the funds for the Maine, organized the conversion, and even sailed for South Africa in her, after being summoned to Windsor to describe the enterprise to Queen Victoria.

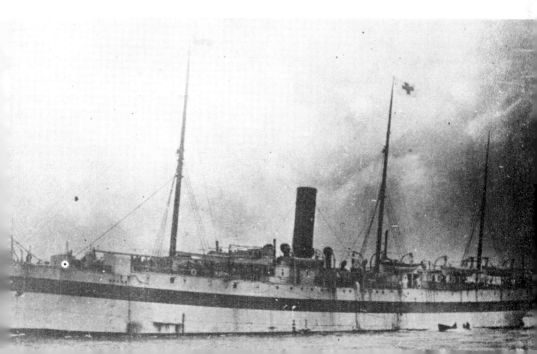

sent me, and photographs of the other ships proved easy to find. The National Maritime Museum at Greenwich possesses what can only be described as a comprehensive collection, and came up trumps with the *Bavarian,* the *Maine* and HMS *Terrible.* But I wanted to illustrate my grandfather's experiences as fully as I could and this meant much more picture research.

When I started the project I had no photographs, none. I had not even any idea what my grandfather looked like. My only window into his character was his diary. Therefore, I had to cast my net wide. First on the list, relatives. I wrote round, and an uncle in San Francisco actually sent me a picture of my grandfather. At last! Next, institutions. I have had nothing but kindness from museum staff, whether writing or calling, buying or 'just looking'. There seems to be one universal, invariable law: co-operate. Truly, I have yet to be snubbed by a museum, library or indeed any corporate body. The cost of illustration, however, varies enormously. I spent a wonderful day at the Guildhall Library in London, browsing through their comprehensive collections of photographs of London in 1900, armed with the knowledge that the photographs I had purchased from the National Maritime Museum had cost 20p each. I must admit I was rather lavish, indiscriminate even, in my selection. The euphoric bubble burst about 2.30 p.m. that day, when having sorted out a wonderful array of illustrations, I asked the cost and found that if the Museum provided the prints, the minimum charge was £2.00 each (since increased fourfold). However, if I could provide my own copying equipment—camera, lights, easel, etc.—there was no charge. Luckily, Patrick Beaver, the author, took pity on me and offered to do the copying job. There would have been no photographs from the Guildhall Library in my presentation but for him.

All this time letters were being written and received. A book on naval gunnery was recommended. Why naval gunnery? It gave a history of HMS *Terrible* and a biography of her captain, Percy Scott. A letter arrived from Liverpool. The editor of *Sea Breezes* had featured the *Bavarian* in an article four years previously. He enclosed the article and an illustration.

In June 1974, I spent a day at the National Army Museum digging through the records. What a wonderful place, saturated in our Imperial past. It could also provide photographs of the Boer War—indeed, something in excess of ten thousand!

A troopdeck of the SS Bavarian, *which carried 2,170 officers and men*

One collection alone consists of four thousand. I had no luck with the field hospital—illustrations of that place were proving to be elusive—but I did find a drawing of one of the troop decks of the *Bavarian,* hammocks and all, a very lucky break.

The big breaks, however, were lurking just over the horizon.

When I visited St John's Gate in London, the headquarters of the Order of St John of Jerusalem, the curator, Pamela Willis, gave me the freedom of the library. There was so much that was relevant: reports on the organization in South Africa, a specific report on the field hospital at Orange River, details of the *Maine,* an illustration of the final passing-out parade of Brigade men in London prior to their departure, and a letter from a Brigade man on the Orange River in which my grandfather was mentioned. I was elated!

A week after this visit, Pamela Willis contacted me with the news that she had unearthed a book recounting the experiences of an ordinary Brigade man during the Boer War. Would I care to look at it? Would I! It was written by a W. S. Inder of Kendal and it did more to fill the gaps than anything thus far. But there was more to come. Thanks to a fellow member of the West Surrey Family History Society, I had the privilege of meeting Arthur

The passing-out parade in St John's Square, London, 7 January 1900

Kipling, the noted military authority and historian. I spent an enjoyable evening in his company, and together we ransacked his shelves for relevant books. One of these detailed life in a field hospital. By Frederick Treves, Surgeon Extraordinary to Queen Victoria, it complemented the Inder book, being written from a more 'remote' point of view. Two books, one by a surgeon, the other by a Brigade man. What luck!

It was November 1974, and still I had no illustrations of the Orange River Hospital, nor, incidentally, had I anything pictorial to illustrate Fred Green's subsequent voyage to China. I work for an airline, and at about this time I learned that I was to be sent abroad for a few weeks. Before leaving I wrote to the Africana Museum, Johannesburg, and to a small township on the Orange River named Hopetown, near which the hospital had stood. I left for the Far East in December 1974 and took advantage of the tour to select and order a number of photographs of Hong Kong in 1900. When I returned home three weeks later, waiting for me was a letter from Johannesburg. Yes, the Museum had photographs of Hopetown, and could supply them at very moderate cost. The pictures included one of the hospital. At last a picture of that hospital!

Soon afterwards my job took me to South Africa, and of

Above: the first picture of the field hospital at Orange River I ever received, and below, one of the hospital huts. Both photographs are from the Africana Museum in Johannesburg. I was glad to see the case of antiseptics in the first one and the bedsteads in the second—not to mention the nurses! Conditions could have been much worse. When I visited the Wellcome Museum of Medical Science in London I found that their exhibits included equipment from the Maine. I picked up a medicine case and revelled in the thought that Fred, too, might have handled the selfsame item.

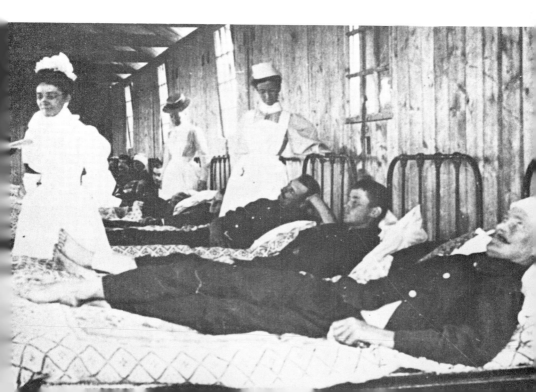

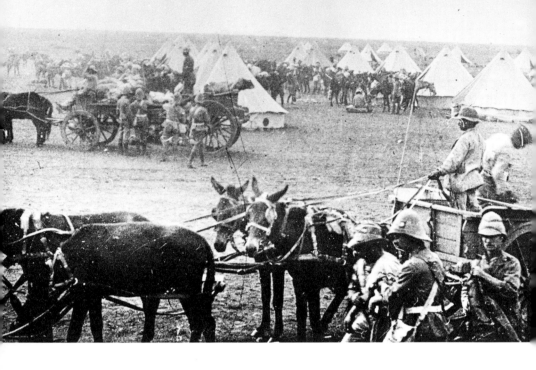

Two more photographs which came from the Africana Museum in Johannesburg: above, the camp at Orange River; below, Hopetown as it was in 1900—the Dutch Reformed Church has since been demolished and rebuilt on a new site, but the corner store remains, and it gave me great satisfaction to recognize it when I visited the town over seventy-five years later.

course I returned with a further clutch of illustrations. Working for an airline has its advantages! It was on this visit that I found a recently published book of Boer War illustrations—one of which I felt I could use. It was credited to a collection held by the McGregor Museum at Kimberley and proved to be the start of a trail which led to the most exciting experiences of the whole project. In the ensuing correspondence, the curator, Fiona Barbour, invited me to visit the museum and present my project to the local historical society. Kimberley is eighty miles north of the Orange River and I was determined to visit the site of the field hospital. Fiona was kind enough to act as my chauffeur and guide, and has done so on three further occasions. Each of these visits has produced a new crop of contemporary pictures to set alongside those so painstakingly built up from various sources.

When I gave my lecture in Kimberley in 1979 I had no thought that it would be particularly helpful to me in my project. However, the more people who know what you are interested in, the better. Two years later, in September 1981, an historian who had heard my lecture happened to be researching at Rhodes University and came across an album of photographs taken at and around Orange River Camp and Railway Station, especially in the field hospital, in 1900. The Rhodes University librarian was able to supply me with photocopies of this 48-page album and negatives of all 93 pictures.

But you don't have to go thousands of miles to get results. In its own way a trip to Northamptonshire was just as useful, producing material from the semi-public area suggested by Lawrence Taylor (see above, page 144). At Wollaston, where my grandfather came from, the village preservation society found me a picture of a football team featuring my grandfather. The local museum dug out a photograph of my grandfather aged about twenty-two and wearing a bowler hat, surrounded by a group of young men, all in cloth caps. And in his local paper, the *Wellingborough News,* filed at the British Museum Newspaper Library (see page 140), was an account of his departure for South Africa.

But even the well-explored private area still held unsuspected riches. When my mother died in November 1982, I was clearing out the flat and discovered two notebooks at the bottom of an old tea-chest. My mother had always assured me that she had no family documents. What were they? No one who had wrestled

These photographs of Fred Green in the 1890's were provided by the Village Preservation Society at Wollaston in Northamptonshire, my grandfather's home village. When I contacted them, their former secretary, John Crane, proved to be a fund of knowledge. My grandfather was born in 1876, and there were still people in the village who remembered him—indeed, some of them even remembered his father. The picture on the left shows him as goalkeeper and captain of the village football team. Below, he is pictured with a group of local lads; while they are in cloth caps, he wears a prestigious bowler hat. Is this perhaps a photograph of him with the local Bible Class? His diary makes it plain that he was a committed Christian. I also treasure a later photograph showing Fred on his wedding day, flanked by two supporters. It appears at the start of this chapter, on page 147—a fitting place for it, as it was the one sent to me by my uncle in America, the first picture I ever saw of my grandfather.

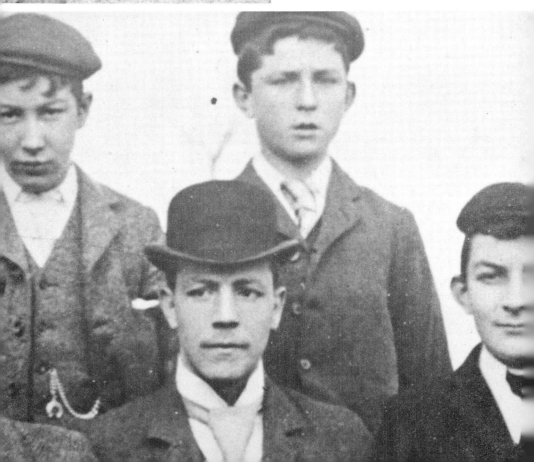

with my grandfather's handwriting could fail to recognize it. The first turned out to be medical notes taken during his training with the St John Ambulance Brigade. The second was a much more detailed account of his entire experiences in 1900.

I decided to transcribe the contents . . . !

That's the story up to now. It is not, of course, the end, for a project such as this is never complete. What has struck me most forcibly has been the wealth of visual and written material available which can relate to an obscure hospital ward orderly of nearly a century ago. The extraordinary thing is that just when you have made up your mind that this time the gold mine is completely exhausted, a rich lode-bearing seam is discovered by chance. So whichever area you are searching, whether private or public or in between, you must never give up.

Letter writing is undoubtedly the key, and a letter on one subject will, as likely as not, produce a reply about something else. For instance, my enquiry about the hospital ship *Maine* resulted in the Red Cross report on the South African War. A request to the McGregor Museum for a picture of a gun led to a guided tour of my grandfather's camp site and, indirectly, to a superb collection of very relevant photographs gathering dust in a university library. Not all letters produce an immediate response. The predominating and utterly frustrating reply is 'Mañana'—'I'll help all I can, tomorrow'—but quite often a tactfully phrased follow-up letter will deliver the goods. Failing that, there is always the telephone. Even for overseas repositories, the results usually justify the expense.

Admittedly, I am fortunate in having a job which enables me to travel abroad. However, if your job is not helpful in the same way, it may be in another. A school teacher can save the next piece of research for the long summer holiday. A librarian has the full range of bibliographies at his fingertips. Many firms have overseas or provincial branches which may offer temporary attachments or, if this is unrealistic, contacts who can at least provide local knowledge and perhaps local help. A bank employee in Liverpool may well get a friendly response if he writes to his opposite number in Bangkok, Buenos Aires or Brisbane. Most of us have a wide circle of relations, friends and acquaintances, who in turn know other people, who can help. So spread the word. It pays to advertise.

IO
Illustrating Your Family History
Publishing

DON STEEL

If, like Howell Green, you have spent a great deal of time and effort tracking down photographs associated with your family, it can be very satisfying to display your 'finds' to a wider audience—perhaps at a family wedding or christening, or even at a meeting of the local family history or one-name society. Asking people to thumb through annotated albums or files of prints and photocopies can be very dull, so try to organize the material as attractively as possible.

PHOTOGRAPHIC DISPLAYS[1]
Unless you have access to secure display cases and cabinets, never use the original photographs. Not only is there the danger of loss or damage, but a display looks much neater if all the pictures are the right size. Moreover, you may wish to use only portions of some photographs. So choose exactly what you want, and have prints made accordingly.

A PHOTO-PEDIGREE is the simplest kind of display. Here a family tree is carefully designed to accommodate small portraits. This not only adds interest to the pedigree but may enable hereditary physical characteristics to be seen at a glance, especially if all the photographs are taken around the age of thirty, before ageing has altered the features.

A PHOTO-SERIES tells a story: for instance, a display of carefully selected photographs shows one person from infancy to old age. Reverse chronological order may be even more dramatic. Starting with Granny as she is now, the pictures lead like

stepping-stones into the past, showing you the middle-aged mum, the young flapper, the Edwardian baby. Such a display can be very touching, and invaluable as an adjunct to tape recording Granny's memories. All too often you know only the old person, not that same person twenty, forty, seventy years ago, and the photo-series may make you see the rather crotchety, elderly widow through fresh eyes.

Similar photo-series may be concerned with the life-history of an individual, with biographies of several generations, or with the story of a particular episode, such as a family's emigration to Canada or Australia. In all these cases, a photo-series will obviously be made much more interesting if pictures of places and artefacts are added. Indeed, these may predominate in series which show, for instance, the history of a street, the forms of transport owned by successive generations, or the vicissitudes of a family business or farm.

PHOTO-SYNTHESIS, a mixture of documents and pictures, is an excellent way of livening up a collection of written records, and these in turn can add interest to a photo-series. Pictures and documents usually complement each other. Shown on pages 164–5 are two displays, one including wedding ephemera found among the bride's sister's papers on her death in 1978, and the other telling a moving story from the First World War. The documents alone would still be of real interest, but most would agree that the pictures make the display both more personal and more lively. Sometimes it may help to make a document the focus for a group of photographs, or vice versa.

Of course, for more distant periods in the family history photographs simply do not exist, and relatively few people own ancestral portraits. Even so, photocopies of documents judiciously mingled with old prints (or even modern photographs) of places and occupations, can be very effective.

Photographs and artefacts can also make an interesting display. Like the documents, artefacts on their own lack human interest. Shown on page 166 are six swimming medals (two for county championships) which an old lady, Mrs McKinley of Reading, won as a girl in the early 1900's. They become much more meaningful when placed alongside a photograph of the fourteen-year-old champion wearing them, together with a selection of certificates awarded to her.

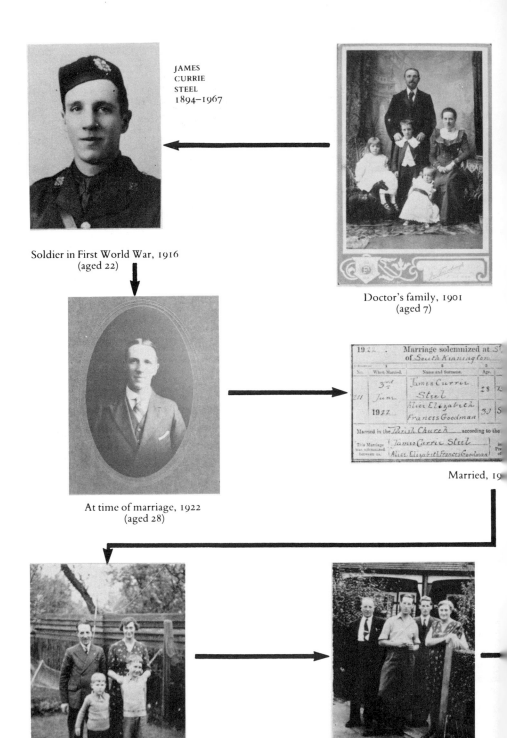

JAMES
CURRIE
STEEL
1894–1967

Soldier in First World War, 1916
(aged 22)

Doctor's family, 1901
(aged 7)

At time of marriage, 1922
(aged 28)

Married, 19

Young family, 1940

The family grows up, 1958

ALICE
GOODMAN
1891–1970

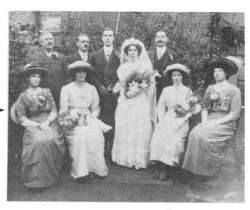

Schoolgirl, 1906
(aged 15)

Bridesmaid, 1913
(aged 22)

At the time of marriage, 1922
(aged 31)

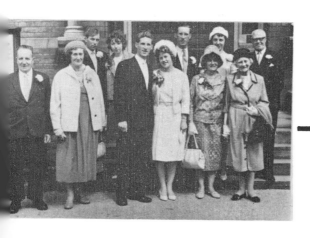

Children marry, 1962

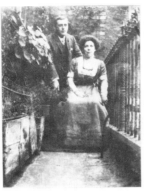

Engagement photograph, summer 1912

Postcard of congratulations from the groom's mother

Postcard of congratulations from a friend of the bride

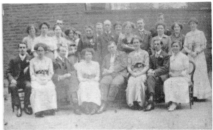

Wedding party

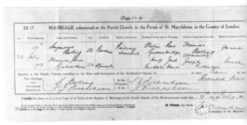

Marriage certificate, 27 July 1913

Wedding cake card

Cutting from the groom's local newspaper

GROOMBRIDGE.

WEDDING.—On Sunday morning last, at the Parish Church of St. Marylebone, the marriage took place of Florence, the second daughter of Mr. and Mrs. Joseph Richardson, and Seymour (Sid) the sixth son of the late Mr. Thomas and Mrs. Botting, of Manchester, and formerly of Firle, Sussex. The bride wore a cream delaine dress, with a black hat and white ostrich plumes. She was given away by her father, and was attended by her sister Violet, who wore Tussore silk, with brown hat, and a gold brooch, the gift of the bridegroom. Mr. F. Smith was best man. The ceremony was performed by the Rev. Cavendish Moxon. A reception was afterwards held at the bride's parents' residence. Considerable interest was created in the event locally as Mr. Botting has been ticket collector and clerk at Groombridge Station for some years past.

Above: a wedding display of photographs, certificate and ephemera
Right: a story told through documents and photographs

In training

Enlisted

Wounded and captured,
but safe

Fill up this card immediately!
I am prisoner of war in Germany.

Name: Godfrey
Christian name: Frederick William
Rank: Lance Corporal
Regiment: 7 Batt. Rifle Brigade

Wounded.		Improper to be erased.
2/4/18		

Do not reply to Limburg, await further information.

A prisoner of war

prison camp,
mewhere in Germany

A letter from the King

BUCKINGHAM PALACE

1918.

The Queen joins me in welcoming
you on your release from the
miseries & hardships, which you have
endured with so much patience &
courage.

During these many months of trial,
the early rescue of our gallant Officers
& men from the cruelties of their captivity
has been uppermost in our thoughts.

We are thankful that this longed
for day has arrived, & that back in
the old Country you will be able
once more to enjoy the happiness of
a home & to see good days among
those who anxiously look for your
return.

George R.I.

A display of artefacts, documents and photographs

Eva Spencer
of Reading
aged 14

PHOTO-ANTITHESIS has long been used by book illustrators or those mounting exhibitions to make vivid contrasts: past and present, town and country, different social classes. Perhaps the most interesting are 'then and now' pictures of places. Photographs may be mounted in pairs, in groups, or even in two contrasting wall displays.

PRINTED OR DUPLICATED FAMILY HISTORIES[2]

An increasing number of family historians are publishing their findings—for private circulation, in a one-name journal or newsletter, or as a full-scale family history. Like the journals of local family history societies, few of these publications seem to make very extensive use of photographs.

If you are not satisfied with anything less than glossy plates which do full justice to the original pictures, illustration is obviously going to be expensive. Moreover, in book production such halftone plates are often printed on special art paper to get the best reproduction possible, and appear as a separate plate section, which disrupts the close relationship between text and picture. However, it is possible to print halftones 'in text' on ordinary paper; this preserves the text/illustration relationship, and may well be cheaper, though the quality of reproduction may suffer.

Halftone printing does not accurately reproduce every tone of the original photograph (hence its name), and it reduces the quality of any illustration by about ten per cent. If there is a high contrast (blinding whites and very dense blacks) in the original, the loss of middle tones tends to emphasize it still further; and if a photograph is very 'flat' (middle tones with little contrast) the lack of depth will make it look lifeless when printed. Both sorts of picture should be avoided. Of course, if these are the only photographs available, as is so often the case, you have to decide whether a poor reproduction is preferable to none at all. When choosing your pictures do not forget that some of them will probably be in copyright, and you should, if possible, clear permission to use them (see Appendix, page 174).

You should be sensitive to the dramatic force of the picture and the importance of its relationship to the text, and make your plans accordingly. If you simply hand over your photographs to the printer and leave it to him to reproduce them as he thinks best, his main consideration will be to keep the cost down. But the

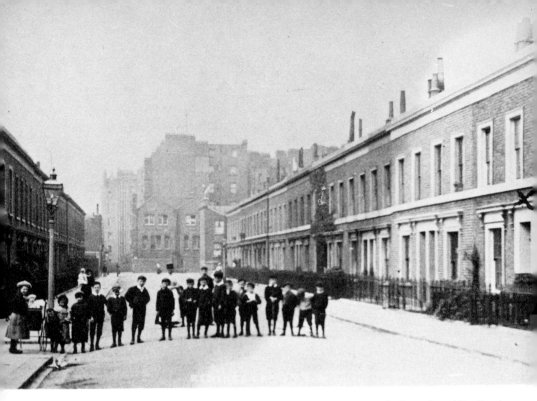

An example of photo-antithesis: Number 18, Kenchester Street, Lambeth, is where Alice Goodman lived as a child (see page 128) in the early years of this century. On the old postcard seen above, her home was marked with an X.

The photograph on the facing page shows the same street today.

cheapest way may not be the best for your purposes.

You may decide to reproduce all your photographs 'same size' (commonly referred to by printers as 's/s'). Probably, though, you will need to reduce the larger ones and increase the smaller. Pictures should not be reduced in size more than can be helped, as this decreases the amount of detail which can be seen. Conversely, 'blowing up' a small picture to a larger size makes it fuzzy and magnifies the grain to a distracting degree.

Photographs can also be 'cropped' and in book production they frequently are. Instead of reproducing the original in its entirety, the printed reproduction trims, say, some blank sky off the top of a landscape shot; or the original is 'masked' with a paper frame to show, for instance, only the central figures in a family group.

Illustrations in books and magazines often 'bleed', i.e. they are carried out to the edge of the paper, filling the usual margin. A photograph may bleed on all four sides (in which case it will

The houses have changed little, but the railings have gone (probably in the Second World War scrap drive). The local community now includes many black families. Though there is substantial unemployment, the parked cars show the more affluent standard of living achieved by those in work— and contrast strikingly with the earlier picture.

completely fill the page), or on one, two or three sides. If you want your pictures to bleed, allow for the loss of at least 3mm (⅛ inch) when the printed page is trimmed for binding.

Designing your own 'camera-ready copy' means supplying the printer with a page-by-page assembly of illustration material, with type-set captions or text as necessary, securely mounted on a page layout, so that he can photograph and reproduce each page as a whole.

Try to vary the arrangement of the pictures, clustering them in groups—preferably on related subjects. A novel, tasteful display adds interest to the page, but do not overlap pictures too much as this only creates visual confusion.

A SLIDE-TAPE PROGRAMME[3]

A slide-tape programme has advantages and disadvantages when compared with a typescript family history illustrated with

photographs. The cost of reproducing slides and copying cassettes means that it is expensive to produce a duplicate programme. However, slides are a far more dramatic way of using illustrations, and if you exploit the advantages of tape recording, it can be particularly effective in re-creating atmosphere. Besides capturing voices, you can recall the sounds of the past: the thud of the hammer in a blacksmith's forge, the distinctive hiss and whistle of the steam train, the tramp of soldiers marching, the clatter of machinery in a factory, the bustle of market day. Another very evocative class of sound is music of the period, from a colliery brass band to a traditional folk song, from hymns in the village church to the jazz music of the 1920's or the banjo strummed by pierrots at a summer show on the pier.[4] A slide-tape programme is thus an ideal presentation for such occasions as a family reunion or a meeting of a one-name society.

Making the programme is time-consuming, and does demand some technical knowledge, though a large measure of expertise can be acquired 'on the job'. It involves not only careful researching, but also careful planning so that the mix of pictures, voices and sound effects will hold the attention of the audience. For well-known families the only problem lies in selecting one theme or story from a hundred interesting episodes. Most of us are not so fortunate. What is more likely is that there will be long periods when the raw material is very scanty—a few dates and places from census returns, a handful of parish register entries, and perhaps a few isolated items gleaned from other parish records. Every now and again, though, a mountain peak soars out of the foothills: a diary with some biting social comment, a collection of letters written by an ancestor who was an Indian missionary, some vivid oral memories of a London childhood in the 1930's. If your direct line is short on mountain peaks, you have only two options. One is to choose a different ancestral family—perhaps your mother's grandmother's family has a wealth of interesting material. The other is to compile an extensive rather than an intensive presentation; you could, for instance, take a family over several generations. The basic principles, however, are the same. You must have both action and a change of scene.

It is important to write the text first, and *then* to illustrate it. Do not under any circumstances bring together a collection of illustrations around which to write a story. You will find your

work inhibited, crabbed, cramped. You will be cornered. Don't get caught. Words form the brickwork of your structure, illustrations are the windows.

The next job is picture researching. As Howell Green has shown (see Chapter 9, above), the secret is simple: never give up—that elusive illustration probably does exist somewhere. Get good-quality copies of the pictures, obtain permission to reproduce any copyright illustrations (see Appendix, page 174), and make them into slides.

Finally, having shaped the script and decided where the pictures are to go, think about music, sound effects, and—for a slide-tape programme based upon more recent family history—oral evidence. Howell Green's own programme, based on his grandfather's Boer War diary and his own picture research, has become a minor classic in family history circles, and much useful advice, together with details on the more technical aspects, will be found in his booklet, *Projecting Family History: A Short Guide to Audio-Visual Construction,* published by the Federation of Family History Societies.[5]

FILM[6]

Another possibility is to make an 8mm film. This demands even more technical expertise, but it can probably arouse the interest of relatives more readily than any other medium.

Obviously, as with a slide-tape programme, almost any episode in the family history will lend itself to film treatment, though it is important to choose a story likely to interest your potential audience, to ensure that detailed treatment is given only to episodes where there is sufficient material to make it visually interesting, and to keep the pace moving. A very effective subject which usually meets all these criteria, as well as probably being the simplest to make, is your own search for your ancestors. This obviates the need for a cast of thousands, a multi-million-pound film-set of 18th-century London, and location filming in Virginia or Melbourne. Such an approach was decided upon by Bryn Brooks, producer of the BBC Television series on Family History, in which the presenter, Gordon Honeycombe, started his own search with himself in Episode 1, and ended up five programmes later in the Middle Ages. It was also the plan adopted by the amateur family historian Ron Denyer, in his 35-minute 8mm film *Skeletons in the Cupboard,* first shown in

March 1973 to Manchester Genealogical Society.

Start with a brief written outline of the story you intend to tell. Keep it simple—the details of how you established the parentage of your great-great-grandfather may make fascinating reading, but on film the barest summary, together with pictures of a few key documents, will probably have to suffice. List the film shots you will need, and then draft your commentary. Aim for a film about thirty minutes long.

As with a slide-tape programme, picture researching can be quite a big job, but unlike slide-tape, where additional pictures can be added or substituted almost indefinitely, it has to be completed before the film is made. So do your research as thoroughly as time and money will permit and select those documents and photographs which make the points in the commentary most succinctly. Revise and adapt your script at this stage. It is quicker, easier and cheaper to do it now, on paper, than to try to make major changes as you go along.

You may already have used your 8mm cine camera to film your immediate family. Your list of shots will probably include clips from these. Others may be of elderly relatives, the places where your ancestors lived, the repositories where you found the records. If possible, get a companion to do the actual filming. It is much more interesting to see you walking down the village street or going into the record office than to be shown anonymous passers-by or unknown searchers.

Next, film your selection of documents, photographs and prints. Do not be satisfied with the photocopies you obtained during your researches, but ensure that top-quality copies are taken. Lastly, film your titles, including the name of your film, portions of your family tree, and 'The End'. Use your plan to edit them together in one length. Try out your commentary and adapt the film shots and words as needed. Get the film 'striped' with sound-track tape. Now use your cine sound projector to record the sound effects and music, and then your commentary. Try out your masterpiece on your friends, and be prepared to make changes to improve it.

Each step is not difficult, but it will take some time to make the film. The *All-in-One Cine Book* by Paul Petzold or the *Beginner's Guide to Super 8 Film Making* by Frank Arrowsmith will give you the basic know-how; *The Book of Movie Photography* by David Cheshire will provide useful advice on the finer points.[7]

VIDEO

A video camera is much more expensive than an 8mm camera, and amateur editing is rather more difficult than with film. It cannot be done by cutting and splicing; you have to copy your chosen shots from the original tapes on to a fresh videotape in whatever order you require. Unfortunately, a smooth edit can be obtained only with an expensive and complex machine which will line up the synchronization signals in the various portions of tape used. Nevertheless, though there will inevitably be some problems with 'glitches' (picture break-up before a new sequence can establish itself) reasonable results can be obtained with Do-It-Yourself 'crash editing', and if you do not feel you have done well enough, you can always try again, wiping the unacceptable copy in the process. It does, however, take time and patience, and, of course, needs two video recorders.

Detailed guidance not only on editing techniques but on all other aspects of making a videotape, such as scripting, interviewing, typography, animation and sound effects is given in *The Complete Handbook of Video* by David Owen and Mark Dunton.[8] Much of the advice is, of course, equally applicable to making a film.

Even if you work entirely with 16mm film, it is not a bad idea to get your film copied on to a video cassette, as it is then available for informal showings to groups of friends or relatives without the bother of setting up projector and screen.

★ ★ ★

You will have your own ideas on how to present the visual material in a novel and interesting manner. The essential thing is not to hide your collection away, but to make sure it is seen. None of the projects in this chapter need be very elaborate. A short family history in duplicated typescript, with good-quality photocopies of illustrations, stands a chance of completion; more ambitious plans for a copiously illustrated, professionally printed book may never be realized. Similarly, how much can the usual family gathering, such as a wedding reception or a christening party, be enhanced by a few attractive displays of photographs, a short slide-tape sequence, or a fifteen-minute film. But how rarely it is done.

APPENDIX
A NOTE ON PHOTOGRAPHIC COPYRIGHT[9]

If you want to reproduce photographs in an article or book, you should first clear permission with the owner of the copyright.

At present (1983) the copyright in a commissioned photograph rests, unless otherwise agreed, with the person who commissions it. If you pay a photographer to take your photograph, you may reproduce it as often as you like, without paying him a reproduction fee, though the negative remains his property and he may charge you for any extra prints you want. This law is under review, and a new act may be brought in which will vest the copyright in the photographer during his lifetime, and in his estate for fifty years after his death (exactly like an author's copyright in any written work), though with special provisions protecting a sitter's 'right to privacy' in any use of a photographic portrait.

If a photographer takes an uncommissioned shot, the copyright is normally his, although if it features your family he should get your permission before using it commercially.

Suppose you want to reproduce an old photograph of the local village street, showing the inn your family owned years ago. The chances are this was an uncommissioned shot. Are the photographer's name and address given on the print? Is the studio still listed in the local directories? Can the reference library or the local history society tell you what became of the business? If you can trace the photographer or his descendants, you should write asking permission to reproduce the photograph—particularly if you are going to put your booklet on sale. If you try but fail to trace the photographer, put a note to this effect in the acknowledgements, showing that you did your best.

If you illustrate your family history with prints from library or museum collections, the conditions will be clearly set out in their 'permission to reproduce' form, and there should be no difficulty.

NOTES AND REFERENCES

1. Steel, D. J., and Taylor, L., *Family History in Schools,* Phillimore, Chichester, 1973, pp. 84–96.
2. The author is grateful to Jenny Overton for assistance with this section.
3. The author is grateful to Howell Green for assistance with this section.
4. For an interesting discussion on the role of music in the lives of Victorians and early Edwardians, see Janet and Peter Philips' *Victorians At Home and Away* (Croom Helm, London, 1978),
pp. 90–3, 110–11, 118–20 and 128–46.
5. The Federation of Family History Societies, 96 Beaumont Street, Milehouse, Plymouth, Devon PL2 3AQ.
6. The author is grateful to Ron Denyer for considerable assistance with this section.
7. For details, see Book List, page 189.
8. For details, see Book List, page 189.
9. The author is grateful to his publishers for assistance with this section.

11

Futurography

PETER MARMOY

'There'll never be another you,' so the song says. How many ears has that been whispered into, perhaps yours as well? For better or for worse there never will be another you, nor another me, nor another him, nor another her. We are each a unique and indispensable part of our family's heritage. Photography for posterity is real and important; recording your life and the life of your family rests squarely on you and your camera.

But do you try to record it truthfully? To judge from the average collection of family photographs, children never cry, and most people dress neatly—except on the beach where they wear the minimum because the sun is always shining. We even speak of 'good' pictures when we mean flattering, while 'candid' usually means comic. Yet candid snaps are often the more real, the more representative. Should we, therefore, make a conscious effort to reflect reality—untidy rooms, dirty cars, children in tantrums, dogs in disgrace? Only you can decide. But one thing is certain. Whatever window-dressing you do, whatever horrors you leave unrecorded, your great-grandchildren will know, for human nature is the one constant in recorded history.

But there is much more to 'truth' than this. The ability to control time has always been one of man's dreams and the camera is the nearest thing to a time-machine that man has yet invented. Perhaps this is a new role for your camera—a way of meeting your grandchildren in a world very different from yours. What will they want to know about you? What will they want to explore that they can see only through your eyes? While your great-grandchildren will value those beautiful wedding photographs and not-so-beautiful holiday exposures, truthful or not,

will they really consider them an adequate reflection of the lives of you and your family?

In the systematic recording of the present which will one day be the past, the family historian has two responsibilities: reporting and documenting. The dividing line is narrow. Reporting is concerned with transient events and occasions. Documentary photography concerns itself with the more permanent scene: the physical environment, social conditions, values and attitudes and changing fashions in costume, furniture, food and transport.

Of course, it goes without saying that your labours will be of little avail unless the level of your documentation matches the coverage of your photographs. Anyone who has browsed through old family albums crowded with unidentified ancestors and relatives will know the feeling of frustration at their great-grandparents' lack of consideration for their descendants in failing to say who was who, where and when. But are most of us any better in this respect than our Victorian ancestors? Each time a new batch of prints arrives, ensure that they are properly documented along the lines suggested in Chapter 1.

REPORTING

The media will record national and world events—and maybe some of your own more memorable moments if you are particularly lucky or unlucky. But usually the recording of personal involvement in incidents great and small depends on you. The 'I was there' theme personalizes events and has always been a source of keen interest to families. Prior to photography, only the richest in the land could afford a visual record of their ancestors' involvement in major events, and then only occasionally. The coming of the Kodak meant that Everyman could now do the same.

Until recently, still cameras played the major role in family photographic history, but with the steady improvement in cine-camera cost and quality, home movies have become more common, and now video recording offers opportunities undreamed of less than a generation ago.

Whether they are using a still, a movie or a video camera, most people do not give reporting sufficient forethought. Journeys, Sports Days or Open Days are events which can have shooting-scripts planned well in advance. The preparations for the great

day make a suitable introduction; then you can follow it through chronologically to its conclusion. It is not only what you choose to photograph, but how you decide to do it which is important. Select interesting viewpoints beforehand if possible. Take some photographs close up, some from a distance, some from low down, some from high up. Variety maintains interest in pictures as it does in other things. Keep your camera ready to record the unplanned events, whether amusing or catastrophic, which often make such days memorable. Take more photographs than you need so that you can be selective when you come to make up a sequence. Allow for mistakes. They do happen—frequently!

DOCUMENTING

However painstaking your reporting, it is a partial world you are showing—that world of living-room and garden, of beach and park, of weddings and birthdays, highdays and holidays. How many family historians have even one picture recording the interior of their place of work or of the crowded tube the commuter fights his way into daily? The objects which surround you are commonplace today but grow that little bit rarer each week, each month, each year, each decade, until they become a matter of history. Things familiar to us will not be so to our grandchildren. The number of small shops has probably been halved since 1900; like the old street-markets they are being replaced by super- and hypermarkets. Thousand-year-old hedges are grubbed up daily to create a new open field system. Our way of life changes at an ever-increasing pace. The national press, television and film companies record such trends, but they are unlikely to chronicle the details of your daily life—your work-place, your children's schools (inside and out), your journey to work.

Here is a short checklist to help you to record your total environment. You can probably think of many other items:

1. *The Locality*
 (a) Buildings old and new: styles, periods, materials; doors, gate and window designs; exterior decoration; memorials;
 (b) Amenities and social services: schools, hospitals, power stations, waterworks—not only the buildings but the employees and their working conditions, machines and vehicles;

Morden, Surrey, in 1975: note the modern block on the left, and the difference in scale between the new underground station and the 1930's shopping centre. Even the road markings may be of interest in 2075.

(c) Commerce: shops, shop-fronts and window-displays, shopkeepers, markets, pedestrian precincts, signs, symbols and advertising;

(d) Industry: factories and workshops, rural crafts, workers of all kinds;

(e) Agriculture: fields and agricultural machinery, farm workers;

(f) Relaxation: parks, rivers and lakes, theatres, cinemas, swimming-pools, libraries, gardens, circuses and fairs;

(g) Preservation and conservation: refuse tips, scrap yards; the best and worst streets in your area; the buildings you like best, and those you would most like to pull down.

Some at least of these areas might be observed and recorded in detail. But be careful that your documentary archive does not become too static. Record also construction developments such as building a house, a bridge or a motorway.

Take photographs of construction work too, such as this housing development being built (1983) at Reading in Berkshire. The road-name might be a valuable clue in years to come—but proper annotation, as described in Chapter 1, is far better!

2. *Your Home*

Take a camera systematically through your house, recording each room in turn. Yes, even the loo! Record the kitchen labour-saving devices. Take a photograph of your breakfast table tomorrow morning, the contents of your freezer, the inside of your kitchen cupboards. In the lounge, record the furnishings—the three-piece suite, the coffee-table. Photograph the means of entertainment: the television set, the music-centre. And remember the bedrooms, too.

3. *Your Place of Work*

Photograph your workplace, exterior and interior. Get your employers' and colleagues' permission to take pictures of them at work. Record special events: a union meeting, strike pickets, a meeting of the Board, the presentation of long-service awards.

Take photographs of your workplace, like this picture of signal box staff; they will be as fascinating to your descendants as the fishmongery on page 141 is to us today.

4. *Your Children's School*

 Again, the interior is more interesting than the exterior, and photographs of teachers and children at work are more interesting than empty classrooms.

5. *Transport*

 Railways and motorways; cars, buses, tube trains, taxis; car parks; street lights, traffic signals, pedestrian crossings; railway stations.

Still and moving pictures both have a part to play in recording the total environment. The cameras themselves demand a different kind of thinking eye behind the viewfinder to develop their potential. Many situations can be automatically categorized as 'still' or 'moving'. To state the obvious, static objects and situations suit still film and active situations suit moving film. There are exceptions, however. 'Freezing' movement can often enhance it, and passing a movie camera across a static object can create a unity which a series of still photographs will fail to achieve—for example, sweeping a camera across the front of your house will show its relationship with the garden and the

Do not take only 'modern' pictures. Continuity is as important as change. The exterior view of the village school at East Brent, Somerset, could have been taken at almost any time since 1887. But inside there have been radical changes. Eighty years ago the pupils were farmers' and labourers' children, of all ages. Today, many of the farmers' children go to private schools, there are few labourers in the village, and many pupils are children of middle-class families, their parents commuting to work in Bristol and Weston-super-Mare. Since 1977, this has been a First School, taking five- to nine-year-olds only.

Take pictures of your children's classrooms, their fellow pupils and their teachers. The middle picture shows a secondary school—there is an informal working atmosphere with a shirt-sleeved teacher, and the children look relaxed and interested, though the classroom decor has probably changed very little over the years. In the last picture, tables replace desks and the children are sitting in groups, not rows—very different from a hundred, or even a mere twenty, years ago.

Streamlined fitted kitchen, with mixer, wine rack, electric kettle, worktops—very different from the formidable coal-fired range, massive copper and open shelves of the Edwardian era

surrounding area. Movement recorded *as* movement is imagery at its most stimulating. The gracefulness of a cat, the flight of a gull, wind blowing across crops, the functional motion of aircraft and vehicles, the skill of the craftsman: these are all beautiful to watch. But more subtle than these, and a new area for the family photographer to explore, are family movements. Do you remember, as a child, listening for your mother's or your father's footsteps, and recognizing them? We each walk in a subtly different way. Each of us has our own poise and bearing, our own built-in characteristics. 'Isn't he like his father'—'Doesn't she look like her mother'—these judgments may be based not just on physical similarities but also on characteristic movements, gestures, ways of walking. The hats, clothes, shoes, we wear affect the way we move and must always have done so. So do our skills, talents and experiences. Whether you play tennis or shear sheep, the moving record will tell your great-grandchildren where your skills lie.

In recent years family historians have come to recognize the value of the tape recorder, not only in preserving memories of the past but also in capturing for posterity current ways of life and labour, and particularly those which are threatened with imminent social or technological extinction. The still picture or the

Lounge with modern radiators, television and fitted carpet on the one hand, and a traditional (though unlaid) hearth on the other to intrigue future generations

silent 8mm film have played a complementary role in such documentation. Today the video camera can combine the advantages of all of these—capturing not just the interviewee's voice but also his physical presence and often the environmental ambience. Although rare at present, such video-taped evidence for the family archive will eventually become the norm. As with audio tape recording, you should try not only to interview your older relatives before it is too late, but also to record the everyday rhythms of family life. They will be just as impossible to recapture in twenty years' time. The permanency of some of these materials has yet to be determined, but this must not prevent our recording them just the same. The transference of images from one material to another will always be possible.

* * *

When you look in local or social histories at pictures taken a hundred years ago, which are the ones which fascinate you most? Did your great-grandparents take any like that? If you could pass your camera to your great-grandparents, what would you have them photograph? Ask yourself these questions, and then do that for your own great-grandchildren. You will not be there to receive their thanks, but thank you they surely will.

Book List

Place of publication is London, unless otherwise stated. FHS = Family History Society. HMSO = Her (His) Majesty's Stationery Office, London. NY = New York. UP = University Press.

GENERAL WORKS ON FAMILY HISTORY

Although many books have been published on tracing your ancestors there are still relatively few on family history, i.e. setting the family in its total historical context. Some general guides are:

Dixon, J. T., and Flack, D. D., *Preserving Your Past*, Doubleday, NY, 1977. Very practical.

Kyvig, D. E., and Marty, M. A., *Your Family History*, AHM Pub. Corp., Arlington Hts, Ill., 1978. Stresses critical analysis, evaluation of sources, and writing of the family history.

Lichtman, A. J., *Your Family History*, Random House, NY, 1978. Exciting general book on family history as against genealogy. Strong emphasis on oral history. Useful section by Joan Challinor on photographs

Steel, Don, *Discovering Your Family History*, BBC, 1980. Well-illustrated book associated with BBC TV series. Extensive bibliography.

GENEALOGY: SOURCES & METHODS

In recent years there has been a proliferation of 'How to Do It' books. Some useful general introductions are:

England and Wales

Colwell, Stella, *The Family History Book*, Phaidon, Oxford, 1980. Well-presented, attractively illustrated survey both of genealogical sources and historical background.

Hamilton-Edwards, Gerald, *In Search of Ancestry*, Phillimore, Chichester, Sx, 1983. Long a standard work, now completely revised. Strong on Army and Navy; Scotland; East India Co. Extensive bibliography.

Matthews, C. M., *Your Family History*, Lutterworth, Guildford, Sy, 1982 (rev. ed.). Enjoyable genealogical guide. Good on ancillary topics, e.g. surnames, handwriting.

Steel, Don, *Discovering Your Family History*, BBC, 1980. See previous section.

Scotland and Ireland

Black, J. Anderson, *Your Irish Ancestors*, Paddington Press, 1974

Falley, M. D., *Irish and Scotch-Irish Ancestral Research*, priv. printed, Evanston, Ill., 1961–2 (2 vols)

Hamilton-Edwards, Gerald, *In Search of Scottish Ancestry*, Phillimore, Chichester, Sx, 1972

United States

American Genealogical Research Institute, *How To Trace Your Family Tree*, Heritage Press, Forest Pk, Ga, 1973, and Dolphin Books, NY, 1975

Doane, G. H., *Searching for Your Ancestors*, Univ. of Minnesota, 1973 (4th ed.) and Bantam Books, NY, 1974. First published 1939, reissued several times, still stands well as introduction.

Greenwood, Val D., *The Researcher's Guide to American Genealogy*, Genealogical Pub. Co., Baltimore, Ma, 1978. Standard reference work.

Linder, Bill R. *How To Trace Your Family History*, Everest, NY, and Beaver, Pickering, Ont., 1978. Beginner's guide, stressing systematic procedures and good record keeping.

Canada

Baxter, Angus, *In Search of Your Roots*, Macmillan, Toronto, 1978

Jonasson, Eric, *The Canadian Genealogical Handbook*, Wheatfield Press, Winnipeg, 1978

Public Archives of Canada, *Tracing Your Ancestors in Canada*, 1966. Booklet reprinted in *Genealogists' Magazine*, Vol. 15, No. 293, Dec. 1966.

Australasia

Gray, Nancy, and others, *Compiling a Family History*, Soc. of Australian Genealogists, Richmond Villa, 120 Kent St, Sydney, Australia 2000

Joseph, A. P., 'Anglo-Australian Genealogy', *Genealogists' Magazine*, Vol. 20, Nos 5 and 6, Mar. and June 1981

Lea-Scarlett, E. J., *Roots and Branches*, Soc. of Australian Genealogists; see Gray, above

Society of Genealogists, *Genealogical Research in New Zealand*, Leaflet 11, London, 1983

THE FAMILY PHOTOGRAPHIC ARCHIVE

Challinor, Joan, 'Family Photographs', in Lichtman, A. J., *Your Family History*, Random House, NY, 1978

Davies, Thomas L., *Shoots*, Addison House, Danbury, NH, 1977, and Travelling Light, 1978. Professional photo-historian's guide to taking, storing, restoring, preserving photographs.

Eakle, Arlene, 'Photographic Analysis', *Family History World*, 10 S. Main St, Salt Lake City, Utah, 1976

Hill, May Davis, 'The Family Historian: Photograph Albums', World Conference on Records,

Vol. 2, Paper 111b, LDS Church, Salt Lake City, Utah, 1980
——— 'The Stories Behind Your Photographs', World Conference on Records, Paper 353, 1980. For details, see previous entry.
Lieberman, Archie, *Farm Boy*, Harry N. Abrams, NY, 1974. Family photographs 1950 to 1970, illustrating that family histories need not go back generations.
Lindsay, Dean T. and J., 'Tombstone Photography', *Genealogical Journal*, Utah Genealogical Assoc., Salt Lake City, Utah, Vol. 4, No. 3, Sept. 1975, pp. 103–6. Virtually illegible tombstones made readable by flashlight photography.
Noren, Catherine H., *The Camera of my Family*, Knopf, NY, 1976. A hundred years of one family's history, generously illustrated.
Simpson, Jeffrey, *The American Family*, Viking, NY, 1976. Photographic history of American families, 1840's to 1970's.
Warhurst, C., Stephens, C. and Linkman, A., *Family Albums*, Manchester Polytechnic, Manchester, 1982. Strong on social significance of old family photographs; exhibition catalogue.
Weitzman, D. L., *My Backyard History Book*, Little, Brown, Boston, Mass, 1975. Engaging projects for children.
——— *Underfoot: An American Everyday Guide to Exploring the American Past*, Scribner, NY, 1976. Includes copying; setting up an archive; photographing artefacts, buildings, etc.
——— 'Illustrating Your Family History', World Conference on Records, Paper 124, 1980. For details, see Hill, May Davis, above.
Whittleton, Eric, 'The Camera and Family History', *Greentrees* (Journal of Central Middlesex FHS), Vol. 2, No. 2, Spring 1981. On relevance to family history of the Kodak Museum, Harrow, Mx.

COPYING, ORGANIZING, STORING

(No author), *Caring for Photographs*, Time-Life, NY, 1972. Thorough advice on preserving, displaying, organizing, storing.
Castle, Peter, *Collecting and Valuing Old Photographs*, Garnstone, 1973
Corbett, Neville, 'Conservation of Historic Records at Home', *Descent* (Journal of Soc. of Australian Genealogists), Vol. 10, Pt 3, Sept. 1980, p. 114. Useful advice on adhesive tape, flour paste, marking pens, hinges, archive paper, etc.
Davies, T. L., *Shoots* (see previous section). Particularly helpful in this area.
Goddard, J., 'Slide Storage System', *Amateur Photographer*, Vol. 166, No. 36, 27 Nov. 1982, pp. 114–15
Gray, Madeleine, 'Photograph Storage in Gwynedd, an ad hoc solution', *Journal of Soc. of Archivists*, Vol. 5, No. 7, April 1977, pp. 437–40

MacKichan, Margaret A., 'Family Photographs— how to prolong their life', *Families* (Journal of Ontario Genealogical Soc.), 20 Feb. 1981, pp. 103–9
Weinstein, R. A. and Booth, L., *Collection, Use and Care of Historical Photographs*, American Assoc. for State and Local History, Nashville, Tenn., 1977. Collection, use and initial care of photographs; caring for historical photographs.

COSTUME

Anthony, P., and Arnold, J., *Costume, a General Bibliography*, Victoria & Albert Museum and the Costume Society, 1974
Corson, R., *Fashions in Hair*, Peter Owen, 1965
(Journal) *Costume* (pub. quarterly), the Costume Society, c/o 63 Salisbury Rd, Liverpool L19 0PH. Circulated to members; includes articles, book reviews, lists of new publications.
Cunnington, C. W., *Englishwomen's Costume in the 19th Century*, Faber & Faber, 1937
——— *Englishwomen's Costume in the Present Century*, Faber & Faber, 1952
——— and P., *Handbook of English Costume in the 19th Century*, Faber & Faber, 1970
Cunnington, P., *Costume of Household Servants, Middle Ages to 1900*, A. & C. Black, 1974
——— and Lucas, C., *Occupational Costume in England, 11th Century to 1914*, A. & C. Black, 1967
Ewing, E., *History of Children's Costume*, Batsford, 1977
——— *History of Twentieth-Century Fashion*, Batsford, 1974
Gibbs-Smith, C. H., *The Fashionable Lady in the 19th Century*, HMSO, 1974
Ginsburg, Madeleine, *Victorian Dress in Photographs*, Batsford, 1982
——— *Wedding Dress, 1740–1970*, HMSO, 1981.
Mansfield, A., and Cunnington, P., *English Costume for Sports and Outdoor Recreation*, A. & C. Black, 1969

The best sources for published sets of outline drawings are museum bookstalls, e.g. the Museum of Costume, Bath; the Bethnal Green Museum of Childhood, the Museum of London and the Victoria & Albert Museum, London; and the Gallery of English Costume, Platt Hall, Manchester. Some examples are:

Dolton, Phyllis, and Langley Moore, Doris, *Fashion Outlines 'A', 1880–1913*, Museum of Costume, Bath. Leaflet with 24 drawings.
——— *Fashion Outlines 'B', 1914–68*. Details as previous entry.
Gibbs-Smith, C., *Synopsis of 19th Century Women's Fashion*, HMSO for the Victoria & Albert Museum, London. Leaflet with 21 drawings, 1800–1900.

Official Publications

Army List: lists of Army officers have been issued annually since 1754. In 1840 H. G. Hart compiled and published the first edition of *Hart's Army List*, supplementing the official record; his series continued until 1916. An *Army List* is now published annually by HMSO, London.

Navy List: from 1782 to 1817 *Steel's Navy List* of officers appeared annually. Since 1814 official *Navy Lists* (including Royal Marines) have appeared annually. Now published by HMSO, London.

Air Force List: until April 1918, when the Royal Flying Corps and the Royal Naval Air Service merged to form the RAF, RFC officers appeared in the *Army List* and RNAS officers in the *Navy List*. An *Air Force List* is now published annually by HMSO, London.

Casualty Lists

For reissues of published casualty lists, see the catalogues of specialist publishers, such as J. B. Hayward (distributors, The London Stamp Exchange, 5 Buckingham St, London WC2). Given below are, first, three Boer War examples, and secondly, three for World War I:

Dooner, Mildred G., *The Last Post*, Simpkin Marshall, 1903. Biographical roll of all officer casualties, naval, military and colonial.

Evans, S. (ed.), *South African Field Force Casualty List, 1899–1902*, Oaklands Book Div., Ilford, Essex, 1972

(No author) *The South African War Casualty Roll*, Vols I & II, J. B. Hayward & Son, 1972

Campbell, G. L., and Blinkhorn, R. H., *Royal Flying Corps (Military Wing), Casualties and Honours, 1914–17*, Picture Advertising Co., 1917. Casualties up to June/July 1917.

(No author) *Officers Died in the Great War*, HMSO, 1919. May be consulted at Imperial War Museum, London SE1.

———Soldiers Died in the Great War (80 parts), HMSO, 1921–22. See previous entry.

Regiments and their Histories

Barnes, R. M., see next section.

Bowling, A. H., *British Infantry Regiments 1660–1914*, Almark, 1970

James, E. A., *British Regiments 1914–18*, Samson Books, 1982. Gives locations.

Swinson, A., *Register of the Corps and Regiments of the British Army*, Archive Press, 1972

White, Arthur S., *Bibliography of Regimental Histories of the British Army*, F. Edwards Ltd and Journal of Soc. for Army Historical Research, 1965

Uniforms, Badges and Insignia

Barnes, R. M., *History of the Regiments and Uniforms of the British Army*, Seeley Service, 1950.

Appendix gives facing colours.

Carman, W. Y., *British Military Uniforms from Contemporary Pictures*, Leonard Hill, 1957. Appendix gives facing colours.

Cox, R. H. W., *Military Badges of the British Empire, 1914–18*, Benn, 1982

Dress Regulations, see Note 6, p. 73

Edwards, T. J. (ed., Kipling, A. L.), *Regimental Badges*, Gale & Polden, Aldershot, Hants, 1968

Kipling, A. and King, H., *Headdress Badges of the British Army*, Muller, 1978–79

Lemonofides, Dino, *British Infantry Colours*, Almark, 1971. Deals with regimental flags, etc., but has brief appendix giving facing colours.

May, W. E., Carman, W. Y., and Tanner, J., *Badges and Insignia of the British Armed Services*, A. & C. Black 1974

Ripley, Howard, *Buttons of the British Army 1855–1970*, Arms & Armour Press, 1971

Westlake, Ray, *Collecting Military Shoulder Titles*, Fredk. Warne, 1980

Orders, Medals, Decorations

For lists of recipients of particular medals, consult catalogues of specialist publishers such as Arms & Armour Press (Hampstead High St, London NW3), J. B. Hayward & Son (The London Stamp Exchange, 5 Buckingham St, London WC2), Samson Books (Jamaica Rd, London SE1), Seaby Numismatic Pubs (11 Margaret St, London W1), and Spink & Son (5 King St, London SW1).

Joslin, E. C., *Spink's Catalogue of British and Associated Orders, Decorations and Medals*, Webb & Bower, Exeter, Devon, 1983 (rev. ed.).

Purves, Alec A. *Collecting Medals and Decorations*, Seaby, 1978. Brief details of British orders, decorations, gallantry awards, campaign, polar, commemorative and long service medals; general survey of foreign awards.

Military Genealogy and Sources

Hamilton-Edwards, Gerald, *In Search of Army Ancestry*, Phillimore, Chichester, Sx, 1979.

Higham, R. (ed.) *Guide to the Sources of British Military History*, Routledge & Kegan Paul, 1972.

Holding, N.H., *World War One Army Ancestry*, Fed. of FHS, 96 Beaumont St, Milehouse, Plymouth, Devon. Vol. I (1982) describes identifying group photographs by identification of officers or medal-holders. Vol. II (in preparation 1983) includes regimental histories and numbers, sources for lists of men serving, uniforms and equipment, Army records, Army postal services, military museums.

——— 'World War I Army Ancestors', Beds FHS Journal, Vol. 4, No. 1, Spring 1983, pp. 8–12. Identifying photographs by badges, headgear, footwear, gas masks, pistols, etc.; using army postmarks to trace places of origin of letters.

Smith, Frank, and Gardner, D.E., *Genealogical Research in England and Wales*, Bookcraft, Salt

Lake City, Utah, 1956–59, 1964. Vol. II includes military and naval records.

Watts, C. T. and M. J., 'In Search of a Soldier Ancestor', *Genealogists' Magazine*, Vol. 19, No. 4, Dec. 1977.

HISTORY OF PHOTOGRAPHY

Beaton, Cecil, and Buckland, Gail, *The Magic Image*, Weidenfeld & Nicolson, 1975

Bernard, Bruce, *The Sunday Times Book of Photo-discovery, 1840–1940*, Thames & Hudson, 1980

Braive, M. F., *The Era of the Photograph*, McGraw Hill, NY, and Thames & Hudson, 1966

(No author) *Chronology of Photography*, Handbook Co., Athens, Ohio. History of art photography, with sections on portraiture, cityscape, etc.; compares history of photography with events in other arts; concludes with a chronology. Useful for reference.

Coe, Brian, *The Birth of Photography*, Ash & Grant, 1976. Very readable, well-illustrated survey.

———— *Cameras, from Daguerreotypes to Instant Pictures*, Marshall Cavendish, 1978

———— *Colour Photography, 1840–1940*, Ash & Grant, 1978

———— *George Eastman and the Early Photographers*, Priory Press, Hove, Sx, 1973

———— *The History of Movie Photography*, Ash & Grant, 1981

———— and Gates, P., *The Snapshot Photograph*, Ash & Grant, 1977. Well-illustrated, very readable.

———— and Haworth-Booth, Mark, *A Guide to Early Photographic Processes*, Hurtwood Publications, Westerham, Kent, 1983

Eder, Josef Maria, *The History of Photography*, Columbia UP, NY, 1945

Gernsheim, Helmut and Alison, *The History of Photography from the Camera Obscura to the Beginning of the Modern Era*, McGraw Hill, NY, and Thames & Hudson, 1969; reissued Aperture, Millerton, NY, 1973

(No author) *Great Photographers*, Time-Life, NY, 1971

Green, J., *The Snapshot*, Aperture, Millerton, NY, 1974

Greenhill, R., *Early Photography in Canada*, Oxford UP, Montreal, 1965. Chapters on origins, commercial trends, artistic trends; remainder on well-known photographers.

Hannavy, J., *The Victorian Professional Photographer*, Shire Publications, Princes Risborough, Bucks, 1980. Useful 32-page booklet.

Harker, Margaret F., *Victorian and Edwardian Photographs*, Letts, 1975. Useful survey of main processes; section on famous photographers.

Heyert, E., *The Glass House Years, Victorian Portrait Photography, 1839–70*, Allanheld & Schram, Montclair, NJ, 1979

Hillier, Bevis, *Victorian Studio Photographs*, Ash & Grant, 1976

(Journal) *History of Photography* (pub. quarterly), Taylor & Francis, 4 John St, London WC1

Holmes, Edward, *An Age of Cameras*, Fountain Press, Watford, Herts, 1974

Howarth-Loomes, B. E. C., *Victorian Photography: A Collector's Guide*, Ward Lock, 1974. Well-illustrated; invention of photography, daguerreotype, calotype, wet plate period, stereoscopic photography, cartes de visite, and dry plate.

Jenkins, Reese V., *Images and Enterprise: Technology and the American Photographic Industry*, Johns Hopkins UP, Baltimore, Ma, 1975

Langford, Michael, *The Story of Photography*, Focal Press, 1980. Survey for school and college use.

(No author) *Light and Film*, Time-Life, NY, 1981 (rev. ed.). Every stage of making a daguerreotype, calotype and collodion wet plate pictorially demonstrated by modern photographer; sections on some great Victorian photographers; scientific background explained with crisp clarity and good diagrams, many in colour; very useful practical advice.

Martin, P., *Victorian Snapshots*, Country Life, 1939

Mathews, Oliver, *The Album of Cartes de Visite and Cabinet Portrait Photography, 1854–1948*, Reedminster, 1974

———— *Early Photographs and Early Photographers*, Pitman, NY, and Reedminster, 1973

Newhall, Beaumont, *The History of Photography from 1839 to the Present Day*, Museum of Modern Art, NY, 1964; reissued 1972 (Secker & Warburg). Very readable, strong on social aspects.

———— *Photography, A Short Critical History*, Museum of Modern Art, NY, 1938

Ovenden, Graham (ed.), *A Victorian Album*, Secker & Warburg, 1975

Pollack, P., *The Picture History of Photography*, Harry N. Abrams, NY, 1958 and 1970

Scharf, Aaron, *Pioneers of Photography*, BBC, 1975

Taft, R., *Photography and the American Scene, 1839–1889*, Macmillan, NY, 1938; reissued Dover, NY, 1964

Taylor, John, *Pictorial Photography in Britain, 1900–20*, Arts Council and Royal Photographic Society, 1978

Thomas, D. B., *The First Negatives*, HMSO, 1974.

———— *'From Today Painting is Dead', The Beginnings of Photography* (catalogue), Victoria & Albert Museum, 1972

———— *The Science Museum Camera Collection*, Science Museum, 1981

Welling, William, *Collector's Guide to 19th-Century Photographs*, Macmillan, NY, 1976. Useful, well-illustrated sections on each process.

EARLY PHOTOGRAPHERS

Two useful overviews of early photographers, followed by notes on individuals:

Hannavy, J., *Masters of Victorian Photography*, David & Charles, Newton Abbot, Devon, 1976

Harker, Margaret F., *Victorian and Edwardian Photographs*, Letts, 1975.

ROBERT ADAMSON see below, under D. O. HILL

FRANCIS BEDFORD, practising mid 1850's–70's, artist, lithographer, leading landscape and architectural photographer; published in 1863 a collection of photographs taken on a Royal tour of the Middle East

MATHEW BRADY, practising c. 1844–74, probably the best-known photographer in American history, took famous pictures of Civil War; see Horan, James D., *Mathew Brady*, Crown, NY, 1955

JULIA MARGARET CAMERON, practising c. 1864–78, celebrated portrait photographer; see Ford, Colin, *The Cameron Collection*, Van Nostrand Reinhold, NY, 1975

LEWIS CARROLL, practising c. 1856–80, mathematician, Oxford don, author of *Alice in Wonderland*, outstanding photographer of children; see Gernsheim, Helmut, *Lewis Carroll, Photographer*, Aperture, Millerton, NY, 1969 (rev. ed.)

PETER HENRY EMERSON, practising 1882–c. 1933, photographed the people and landscape of East Anglia; see Turner, P., and Wood, R., *P. H. Emerson*, Gordon Fraser, 1974

ROGER FENTON, practising c. 1847–62, best-known for pictures of Crimean War; work often documentary in character; see Hannavy, J., *Roger Fenton of Crimble Hall*, David R. Godine, Boston, Mass, and Gordon Fraser, 1974

WILLIAM HENRY FOX TALBOT, developed the calotype 1840–c.64; distinguished mathematician and scientist; see Arnold, H. J. P., *William Henry Fox Talbot*, Hutchinson, 1977

FRANCIS FRITH, practising c. 1855–93, pioneer in precursors of postcard; see Jay, Bill, *Victorian Cameraman: Francis Frith's Views of Rural England, 1850–98*, David & Charles, Newton Abbot, Devon, 1973

DAVID OCTAVIUS HILL and ROBERT ADAMSON, Scots calotype portrait photographers 1843–47; see Stevenson, Sara, *David Octavius Hill and Robert Adamson*, HMSO, Edinburgh, 1981

PAUL MARTIN, in 1890's took striking pictures of street and seaside-resort life; see Jay, Bill, *Victorian Candid Camera: Paul Martin 1864–1944*, David & Charles, Newton Abbot, Devon, 1973

JAMES MUDD, practising 1854–c.93, leading photographer in North-West England; the Central Library and Science Museum, Manchester, hold his photographic records of the heavy industrialization of the period.

EADWEARD JAMES MUYBRIDGE, practising 1860's–1904, Englishman who photographed West Coast of USA and took pioneer photographs of humans and animals in motion; see (no author) *The Photographs of Eadweard James Muybridge*, John Judkyn Memorial, Freshford Manor, Bath, Avon

SAMUEL SMITH, died 1892; pioneer in systematic documentation of his home town, Wisbech, Cambs; see Millward, M., and Coe, Brian, *Victorian Townscape*, Ward Lock, 1974

FRANK MEADOW SUTCLIFFE, practising 1875–c.1920, photographer of Whitby, Yorks; see Hiley, M., *Frank Sutcliffe*, Gordon Fraser, 1974

HENRY TAUNT, practising 1856–1922, prolific photographer, best-known for studies of the Thames 1860's and 70's; see Brown, B., *The England of Henry Taunt*, Routledge & Kegan Paul, 1973

JAMES VALENTINE, practising mid 1850's–1880, Scots landscape photographer, founder of James Valentine & Sons, Dundee, one of the largest producers of photographic postcards in U.K.

GEORGE WASHINGTON WILSON, practising 1853-93, Scots professional photographer, head of J. W. Wilson & Co., Aberdeen, photographic publishing firm; see Taylor, Roger, *George Washington Wilson*, Aberdeen UP, Aberdeen, 1981

PICTURE RESEARCHING

Barley, M. W., *Guide to British Topographical Collections*, Council for British Archaeology, 112 Kennington Rd, London SE1, 1974. Photographs, prints and estate drawings in libraries, museums, record offices, private collections.

Evans, H. and M., and Nelki, A., *The Picture Researcher's Handbook*, David & Charles, Newton Abbot, Devon, and Vancouver, 1975. Lists main collections throughout the world.

Hudson, K., and Nicholls, A., *Directory of Museums*, Macmillan, 1975. Specialized and outstanding collections, country by country.

Huyday, R. J., 'Photographs and Archives in Canada'. *Archivaria*, Winter, 1977-78.

(No author) *Libraries, Museums and Art Galleries Year Book*, James Clark & Co., All Saints Passage, Cambridge. Published annually.

(No author) *Museums and Galleries in Great Britain and Ireland*, ABC Publications, Dunstable, Beds. Published annually.

Wall, John (comp.), *The Directory of British Photographic Collections*, Heinemann, 1977. Lists 1,580 collections; indexed by subject, owner, location, title and photographer.

Welling, William, *Collector's Guide to 19th-Century Photographs*, Macmillan, NY, 1976. Lists principal North American collections.

PUBLISHED COLLECTIONS OF LOCAL AND TOPOGRAPHICAL PHOTOGRAPHS

This is a rapidly growing field and no list can do more than indicate the coverage available. For bibliographical assistance, consult the quarterly journal *The Local Historian* (26 Bedford Sq., London WC1) which contains excellent reviews, lists 'Books Received' and has an 'Historical Photographs' section.

Regions and Counties

Batsford Ltd (4 Fitzhardinge St, London W1) has published a comprehensive series of books illustrated with old photographs, each title beginning '*Victorian and Edwardian—*' Included are *Ireland, Scotland* and *Wales;* regions (e.g. *The Lake District*); and individual counties.

Local publishers produce excellent books with evocative period photographs showing people at work, at home, at play, which can be invaluable sources of background illustration. Some examples are:

Burnett, David, *A Wiltshire Camera, 1834-1914* and *A Wiltshire Camera, 1914-1945*, Compton Russell, Tisbury, Wilts

Henderson, Tom, *Shetland from Old Photographs*, Shetland Library and Museum, 1978

Read, Susan, *Berkshire in Camera, 1845-1920*, Countryside Books, 3 Catherine Rd, Newbury, Berks

Towns and Cities

Batsford's '*Victorian and Edwardian*' series (see previous section) includes towns and cities. EP Publishing (East Ardsley, Wakefield, West Yorks) publishes an '*Old and New*' series on towns and cities with historic and modern photographs juxtaposed, and Hendon Publishing Co. (Hendon Mill, Nelson, Lancs) an '*As It Was*' series. The work of local publishers in this field is often excellent. A few examples are:

Bristol As It Was, 1850-1959, a monumental 13-volume pictorial history, published by the author, Reece Winstone (23 Hylands Grove, Bristol 9); see also his photographic histories, *Bristol's Earliest Photographs, Bristol Fashion, Bristol Today* and *Bristol Tradition*

Bygone Brighton, John Hallewell Publications, 38 High St, Chatham, Kent

Reading Past and Present, by Daphne Phillips for Countryside Books, 3 Catherine Rd, Newbury. Berks, 1982

Out of the vast number of books on London, only a few can be mentioned:

Betjeman, John, *Victorian and Edwardian London from Old Photographs*, Batsford, 1969

(No author) *Hackney Camera, 1883-1918*, Centreprise, 136 Kingsland High St, London E8 (no date)

Margetson, Stella, *Fifty Years of Victorian London from the Great Exhibition to the Queen's Death*, Macdonald, 1969

Morris, O. J., *Grandfather's London*, Godfrey Cave, 1979. Facsimile reissues of photographs of street life in mid 1880's; inspired by work of Charles Spurgeon in Greenwich, *c*. 1885

(No author) *Tower Hamlets in Photographs, 1914-1939*, Tower Hamlets Central Library,

Bancroft Rd, London E1, 1980

Winter, Gordon, *Past Positive*, Chatto & Windus, 1971

THEMATIC COLLECTIONS OF HISTORICAL PHOTOGRAPHS

Batsford (see previous section) includes thematic titles in its '*Victorian and Edwardian*' series, among them *Canals, Crime and Punishment, Clyde Shipbuilding, Cycling and Motoring, Entertainment, The Navy, Railways, Sailing Ships, Yachting.*

There are also photographic histories of particular periods, including more recent times. Some examples of the extensive coverage of Victorian and Edwardian Britain are:

Bentley, Nicolas, *Edwardian Album*, Weidenfeld & Nicolson, 1974

Buckland, Gail, *Reality Recorded: Early Documentary Photography*, David & Charles, Newton Abbot, Devon, 1974

Evans, H. and M., *The Victorians at Home and Work*, David & Charles, Newton Abbot, Devon, 1973

Ford, Colin, and Harrison, Brian, *A Hundred Years Ago: Britain in the 1880's*, Allen Lane, 1982

Gorman, J., *To Build Jerusalem: A Photographic Remembrance of British Working-Class Life*, Scorpion Publications, 1981

Hiley, Michael, *Victorian Working Women*, Gordon Fraser, 1979

Ovenden, G., and Melville, R., *Victorian Children*, Academy Eds, NY, 1972

Sansom, W., *Victorian Life in Photographs*, Thames & Hudson, 1974

Ward, Sadie, *Seasons of Change: Rural Life in Victorian and Edwardian England*, Allen & Unwin, 1982

Winter, Gordon, *A Country Camera, 1884-1914*, David & Charles, Newton Abbot, Devon, 1972

——— *The Golden Years, 1903-1913*, David & Charles, Newton Abbot, Devon, 1975

SLIDE-TAPE, FILM AND VIDEO

Slide-Tape

Green, Howell, *Projecting Family History*, Fed. of FHS, 96 Beaumont St, Milehouse, Plymouth, Devon

Film

Arrowsmith, F., *Beginner's Guide to Super 8 Film Making*, Newnes, Sevenoaks, Kent, 1981

Cheshire, D., *The Book of Movie Photography*, Ebury Press, 1979

Petzold, P., *The All-in-One Cine Book*, Focal Press, 1969

Video

Owen, D., and Dunton, M., *The Complete Handbook of Video*, Allen Lane, 1982

Index